SANTA BARBARA STORIES

Santa Barbara Stories

EDITED BY

Steven Gilbar

A STEVEN GILBAR BOOK

John Daniel & Company
SANTA BARBARA • 1998

Design and typography by Jim Cook

Published by John Daniel & Company, a division of Daniel & Daniel, Publishers, Inc.,
Post Office Box 21922, Santa Barbara, California 93121

LIBRARY OF CONGRESS CATALOGING-IN-PUBLICATION DATA
Santa Barbara stories / edited by Steven Gilbar.
 p. cm.
"A Steven Gilbar book."
Contents: Find the woman / Ross Macdonald – The women on the wall /
Wallace Stegner – The professor and the poet / Marvin Mudrick – Old Spanish
days / John Sayles – K. 590 / Nicholson Baker – The girl in white / Dennis Lynds –
Yardwork / Sheila Golburgh Johnson – The man within / Shelly Lowenkopf –
Jeanette / Gayle Lynds – The four of us / Salvatore LaPuma – She wasn't soft /
T. Coraghessan Boyle – From out there / John M. Daniel – The last younger man /
Catherine Ryan Hyde.
 ISBN 1-880284-31-6 (alk. paper)
 1. Santa Barbara (Calif.) – Social life and customs – Fiction. 2. Short stories,
American – California – Santa Barbara. 3. American fiction – 20th century.
 I. Gilbar, Steven.
 PS572.S35S28 1998
 813'.01083279491–dc21 97-44220
 CIP

ACKNOWLEDGMENTS

"K.590" ©1981 by Nicholson Baker. First appeared in *The Little Magazine,* vol. 13, nos. 1 and 2, 1981. Reprinted by permission of Melanie Jackson Agency.

"She Wasn't Soft" ©1995 by T. Coraghessan Boyle. Reprinted by permission of Georges Borchardt, Inc., for the author. Originally appeared in *The New Yorker* (September 1995).

"From Out There" ©1996 by John M. Daniel. First appeared in *Fish Stories,* Collective 2, 1996. Reprinted by permission of the author.

"The Last Younger Man" ©1997 by Catherine Ryan Hyde. First appeared in *Eureka Literary Magazine* (Spring 1998). Reprinted by permission of the author.

"Yardwork" ©1991 by Sheila Golburgh Johnson. First appeared in *Crosscurrents,* vol. IX, no. 4 (January 1991). Reprinted by permission of the author.

"The Four of Us" from *Teaching Angels to Fly* ©1992 by Salvatore LaPuma. Reprinted by permission of W.W. Norton & Co., Inc.

"The Man Within" ©1991 by Shelly Lowenkopf. First appeared in *South Dakota Review,* vol. 29, no. 4 (Winter 1994). Reprinted by permission of the author.

"The Girl in White" ©1984 by Dennis Lynds. First appeared in *South Dakota Review,* vol. 22, no. 3 (Autumn 1984). Reprinted by permission of the author.

"Jeannette" ©1985 by Gayle Lynds. First appeared in *The Florida Review,* vol. XIII, no. 1 (Spring 1985). Reprinted by permission of the author.

"Find the Woman" ©1946, 1973 by The Margaret Millar Charitable Remainder Unitrust u/a 4/12/82. Reprinted by permission of Harold Ober Associates, Inc.

"The Professor and the Poet" ©1954 by Marvin Mudrick. First appeared in *Shenandoah* 5 and republished in *Best American Short Stories 1955.* Reprinted by permission of Jeanne Mudrick.

"Old Spanish Days" from *The Anarchists' Convention* ©1979 by John Sayles. Reprinted by permission of the author.

"The Women on the Wall," from *The Women on the Wall* ©1950 by Wallace Stegner. Reprinted by permission of Brandt & Brandt.

Santa Barbara Stories

Introduction

STEVEN GILBAR

S OME YEARS AGO, the poet Kenneth Rexroth retired to
Santa Barbara and remarked on what an ideal place it was
to be a writer. "There is nothing to fight about," he
wrote. "Even sex, food, clothing, and shelter and mild intoxicants
are abundant and can be obtained practically for the asking. Then,
too, not least, the extremely conventional citizenry have passionately
defended the beauty of their city, so that it is today the least fouled
up of any place with a Mediterranean climate. . . . All of this has
gone to produce, very quietly, while nobody else in the country was
looking, a considerable amount of significant literary activity."

Whether or not Santa Barbara is still (or ever was) the paradise
that Rexroth saw it to be can be debated, but there is no disputing
that this city, snugly situated on California's central coast between
the Santa Ynez Mountains and the Pacific Ocean, has attracted and
inspired writers. Some of them have visited and moved on; others
have remained and have kept in touch with one another enough to
become a loosely defined and very active "writers' colony."

If there is indeed such a colony in Santa Barbara, it probably
began with Kenneth Millar, who arrived in Santa Barbara after the
end of World War II to start writing under the name of Ross
Macdonald. He and his wife, Margaret Millar, were the first of many

suspense writers who would make Santa Barbara their home, a line continuing down to present-day practitioners such as Richard Barre, Gerald A. Browne, Michael Collins (the pseudonym of Dennis Lynds), David Debin, Roger Dunham, Ron Ely, J.F. Freedman, Tony Gibbs, Sue Grafton, Melody Johnson Howe, Gayle Lynds, Frank McConnell, and Leonard Tourney.

Several of the current Santa Barbara writers are also teachers of writing as well. These include Dennis Lynds and Shelly Lowenkopf, both of whom came to Santa Barbara from the East Coast in the seventies, and Gayle Lynds, who has also worked in publishing, all the while writing short stories, mystery novels, and works of non-fiction. One of her students, Sheila Golburgh Johnson, has written many short stories and is the editor of an anthology of bird poems published by John Daniel and Company. John M. Daniel is a publisher, teacher, and writer, as well as a practitioner and editor of some of the world's shortest stories. Daniel is also a workshop leader at the annual Santa Barbara Writers' Conference, hosted by Barnaby and Mary Conrad, as is Shelly Lowenkopf. Another writer associated with the conference is Catherine Ryan Hyde, whose published fiction has received critical acclaim.

Other writers living in Santa Barbara (although not especially active in a "writers' colony" there) have been Marvin Mudrick, who wrote short stories while teaching at the University of California at Santa Barbara; Salvatore LaPuma, who wrote stories in whatever hours he could steal from his work as a real estate broker; and T. Coraghessan Boyle, the distinguished novelist and short story writer, long associated with the University of Southern California, who moved to Santa Barbara in the nineties and would use it as a setting for his 1998 novel, *Riven Rock*.

There have been any number of writers who lived in Santa Barbara only a short time and yet managed to produce fiction set there. They include Wallace Stegner, who rented a guest house on the large Hammond estate in Montecito in September 1944. In a letter to a friend he described the scene: "For plain, unadulterated good looks, they don't make many towns better than this one. We perch in a royal palm grove up from the beach, and on clear days,

which are few, the view is full of both mountains and ocean and Channel islands. The public schools are good, the ration board fairly liberal, and the place full of refugee writers and publishers, with whom we have so far avoided contact." While there, he worked on a non-fiction book, *One Nation* (1945). He wrote "Women on the Wall" (first published in Harper's in 1946) after leaving Santa Barbara, but used a situation that came to him during his stay there.

John Sayles moved to Santa Barbara in 1976 because he had a film agency interested in representing him as a screenwriter and it insisted that he should live near Los Angeles for a while. He stayed almost two years, during which time he wrote several short stories, including "Old Spanish Days," which is based on Santa Barbara's annual fiesta.

Perhaps the shortest visit that resulted in a short story was Nicholson Baker's. He lived in Isla Vista, the UCSB campus community, for two "very happy" summers during the seventies when he was eighteen and nineteen as a student of the Music Academy of the West. He has written that "much of the setting of 'K.590'—the refreshment room, the odd fountain, the field with sprinklers nearby—was taken more or less from life. A string quartet did frequently practice Mozart in that unclassically carpeted spot." The people, and what few events there are in the story, however, are pure invention.

All of the stories in this collection have two things in common. They are all set in (or very near) Santa Barbara, and they have all been previously published. It is also true that all of the authors of these stories have lived, at least briefly, in Santa Barbara. Mention must also be made of the many fiction writers who have lived in Santa Barbara but are not included in this collection, either because they have not published any short stories or because their published short fiction was not set in Santa Barbara. These range from Stewart Edward White at the turn of the century to such current residents as Gretel Ehrlich, Fannie Flagg, Pico Iyer, Himilce Novas, Max Schott, and Duane Unkefer.

This collection of Santa Barbara short stories is dedicated to all those who live, write, and read in Santa Barbara and all those less-fortunate souls who have only visited or have yet to visit.

Find the Woman

Ross Macdonald

I SAT in my brand-new office with the odor of paint in my nostrils and waited for something to happen. I had been back on the Boulevard for one day. This was the beginning of the second day. Below the window, flashing in the morning sun, the traffic raced and roared with a noise like battle. It made me nervous. It made me want to move. I was all dressed up in civilian clothes with no place to go and nobody to go with.

Till Millicent Dreen came in.

I had seen her before, on the Strip with various escorts, and knew who she was: publicity director for Tele-Pictures. Mrs. Dreen was over forty and looked it, but there was electricity in her, plugged in to a secret source that time could never wear out. Look how high and tight I carry my body, her movements said. My hair is hennaed but comely, said her coiffure, inviting not to conviction but to suspension of disbelief. Her eyes were green and inconstant like the sea. They said what the hell.

She sat down by my desk and told me that her daughter had disappeared the day before, which was September the seventh.

"I was in Hollywood all day. We keep an apartment here, and there was some work I had to get out fast. Una isn't working, so I left her at the beach house by herself."

"Where is it?"

"A few miles above Santa Barbara."

"That's a long way to commute."

"It's worth it to me. When I can maneuver a weekend away from this town, I like to get *really* away."

"Maybe your daughter feels the same, only more so. When did she leave?"

"Sometime yesterday. When I drove home to the beach house last night she was gone."

"Did you call the police?"

"Hardly. She's twenty-two and knows what she's doing. I hope. Anyway, apron strings don't become me." She smiled like a cat and moved her scarlet-taloned fingers in her narrow lap. "It was very late and I was—tired. I went to bed. But when I woke up this morning it occurred to me that she might have drowned. I objected to it because she wasn't a strong swimmer, but she went in for solitary swimming. I think of the most dreadful things when I wake up in the morning."

"*Went* in for solitary swimming, Mrs. Dreen?"

"'Went' slipped out, didn't it? I told you I think of dreadful things when I wake up in the morning."

"If she drowned you should be talking to the police. They can arrange for dragging and such things. All I can give you is my sympathy."

As if to estimate the value of that commodity, her eyes flickered from my shoulders to my waist and up again to my face. "Frankly, I don't know about the police. I do know about you, Mr. Archer. You just got out of the army, didn't you?"

"Last week." I failed to add that she was my first postwar client.

"And you don't belong to anybody, I've heard. You've never been bought. Is that right?"

"Not outright. You can take an option on a piece of me, though. A hundred dollars would do for a starter."

She nodded briskly. From a bright black bag she gave me five twenties. "Naturally, I'm conscious of publicity angles. My daughter retired a year ago when she married—"

"Twenty-one is a good age to retire."

"From pictures, maybe you're right. But she could want to go back if her marriage breaks up. And I have to look out for myself. It isn't true that there's no such thing as bad publicity. *I* don't know why Una went away."

"Is your daughter Una Sand?"

"Of course. I assumed you knew." My ignorance of the details of her life seemed to cause her pain. She didn't have to tell me that she had a feeling for publicity angles.

Though Una Sand meant less to me than Hecuba, I remembered the name and with it a glazed blonde who had had a year or two in the sun, but who'd made a better pin-up than an actress.

"Wasn't her marriage happy? I mean, isn't it?"

"You see how easy it is to slip into the past tense?" Mrs. Dreen smiled another fierce and purring smile, and her fingers fluttered in glee before her immobile body. "I suppose her marriage is happy enough. Her Ensign's quite a personable young man—handsome in a masculine way, and passionate she tells me, and naive enough."

"Naive enough for what?"

"To marry Una. Jack Rossiter was quite a catch in this woman's town. He was runner-up at Forest Hills the last year he played tennis. And now of course he's a flier. Una did right well by herself, even if it doesn't last."

What do you expect of a war marriage? she seemed to be saying. Permanence? Fidelity? The works?

"As a matter of fact," she went on, "it was thinking about Jack, more than anything else, that brought me here to you. He's due back this week, and naturally"—like many unnatural people, she overused that adverb—"he'll expect her to be waiting for him. It'll be rather embarrassing for me if he comes home and I can't tell him where she's gone, or why, or with whom. You'd really think she'd leave a note."

"I can't keep up with you," I said. "A minute ago Una was in the clutches of the cruel crawling foam. Now she's taken off with a romantic stranger."

"I consider possibilities, is all. When I was Una's age, married to Dreen, I had quite a time settling down. I still do."

Our gazes, mine as impassive as hers I hoped, met, struck no spark, and disengaged. The female spider who eats her mate held no attraction for me.

"I'm getting to know you pretty well," I said with the necessary smile, "but not the missing girl. Who's she been knocking around with?"

"I don't think we need to go into that. She doesn't confide in me, in any case."

"Whatever you say. Shall we look at the scene of the crime?"

"There isn't any *crime*."

"The scene of the accident, then, or the departure. Maybe the beach house will give me something to go on."

She glanced at the wafer-thin watch on her brown wrist. Its diamonds glittered coldly. "Do I have to drive all the way back?"

"If you can spare the time, it might help. We'll take my car."

She rose decisively but gracefully, as though she had practiced the movement in front of a mirror. An expert bitch, I thought as I followed her high slim shoulders and tight-sheathed hips down the stairs to the bright street. I felt a little sorry for the army of men who had warmed themselves, or been burned, at that secret electricity. And I wondered if her daughter Una was like her.

When I did get to see Una, the current had been cut off; I learned about it only by the marks it left. It left marks.

We drove down Sunset to the sea and north on 101 Alternate. All the way to Santa Barbara, she read a typescript whose manila cover was marked: "Temporary—This script is not final and is given to you for advance information only." It occurred to me that the warning might apply to Mrs. Dreen's own story.

As we left the Santa Barbara city limits, she tossed the script over her shoulder into the back seat. "It *really* smells. It's going to be a smash."

A few miles north of the city, a dirt road branched off to the left beside a filling station. It wound for a mile or more through broken country to her private beach. The beach house was set well back from the sea at the convergence of brown bluffs which huddled over it like scarred shoulders. To reach it we had to drive along the beach

for a quarter of a mile, detouring to the very edge of the sea around the southern bluff.

The blue-white dazzle of sun, sand, and surf was like an arc-furnace. But I felt some breeze from the water when we got out of the car. A few languid clouds moved inland over our heads. A little high plane was gamboling among them like a terrier in a henyard.

"You have privacy," I said to Mrs. Dreen.

She stretched, and touched her varnished hair with her fingers. "One tires of the goldfish role. When I lie out there in the afternoons I—forget I have a name." She pointed to the middle of the cove beyond the breakers, where a white raft moved gently in the swells. "I simply take off my clothes and revert to protoplasm. *All* my clothes."

I looked up at the plane whose pilot was doodling in the sky. It dropped, turning like an early falling leaf, swooped like a hawk, climbed like an aspiration.

She said with a laugh: "If they come too low I cover my face, of course."

We had been moving away from the house towards the water. Nothing could have looked more innocent than the quiet cove held in the curve of the white beach like a benign blue eye in a tranquil brow. Then its colors shifted as a cloud passed over the sun. Cruel green and violent purple ran in the blue. I felt the old primitive terror and fascination. Mrs. Dreen shared the feeling and put it into words:

"It's got queer moods. I hate it sometimes as much as I love it." For an instant she looked old and uncertain. "I hope she isn't in there."

The tide had turned and was coming in, all the way from Hawaii and beyond, all the way from the shattered islands where bodies lay unburied in the burnt-out caves. The waves came up towards us, fumbling and gnawing at the beach like an immense soft mouth.

"Are there bad currents here, or anything like that?"

"No. It's deep, though. It must be twenty feet under the raft. I could never bottom it."

"I'd like to look at her room," I said. "It might tell us where she went, and even with whom. You'd know what clothes were missing?"

She laughed a little apologetically as she opened the door. "I used to dress my daughter, naturally. Not any more. Besides, more than half her things must be in the Hollywood apartment. I'll try to help you, though."

It was good to step out of the vibrating brightness of the beach into shadowy stillness behind Venetian blinds. "I noticed that you unlocked the door," I said. "It's a big house with a lot of furniture in it. No servants?"

"I occasionally have to knuckle under to producers. But I won't to my employees. They'll be easier to get along with soon, now that the plane plants are shutting down.

We went to Una's room, which was light and airy in both atmosphere and furnishings. But it showed the lack of servants. Stockings, shoes, underwear, dresses, bathing suits, lipstick-smeared tissue littered the chairs and the floor. The bed was unmade. The framed photograph on the night table was obscured by two empty glasses which smelt of highball, and flanked by overflowing ash trays.

I moved the glasses and looked at the young man with the wings on his chest. Naive, handsome, passionate were words which suited the strong, blunt nose, the full lips and square jaw, the wide proud eyes. For Mrs. Dreen he would have made a single healthy meal, and I wondered again if her daughter was a carnivore. At least the photograph of Jack Rossiter was the only sign of a man in her room. The two glasses could easily have been from separate nights. Or separate weeks, to judge by the condition of the room. Not that it wasn't an attractive room. It was like a pretty girl in disarray. But disarray.

We examined the room, the closets, the bathroom, and found nothing of importance, either positive or negative. When we had waded through the brilliant and muddled wardrobe which Una had shed, I turned to Mrs. Dreen.

"I guess I'll have to go back to Hollywood. It would help me if you'd come along. It would help me more if you'd tell me who your daughter knew. Or rather who she liked—I suppose she knew everybody. Remember you suggested yourself that there's a man in this."

"I take it you haven't found anything?"

"One thing I'm pretty sure of. She didn't intentionally go away

for long. Her toilet articles and pills are still in her bathroom. She's got quite a collection of pills."

"Yes, Una's always been a hypochondriac. Also she left Jack's picture. She only had the one, because she liked it best."

"That isn't so conclusive," I said. "I don't suppose you'd know whether there's a bathing suit missing?"

"I really couldn't say, she had so many. She was at her best in them."

"Still *was?*"

"I guess so, as a working hypothesis. Unless you can find me evidence to the contrary."

"You didn't like your daughter much, did you?"

"No. I didn't like her father. And she was prettier than I."

"But not so intelligent?"

"Not as bitchy, you mean? She was bitchy enough. But I'm still worried about Jack. He loved her. Even if I didn't."

The telephone in the hall took the cue and began to ring. "This is Millicent Dreen," she said into it. "Yes, you may read it to me." A pause. "'Kill the fatted calf, ice the champagne, turn down the sheets and break out the black silk nightie. Am coming home tomorrow.' Is that right?'"

Then she said, "Hold it a minute. I wish to send an answer. To Ensign Jack Rossiter, USS *Guam*, CVE 173, Naval Air Station, Alameda—is that Ensign Rossiter's correct address? The text is: 'Dear Jack join me at the Hollywood apartment there is no one at the beach house. Millicent.' Repeat it, please . . . Right. Thank you."

She turned from the phone and collapsed in the nearest chair, not forgetting to arrange her legs symmetrically.

"So Jack is coming home tomorrow?" I said. "All I had before was no evidence. Now I have no evidence and until tomorrow."

She leaned forward to look at me. "I've been wondering how far I can trust you."

"Not so far. But I'm not a blackmailer. I'm not a mind reader, either, and it's sort of hard to play tennis with the invisible man."

"The invisible man has nothing to do with this. I called him when Una didn't come home. Just before I came to your office."

"All right," I said. "You're the one that wants to find Una. You'll get around to telling me. In the meantime, who else did you call?"

"Hilda Karp, Una's best friend—her *only* female friend."

"Where can I get hold of her?"

"She married Gray Karp, the agent. They live in Beverly Hills."

Their house, set high on a plateau of rolling lawn, was huge and fashionably grotesque: Spanish Mission with a dash of Paranoia. The room where I waited for Mrs. Karp was as big as a small barn and full of blue furniture. The bar had a brass rail.

Hilda Karp was a Dresden blonde with an athletic body and brains. By appearing in it, she made the room seem more real. "Mr. Archer, I believe?" She had my card in her hand, the one with "Private Investigator" on it.

"Una Sand disappeared yesterday. Her mother said you were her best friend."

"Millicent—Mrs. Dreen—called me early this morning. But, as I said then, I haven't seen Una for several days."

"Why would she go away?"

Hilda Karp sat down on the arm of a chair, and looked thoughtful. "I can't understand why her mother should be worried. She can take care of herself, and she's gone away before. I don't know why this time. I know her well enough to know that she's unpredictable."

"Why did she go away before?"

"Why do girls leave home, Mr. Archer?"

"She picked a queer time to leave home. Her husband's coming home tomorrow."

"That's right, she told me he sent her a cable from Pearl. He's a nice boy."

"Did Una think so?"

She looked at me frigidly as only a pale blonde can look, and said nothing.

"Look," I said. "I'm trying to do a job for Mrs. Dreen. My job is laying skeletons to rest, not teaching them the choreography of the *Danse Macabre*."

"Nicely put," she said. "Actually there's no skeleton. Una has

played around, in a perfectly casual way I mean, with two or three men in the last year."

"Simultaneously, or one at a time?"

"One at a time. She's monandrous to that extent. The latest is Terry Neville."

"I thought he was married."

"In an interlocutory way only. For God's sake don't bring my name into it. My husband's in business in this town."

"He seems to be prosperous," I said, looking more at her than at the house. "Thank you very much, Mrs. Karp. Your name will never pass my lips."

"Hideous, isn't it? The name, I mean. But I couldn't help falling in love with the guy. I hope you find her. Jack will be terribly disappointed if you don't."

I had begun to turn towards the door, but turned back. "It couldn't be anything like this, could it? She heard he was coming home, she felt unworthy of him, unable to face him, so she decided to lam out?"

"Millicent said she didn't leave a letter. Women don't go in for all such drama and pathos without leaving a letter. Or at least a marked copy of Tolstoi's *Resurrection*."

"I'll take your word for it." Her blue eyes were very bright in the great dim room. "How about this? She didn't like Jack at all. She went away for the sole purpose of letting him know that. A little sadism, maybe?"

"But she did like Jack. It's just that he was away for over a year. Whenever the subject came up in a mixed gathering, she always insisted that he was a wonderful lover."

"Like that, eh? Did Mrs. Dreen say you were Una's best friend?"

Her eyes were brighter and her thin, pretty mouth twisted in amusement. "Certainly. You should have heard her talk about me."

"Maybe I will. Thanks. Good-bye."

A telephone call to a screenwriter I knew, the suit for which I had paid a hundred and fifty dollars of separation money in a moment of euphoria, and a false air of assurance got me past the studio guards and as far as the door of Terry Neville's dressing room.

He had a bungalow to himself, which meant that he was as impor-
tant as the publicity claimed. I didn't know what I was going to say
to him, but I knocked on the door and, when someone said, "Who
is it?" showed him.

Only the blind had not seen Terry Neville. He was over six feet,
colorful, shapely, and fragrant like a distant garden of flowers. For a
minute he went on reading and smoking in his brocaded armchair,
carefully refraining from raising his eyes to look at me. He even
turned a page of his book.

"Who are you?" he said finally. "I don't know you."

"Una Sand—"

"I don't know her, either." Grammatical solecisms had been
weeded out of his speech, but nothing had been put in their place.
His voice was impersonal and lifeless.

"Millicent Dreen's daughter," I said, humoring him. "Una
Rossiter."

"Naturally I know Millicent Dreen. But you haven't said any-
thing. Good day."

"Una disappeared yesterday. I thought you might be willing to
help me find out why.

"You still haven't said anything." He got up and took a step
towards me, very tall and wide. "What I said was *good day.*"

But not tall and wide enough. I've always had an idea, probably
incorrect, that I could handle any man who wears a scarlet silk
bathrobe. He saw that idea on my face and changed his tune: "If you
don't get out of here, my man, I'll call a guard."

"In the meantime I'd straighten out that marcel of yours. I might
even be able to make a little trouble for you." I said that on the
assumption that any man with his face and sexual opportunities
would be on the brink of trouble most of the time.

It worked. "What do you mean by saying that?" he said. A sud-
den pallor made his carefully plucked black eyebrows stand out
starkly. "You could get into a very great deal of hot water by stand-
ing there talking like that."

"What happened to Una?"

"I don't know. Get out of here."

"You're a liar."

Like one of the clean-cut men in one of his own movies, he threw a punch at me. I let it go over my shoulder and while he was off balance placed the heel of my hand against his very flat solar plexus and pushed him down into his chair. Then I shut the door and walked fast to the front gate. I'd just as soon have gone on playing tennis with the invisible man.

"No luck, I take it?" Mrs. Dreen said when she opened the door of her apartment to me.

"I've got nothing to go on. If you really want to find your daughter you'd better go to Missing Persons. They've got the organization and the connections."

"I suppose Jack will be going to them. He's home already."

"I thought he was coming tomorrow."

"That telegram was sent yesterday. It was delayed somehow. His ship got in yesterday afternoon."

"Where is he now?"

"At the beach house by now, I guess. He flew down from Alameda in a Navy plane and called me from Santa Barbara.

"What did you tell him?"

"What could I tell him? That Una was gone. He's frantic. He thinks she may have drowned." It was late afternoon, and in spite of the whiskey which she was absorbing steadily, like an alcohol lamp, Mrs. Dreen's fires were burning low. Her hands and eyes were limp, and her voice was weary.

"Well," I said, "I might as well go back to Santa Barbara. I talked to Hilda Karp but she couldn't help me. Are you coming along?"

"Not again. I have to go to the studio tomorrow. Anyway, I don't want to see Jack just now. I'll stay here."

The sun was low over the sea, gold-leafing the water and bloodying the sky, when I got through Santa Barbara and back onto the coast highway. Not thinking it would do any good but by way of doing something or other to earn my keep, I stopped at the filling station where the road turned off to Mrs. Dreen's beach house.

"Fill her up," I said to the woman attendant. I needed gas anyway.

"I've got some friends who live around here," I said when she held out her hand for her money. "Do you know where Mrs. Dreen lives?"

She looked at me from behind disapproving spectacles. "You should know. You were down there with her today, weren't you?"

I covered my confusion by handing her a five and telling her: "Keep the change."

"No, thank you."

"Don't misunderstand me. All I want you to do is tell me who was there yesterday. You see all. Tell a little."

"Who are you?"

I showed her my card.

"Oh." Her lips moved unconsciously, computing the size of the tip. "There was a guy in a green convert, I think it was a Chrysler. He went down around noon and drove out again around four, I guess it was, like a bat out of hell."

"That's what I wanted to hear. You're wonderful. What did he look like?"

"Sort of dark and pretty good-looking. It's kind of hard to describe. Like the guy that took the part of the pilot in that picture last week—*you* know—only not so good-looking."

"Terry Neville."

"That's right, only not so good-looking. I've seen him go down there plenty of times."

"I don't know who that would be," I said, "but thanks anyway. There wasn't anybody with him, was there?"

"Not that I could see."

I went down the road to the beach house like a bat into hell. The sun, huge and angry red, was horizontal now, half-eclipsed by the sea and almost perceptibly sinking. It spread a red glow over the shore like a soft and creeping fire. After a long time, I thought, the cliffs would crumble, the sea would dry up, the whole earth would burn out. There'd be nothing left but bone-white cratered ashes like the moon.

When I rounded the bluff and came within sight of the beach I saw a man coming out of the sea. In the creeping fire which the sun

shed he, too, seemed to be burning. The diving mask over his face made him look strange and inhuman. He walked out of the water as if he had never set foot on land before.

I walked toward him. "Mr. Rossiter?"

"Yes." He raised the glass mask from his face and with it the illusion of strangeness lifted. He was just a handsome young man, well-set-up, tanned, and worried-looking.

"My name is Archer."

He held out his hand, which was wet, after wiping it on his bathing trunks, which were also wet. "Oh, yes, Mr. Archer. My mother-in-law mentioned you over the phone."

"Are you enjoying your swim?"

"I'm looking for the body of my wife." It sounded as if he meant it. I looked at him more closely. He was big and husky, but he was just a kid, twenty-two or -three at most. Out of school into the air, I thought. Probably met Una Sand at a party, fell hard for all that glamour, married her the week before he shipped out, and had dreamed bright dreams ever since. I remembered the brash telegram he had sent, as if life was like the people in slick magazine advertisements.

"What makes you think she drowned?"

"She wouldn't go away like this. She knew I was coming home this week. I cabled her from Pearl."

"Maybe she never got the cable."

After a pause he said, "Excuse me." He turned towards the waves which were breaking almost at his feet. The sun had disappeared, and the sea was turning gray and cold-looking, an anti-human element.

"Wait a minute. If she's in there, which I doubt, you should call the police. This is no way to look for her."

"If I don't find her before dark, I'll call them then," he said. "But if she's here, I want to find her myself." I could never have guessed his reason for that, but when I found it out it made sense. So far as anything in the situation made sense.

He walked a few steps into the surf, which was heavier now that the tide was coming in, plunged forward, and swam slowly towards

the raft with his masked face under the water. His arms and legs beat the rhythm of the crawl as if his muscles took pleasure in it, but his face was downcast, searching the darkening sea floor. He swam in widening circles about the raft, raising his head about twice a minute for air.

He had completed several circles and I was beginning to feel that he wasn't really looking for anything, but expressing his sorrow, dancing a futile ritualistic water dance, when suddenly he took air and dived. For what seemed a long time but was probably about twenty seconds, the surface of the sea was empty except for the white raft. Then the masked head broke water, and Rossiter began to swim towards shore. He swam a laborious side stroke, with both arms submerged. It was twilight now, and I couldn't see him very well, but I could see that he was swimming very slowly. When he came nearer I saw a swirl of yellow hair.

He stood up, tore off his mask, and threw it away into the sea. He looked at me angrily, one arm holding the body of his wife against him. The white body half-floating in the shifting water was nude, a strange bright glistening catch from the sea floor.

"Go away," he said in a choked voice.

I went to get a blanket out of the car, and brought it to him where he laid her out on the beach. He huddled over her as if to protect her body from my gaze. He covered her and stroked her wet hair back from her face. Her face was not pretty. He covered that, too.

I said: "You'll have to call the police now."

After a time he answered: "I guess you're right. Will you help me carry her into the house?"

I helped him. Then I called the police in Santa Barbara, and told them that a woman had been drowned and where to find her. I left Jack Rossiter shivering in his wet trunks beside her blanketed body, and drove back to Hollywood for the second time.

Millicent Dreen was in her apartment in the Park-Wilshire. In the afternoon there had been a nearly full decanter of Scotch on her buffet. At ten o'clock it was on the coffee table beside her chair, and nearly empty. Her face and body had sagged. I wondered if every

day she aged so many years, and every morning recreated herself
through the power of her will.

She said: "I thought you were going back to Santa Barbara. I was
just going to go to bed."

"I did go. Didn't Jack phone you?"

"No." She looked at me, and her green eyes were suddenly very
much alive, almost fluorescent. "You found her," she said.

"Jack found her in the sea. She was drowned."

"I was afraid of that." But there was something like relief in her
voice. As if worse things might have happened. As if at least she had
lost no weapons and gained no foes in the daily battle to hold her
position in the world's most competitive city.

"You hired me to find her," I said. "She's found, though I had
nothing to do with finding her—and that's that. Unless you want
me to find out who drowned her."

"What do you mean?"

"What I said. Perhaps it wasn't an accident. Or perhaps some-
body stood by and watched her drown."

I had given her plenty of reason to be angry with me before, but
for the first time that day she was angry. "I gave you a hundred dol-
lars for doing nothing. Isn't that enough for you? Are you trying to
drum up extra business?"

"I did one thing. I found out that Una wasn't by herself yester-
day."

"Who was with her?" She stood up and walked quickly back and
forth across the rug. As she walked her body was remolding itself
into the forms of youth and vigor. She recreated herself before my
eyes.

"The invisible man," I said. "My tennis partner."

Still she wouldn't speak the name. She was like the priestess of a
cult whose tongue was forbidden to pronounce a secret word. But
she said quickly and harshly: "If my daughter was killed I want to
know who did it. I don't care who it was. But if you're giving me a
line and if you make trouble for me and nothing comes of it, I'll
have you kicked out of Southern California. I could do that."

Her eyes flashed, her breath came fast, and her sharp breast rose

and fell with many of the appearances of genuine feeling. I liked her very much at that moment. So I went away, and instead of making trouble for her I made trouble for myself.

I found a booth in a drugstore on Wilshire and confirmed what I knew, that Terry Neville would have an unlisted number. I called a girl I knew who fed gossip to a movie columnist, and found out that Neville lived in Beverly Hills but spent most of his evenings around town. At this time of night he was usually at Ronald's or Chasen's, a little later at Ciro's. I went to Ronald's because it was nearer, and Terry Neville was there.

He was sitting in a booth for two in the long, low, smoke-filled room, eating smoked salmon and drinking stout. Across from him there was a sharp-faced terrier-like man who looked like his business manager and was drinking milk. Some Hollywood actors spend a lot of time with their managers, because they have a common interest.

I avoided the headwaiter and stepped up to Neville's table. He saw me and stood up, saying: "I warned you this afternoon. If you don't get out of here I'll call the police."

I said quietly: "I sort of am the police. Una is dead." He didn't answer and I went on: "This isn't a good place to talk. If you'll step outside for a minute I'd like to mention a couple of facts to you."

"You say you're a policeman," the sharp-faced man snapped, but quietly. "Where's your identification? Don't pay any attention to him, Terry."

Terry didn't say anything. I said: "I'm a private detective. I'm investigating the death of Una Rossiter. Shall we step outside, gentlemen?"

"We'll go out to the car," Terry Neville said tonelessly. "Come on, Ed," he added to the terrier-like man.

The car was not a green Chrysler convertible, but a black Packard limousine equipped with a uniformed chauffeur. When we entered the parking lot he got out of the car and opened the door. He was big and battered-looking.

I said: "I don't think I'll get in. I listen better standing up. I always stand up at concerts and confessions."

"You're not going to listen to anything," Ed said.

The parking lot was deserted and far back from the street, and I forgot to keep my eye on the chauffeur. He rabbit-punched me and a gush of pain surged into my head. He rabbit-punched me again and my eyes rattled in their sockets and my body became invertebrate. Two men moving in a maze of lights took hold of my upper arms and lifted me into the car. Unconsciousness was a big black limousine with a swiftly purring motor and the blinds down.

Though it leaves the neck sore for days, the effect of a rabbit punch on the centers of consciousness is sudden and brief. In two or three minutes I came out of it, to the sound of Ed's voice saying:

"We don't like hurting people and we aren't going to hurt you. But you've got to learn to understand, whatever your name is—"

"Sacher-Masoch," I said.

"A bright boy," said Ed. "But a bright boy can be too bright for his own good. You've got to learn to understand that you can't go around annoying people, especially very important people like Mr. Neville here."

Terry Neville was sitting in the far corner of the back seat, looking worried. Ed was between us. The car was in motion, and I could see lights moving beyond the chauffeur's shoulders hunched over the wheel. The blinds were down over the back windows.

"Mr. Neville should keep out of my cases," I said. "At the moment you'd better let me out of this car or I'll have you arrested for kidnapping."

Ed laughed, but not cheerfully. "You don't seem to realize what's happening to you. You're on your way to the police station, where Mr. Neville and I are going to charge you with attempted blackmail."

"Mr. Neville is a very brave little man," I said. "Inasmuch as he was seen leaving Una Sand's house shortly after she was killed. He was seen leaving in a great hurry and a green convertible."

"My God, Ed," Terry Neville said, "you're getting me in a frightful mess. You don't know what a frightful mess you're getting me in." His voice was high, with a ragged edge of hysteria.

"For God's sake, you're not afraid of this bum, are you?" Ed said in a terrier yap.

"You get out of here, Ed. This is a terrible thing, and you don't know how to handle it. I've got to talk to this man. Get out of this car."

He leaned forward to take the speaking tube, but Ed put a hand on his shoulder. "Play it your way, then, Terry. I still think I had the right play, but you spoiled it."

"Where are we going?" I said. I suspected that we were headed for Beverly Hills, where the police know who pays them their wages.

Neville said into the speaking tube: "Turn down a side street and park. Then take a walk around the block."

"That's better," I said when we had parked. Terry Neville looked frightened. Ed looked sulky and worried. For no good reason, I felt complacent.

"Spill it," I said to Terry Neville. "Did you kill the girl? Or did she accidentally drown—and you ran away so you wouldn't get mixed up in it? Or have you thought of a better one than that?"

"I'll tell you the truth," he said. "I didn't kill her. I didn't even know she was dead. But I was there yesterday afternoon. We were sunning ourselves on the raft, when a plane came over flying very low. I went away, because I didn't want to be seen there with her—"

"You mean you weren't exactly sunning yourselves?"

"Yes. That's right. This plane came over high at first, then he circled back and came down very low. I thought maybe he recognized me, and might be trying to take pictures or something."

"What kind of a plane was it?"

"I don't know. A military plane, I guess. A fighter plane. It was a single-seater painted blue. I don't know military planes."

"What did Una Sand do when you went away?"

"I don't know. I swam to shore, put on some clothes, and drove away. She stayed on the raft, I guess. But she was certainly all right when I left her. It would be a terrible thing for me if I was dragged into this thing. Mr.—"

"Archer."

"Mr. Archer. I'm terribly sorry if we hurt you. If I could make it right with you—" He pulled out a wallet.

His steady pallid whine bored me. Even his sheaf of bills bored me. The situation bored me.

I said: "I have no interest in messing up your brilliant career, Mr. Neville. I'd like to mess up your brilliant pan sometime, but that can wait. Until I have some reason to believe that you haven't told me the truth, I'll keep what you say under my hat. In the meantime, I want to hear what the coroner has to say."

They took me back to Ronald's, where my car was, and left me with many protestations of good fellowship. I said good night to them, rubbing the back of my neck with an exaggerated gesture. Certain other gestures occurred to me.

When I got back to Santa Barbara the coroner was working over Una. He said that there were no marks of violence on her body, and very little water in her lungs and stomach, but this condition was characteristic of about one drowning in ten.

I hadn't known that before, so I asked him to put it into sixty-four-dollar words. He was glad to.

"Sudden inhalation of water may result in a severe reflex spasm of the larynx, followed swiftly by asphyxia. Such a laryngeal spasm is more likely to occur if the victim's face is upward, allowing water to rush into the nostrils, and would be likely to be facilitated by emotional or nervous shock. It may have happened like that or it may not."

"Hell," I said, "she may not even be dead."

He gave me a sour look. "Thirty-six hours ago she wasn't."

I figured it out as I got in my car. Una couldn't have drowned much later than four o'clock in the afternoon on September the seventh.

It was three in the morning when I checked in at the Barbara Hotel. I got up at seven, had breakfast in a restaurant, and went to the beach house to talk to Jack Rossiter. It was only about eight o'clock when I got there, but Rossiter was sitting on the beach in a canvas chair watching the sea.

"You again?" he said when he saw me.

"I'd think you'd have had enough of the sea for a while. How long were you out?"

"A year." He seemed unwilling to talk.

"I hate bothering people," I said, "but my business is always making a nuisance out of me."

"Evidently. What exactly is your business?"

"I'm currently working for your mother-in-law. I'm still trying to find out what happened to her daughter."

"Are you trying to needle me?" He put his hands on the arms of the chair as if to get up. For a moment his knuckles were white. Then he relaxed. "You saw what happened, didn't you?"

"Yes. But do you mind my asking what time your ship got into San Francisco on September the seventh?"

"No. Four o'clock. Four o'clock in the afternoon."

"I suppose that could be checked?"

He didn't answer. There was a newspaper on the sand beside his chair and he leaned over and handed it to me. It was the Late Night Final of a San Francisco newspaper for the seventh.

"Turn to page four," he said.

I turned to page four and found an article describing the arrival of the USS *Guam* at the Golden Gate, at four o'clock in the afternoon. A contingent of Waves had greeted the returning heroes, and a band had played "California, Here I Come."

"If you want to see Mrs. Dreen, she's in the house," Jack Rossiter said. "But it looks to me as if your job is finished."

"Thanks," I said.

"And if I don't see you again, good-bye."

"Are you leaving?"

"A friend is coming out from Santa Barbara to pick me up in a few minutes. I'm flying up to Alameda with him to see about getting leave. I just had a forty-eight, and I've got to be here for the inquest tomorrow. And the funeral." His voice was hard. His whole personality had hardened overnight. The evening before his nature had been wide open. Now it was closed and invulnerable.

"Good-bye," I said, and plodded through the soft sand to the house. On the way I thought of something, and walked faster.

When I knocked, Mrs. Dreen came to the door holding a cup of coffee, not very steadily. She was wearing a heavy wool dressing robe with a silk rope around the waist, and a silk cap on her head. Her eyes were bleary.

"Hello," she said. "I came back last night after all. I couldn't work today anyway. And I didn't think Jack should be by himself."

"He seems to be doing all right."

"I'm glad you think so. Will you come in?"

I stepped inside. "You said last night that you wanted to know who killed Una no matter who it was."

"Well?"

"Does that still go?"

"Yes. Why? Did you find out something?"

"Not exactly. I thought of something, that's all."

"The coroner believes it was an accident. I talked to him on the phone this morning." She sipped her black coffee. Her hand vibrated steadily, like a leaf in the wind.

"He may be right," I said. "He may be wrong."

There was the sound of a car outside, and I moved to the window and looked out. A station wagon stopped on the beach, and a Navy officer got out and walked towards Jack Rossiter. Rossiter got up and they shook hands.

"Will you call Jack, Mrs. Dreen, and tell him to come into the house for a minute?"

"If you wish." She went to the door and called him.

Rossiter came to the door and said a little impatiently: "What is it?"

"Come in," I said. "And tell me what time you left the ship the day before yesterday."

"Let's see. We got in at four—"

"No, you didn't. The ship did, but not you. Am I right?"

"I don't know what you mean."

"You know what I mean. It's so simple that it couldn't fool anybody for a minute, not if he knew anything about carriers. You flew your plane off the ship a couple of hours before she got into port. My guess is that you gave that telegram to a buddy to send for you before you left the ship. You flew down here, caught your wife being made love to by another man, landed on the beach—and drowned her."

"You're insane!" After a moment he said less violently: "I admit I flew off the ship. You could easily find that out anyway. I flew around for a couple of hours, getting in some flying time—"

"Where did you fly?"

"Along the coast. I don't get down this far. I landed at Alameda at five-thirty, and I can prove it."

"Who's your friend?" I pointed through the open door to the other officer, who was standing on the beach looking out to sea.

"Lieutenant Harris. I'm going to fly up to Alameda with him. I warn you, don't make any ridiculous accusations in his presence, or you'll suffer for it."

"I want to ask him a question," I said. "What sort of plane were you flying?"

"FM-3."

I went out of the house and down the slope to Lieutenant Harris. He turned towards me and I saw the wings on his blouse.

"Good morning, Lieutenant," I said. "You've done a good deal of flying, I suppose?"

"Thirty-two months. Why?"

"I want to settle a bet. Could a plane land on this beach and take off again?"

"I think maybe a Piper Cub could. I'd try it anyway. Does that settle the bet?"

"It was a fighter I had in mind. An FM-3."

"Not an FM-3," he said. "Not possibly. It might just conceivably be able to land but it'd never get off again. Not enough room, and very poor surface. Ask Jack, he'll tell you the same."

I went back to the house and said to Jack: "I was wrong. I'm sorry. As you said, I guess I'm all washed up with this case."

"Good-bye, Millicent," Jack said, and kissed her cheek. "If I'm not back tonight I'll be back first thing in the morning. Keep a stiff upper lip."

"You do, too, Jack."

He went away without looking at me again. So the case was ending as it had begun, with me and Mrs. Dreen alone in a room wondering what had happened to her daughter.

"You shouldn't have said what you did to him," she said. "He's got enough to bear."

My mind was working very fast. I wondered whether it was pro-

ducing anything. "I suppose Lieutenant Harris knows what he's talking about. He says a fighter couldn't land and take off from this beach. There's no other place around here he could have landed without being seen. So he didn't land.

"But I still don't believe that he wasn't here. No young husband flying along the coast within range of the house where his wife was—well, he'd fly low and dip his wings to her, wouldn't he? Terry Neville saw the plane come down."

"Terry Neville?"

"I talked to him last night. He was with Una before she died. The two of them were out on the raft together when Jack's plane came down. Jack saw them, and saw what they were doing. They saw him. Terry Neville went away. Then what?"

"You're making this up," Mrs. Dreen said, but her green eyes were intent on my face.

"I'm making it up, of course, I wasn't here. After Terry Neville ran away, there was no one here but Una, and Jack in a plane circling over her head. I'm trying to figure out why Una died. I *have* to make it up. But I think she died of fright. I think Jack dived at her and forced her into the water. I think he kept on diving at her until she was gone. Then he flew back to Alameda and chalked up his flying time."

"Fantasy," she said. "And very ugly. I don't believe it."

"You should. You've got that cable, haven't you?"

"I don't know what you're talking about."

"Jack sent Una a cable from Pearl, telling her what day he was arriving. Una mentioned it to Hilda Karp. Hilda Karp mentioned it to me. It's funny you didn't say anything about it."

"I didn't know about it," Millicent Dreen said. Her eyes were blank.

I went on, paying no attention to her denial: "My guess is that the cable said not only that Jack's ship was coming in on the seventh, but that he'd fly over the beach house that afternoon. Fortunately, I don't have to depend on guesswork. The cable will be on file at Western Union, and the police will be able to look at it. I'm going into town now."

"Wait," she said. "Don't go to the police about it. You'll only get Jack in trouble. I destroyed the cable to protect him, but I'll tell you what was in it. Your guess was right. He said he'd fly over on the seventh."

"When did you destroy it?"

"Yesterday, before I came to you. I was afraid it would implicate Jack."

"Why did you come to me at all, if you wanted to protect Jack? It seems that you knew what happened."

"I wasn't sure. I didn't know what had happened to her, and until I found out I didn't know what to do."

"You're still not sure," I said. "But I'm beginning to be. For one thing, it's certain that Una never got her cable, at least not as it was sent. Otherwise she wouldn't have been doing what she was doing on the afternoon that her husband was going to fly over and say hello. You changed the date on it, perhaps? So that Una expected Jack a day later? Then you arranged to be in Hollywood on the seventh, so that Una could spend a final afternoon with Terry Neville."

"Perhaps." Her face was completely alive, controlled but full of dangerous energy, like a cobra listening to music.

"Perhaps you wanted Jack for yourself," I said. "Perhaps you had another reason, I don't know. I think even a psychoanalyst would have a hard time working through your motivations, Mrs. Dreen, and I'm not one. All I know is that you precipitated a murder. Your plan worked even better than you expected."

"It was accidental death," she said hoarsely. "If you go to the police you'll only make a fool of yourself, and cause trouble for Jack."

"You care about Jack, don't you?"

"Why shouldn't I?" she said. "He was mine before he ever saw Una. She took him away from me."

"And now you think you've got him back." I got up to go. "I hope for your sake he doesn't figure out for himself what I've just figured out."

"Do you think he will?" Sudden terror had jerked her face apart. I didn't answer her.

The Women on the Wall

WALLACE STEGNER

T HE CORNER WINDOW of the study overlooked a lawn, and beyond that a sunken lane between high pines, and beyond the lane a point of land with the old beach club buildings at one end and a stone wall around its tip. Beyond the point, through the cypresses and eucalyptuses, Mr. Palmer could see the Pacific, misty blue, belted between shore and horizon with a band of brown kelp.

Writing every morning in his study, making over his old note-books into a coherent account of his years on the Galápagos, Mr. Palmer could glance up from his careful longhand and catch occa-sional glimpses, as a traveler might glance out of the window of a moving train. And in spite of the rather special atmosphere of the point, caused by the fact that until the past year it had been a club, there was something homey and neighborly and pleasant about the place that Mr. Palmer liked. There were children, for one thing, and dogs drifting up and down, and the occasional skirr of an automo-bile starting in the quiet, the diminishing sound of tires on asphalt, the distant racket of a boy being a machine-gun with his mouth.

Mr. Palmer had been away from the States a long time; he found the noises on the point familiar and nostalgic and reassuring in this time of war, and felt as if he had come home. Though California

differed considerably from his old home in Ohio, he fell naturally and gratefully into its procession of morning and afternoon, its neighborhood routines, the pleasant breathing of its tides. When anything outside broke in upon his writing, it was generally a commonplace and familiar thing; Mr. Palmer looked up and took pleasure in the interruption.

One thing he could be sure of seeing, every morning but Sunday. The section was outside the city limits, and mail was delivered to a battery of mailboxes where the sunken lane joined the street. The mail arrived at about eleven; about ten-thirty the women from the beach club apartments began to gather on the stone wall. Below the wall was the beach, where the tides leaned in all the way from Iwo and Okinawa. Above it was the row of boxes where as regularly as the tide the mail carrier came in a gray car and deposited postmarked flotsam from half a world away.

Sometimes Mr. Palmer used to pause in his writing and speculate on what these women thought of when they looked out across the gumdrop-blue water and the brown kelp and remembered that across this uninterrupted ocean their husbands fought and perhaps bled and possibly died, that in those far islands it was already tomorrow, that the green water breaking against the white foot of the beach might hold in suspension minute quantities of the blood shed into it thousands of miles away, that the Japan current, swinging in a great circle up under the Aleutians and back down the American coast, might as easily bear the mingled blood or the floating relics of a loved one lost as it could bear the glass balls of Japanese net-floats that it sometimes washed ashore.

Watching the women, with their dogs and children, waiting patiently on the stone wall for that most urgent of all the gods, that Mercury in the gray uniform, Mr. Palmer thought a good deal about Penelope on the rocky isle of Ithaca above the wine-dark sea. He got a little sentimental about these women. Sometimes he was almost frightened by the air of patient, withdrawn seriousness they wore as they waited, and the unsmiling alacrity with which they rose and crowded around the mailman when he came. And when the mail was late, and one or two of them sat out on the wall until eleven-

thirty, twelve, sometimes twelve-thirty, Mr. Palmer could hardly bear it at all.

Waiting, Mr. Palmer reflected, must cause a person to remove to a separate and private world. Like sleep or insanity, waiting must have the faculty of making the real unreal and remote. It seemed to Mr. Palmer pathetic and somehow thrilling that these women should have followed their men to the very brink of the West, and should remain here now with their eyes still westward, patiently and faithfully suspending their own normal lives until the return of their husbands. Without knowing any of the women, Mr. Palmer respected and admired them. They did not invite his pity. Penelope was as competent for her waiting as Ulysses was for his wars and wiles.

Mr. Palmer had been working in his new house hardly a week before he found himself putting on his jacket about eleven and going out to join the women.

He knew them all by sight just from looking out the window. The red-haired woman with the little boy was sitting on the wall nearest him. Next was the thin girl who always wore a bathing suit and went barefooted. Next was the dark-haired one, five or six months pregnant. And next to her was the florid, quick, wren-like woman with the little girl of about five. Their faces all turned as Mr. Palmer came up.

"Good morning," he said.

The red-haired woman's plain, serious, freckled face acknowledged him, and she murmured good morning. The girl in the bathing suit had turned to look off over the ocean, and Mr. Palmer felt that she had not made any reply. The pregnant girl and the woman with the little girl both nodded.

The old man put his hands on his knees, rounded his mouth and eyes, and bent to look at the little boy hanging to the red-haired woman's hand. "Well!" he said. "Hi, young fella!"

The child stared at him, crowding against his mother's legs. The mother said nothing, and rather than push first acquaintance too far, Mr. Palmer walked on along the wall. As he glanced at the thin girl, he met her eyes, so full of cold hostility that for a moment he

was shocked. He had intended to sit down in the middle of the wall, but her look sent him on further, to sit between the pregnant girl and the wren-like woman.

"Those beautiful mornings!" Mr. Palmer said, sitting down with a sigh.

The wren-like woman nodded, the pregnant one regarded him with quiet ox-eyes.

"This is quite a ritual, waiting for the mail," Mr. Palmer said. He pointed to the gable of his house across the lane. "I see you from my window over there, congregating on the wall here every morning."

The wren-like woman looked at him rather oddly, then leaped to prevent her daughter from putting out the eyes of the long-suffering setter she was mauling. The pregnant girl smiled a slow, soft smile. Over her shoulder Mr. Palmer saw the thin girl hitch herself up and sit on her hands. The expression on her face said that she knew very well why Mr. Palmer had come down and butted in, and why he watched from his window.

"The sun's so warm out here," the pregnant girl said. "It's a way of killing part of the morning, sitting out here."

"A very good way," Mr. Palmer said. He smoothed the creases in his trousers, finding speech a little difficult. From the shelter of his mother's legs the two-year-old boy down the wall stared at him solemnly. Then the wren-like woman hopped off the wall and dusted her skirt.

"Here he is!" she said.

They all started across the mouth of the lane, and for some reason, as they waited for the mailman to sort and deliver, Mr. Palmer felt that his first introduction hadn't taken him very far. In a way, as he thought it over, he respected the women for that, too. They were living without their husbands, and had to be careful. After all, Penelope had many suitors. But he could not quite get over wanting to spank the thin girl on her almost-exposed backside, and he couldn't quite shake the sensation of having wandered by mistake into the ladies' rest room.

After that, without feeling that he knew them at all, he respected them and respected their right to privacy. Waiting, after all, put you

in an exclusive club. No outsider had any more right on that wall than he had in the company of a bomber crew. But Mr. Palmer felt that he could at least watch from his window, and at the mailboxes he could, almost by osmosis, pick up a little more information.

The red-haired woman's name was Kendall. Her husband was an Army captain, a doctor. The thin girl, Mrs. Fisher, got regular letters bearing a Marine Corps return. The husband of Mrs. Corson, the wren-like woman, commanded a flotilla of minesweepers in the western Pacific. Of the pregnant girl, Mrs. Vaughn, Mr. Palmer learned little. She got few letters and none with any postmarks that told anything.

From his study window Mr. Palmer went on observing them benignly and making additions to his notes on the profession of waiting. Though the women differed sharply one from another, they seemed to Mr. Palmer to have one thing in common: they were all quiet, peaceful, faithful to the times and seasons of their vigil, almost like convalescents in a hospital. They made no protests or outcries; they merely lived at a reduced tempo, as if pulse rate and respiration rate and metabolic rate and blood pressure were all turned down. Mr. Palmer had a notion how it might be. Sometimes when he awoke very quietly in the night he could feel how quietly and slowly and regularly his heart was pumping, how slow and regular his breathing was, how he lay there mute and cool and inert with everything turned down to idling speed, his old body taking care of itself. And when he woke that way he had a curious feeling that he was waiting for something.

Every morning at ten-thirty, as regular as sun and tide, Mrs. Kendall came out of the beach club apartments and walked across the point, leading her little boy by the hand. She had the child turned down, too, apparently. He never, to Mr. Palmer's knowledge, ran or yelled or cried or made a fuss, but walked quietly beside his mother, and sat with her on the big stump until five minutes to eleven, and then walked with her across to the end of the stone wall. About that time the other women began to gather, until all four of them were there in a quiet, uncommunicative row.

Through the whole spring the tides leaned inward with the same slow inevitability, the gray car came around and stopped by the battery of mailboxes, the women gathered on the wall as crows gather to a rookery at dusk.

Only once in all that drowsy spring was there any breaking of the pattern. That was one Monday after Mr. Palmer had been away for the weekend. When he strolled out at mailtime he found the women not sitting on the wall, but standing in a nervous conversational group. They opened to let him in, for once accepting him silently among them, and he found that the thin girl had moved out suddenly the day before: the Saturday mail had brought word that her husband had gone down in flames over the Marianas.

The news depressed Mr. Palmer in curious ways. It depressed him to see the women shaken from their phlegmatic routine, because the moment they were so shaken they revealed the raw fear under their quiet. And it depressed him that the thin girl's husband had been killed. That tragedy should come to a woman he personally felt to be a snob, a fool, a vain and inconsequent chit, seemed to him sad and incongruous and even exasperating. As long as she was one of the company of Penelopes, Mr. Palmer had refused to dislike her. The moment she made demands upon his pity he disliked her very much.

After that sudden blow, as if a hawk had struck among the quiet birds on the wall, Mr. Palmer found it less pleasant to watch the slow, heavy-bodied walking of Mrs. Kendall, her child always tight by the hand, from apartment to stump to wall. Unless spoken to, she never spoke. She wore gingham dresses that were utterly out of place in the white sun above the white beach. She was plain, unattractive, patient, the most remote, the most tuned-down, the quietest and saddest and most patient and most exasperating of the Penelopes. She too began to make wry demands on Mr. Palmer's pity, and he found himself almost disliking her. He was guilty of a little prayer that Mrs. Kendall's husband would be spared, so that his pity would not have to go any farther than it did.

❧

Then one morning Mr. Palmer became aware of another kind of interruption on the point. Somebody there had apparently bought a new dog. Whoever had acquired it must have fed it, though Mr. Palmer never saw anyone do so, and must have exercised it, though he never saw that either. All he saw was that the dog, a half-grown cocker, was tied to the end of a rose trellis in the clubhouse yard. And all he heard, for two solid days, was the uproar the dog made.

It did not like being tied up. It barked, and after a while its voice would break into a kind of hysterical howling mixed with shudder-ing diminuendo groans. Nobody ever came and told it to be still, or took care of it, or let it loose. It stayed there and yanked on its rope and chewed at the trellis post and barked and howled and groaned until Mr. Palmer's teeth were on edge and he was tempted to call the Humane Society.

Actually he didn't, because on the third morning the noise had stopped, and as he came into his study to begin working he saw that the dog was gone. Mrs. Corson was sitting in a lawn chair under one of the cypresses, and her daughter was digging in the sandpile. There was no sign either of Mrs. Kendall or Mrs. Vaughn. The owner of the house was raking leaves on the lawn above the seawall.

Mr. Palmer looked at his watch. It was nine-thirty. On an impulse he slipped on a jacket and went down and out across the lawn and down across the lane and up the other side past the trellis. Where the dog had lain the ground was strewn with chewed green splinters.

Mrs. Corson looked up from her chair. Her cheeks were painted with a patchwork of tiny ruddy veins, and her eyes looked as if she hadn't slept. They had a starry blankness like blind eyes, and Mr. Palmer noticed that the pupils were dilated, even in the bright light. She took a towel and a pack of cigarettes and a bar of coco-butter off the chair next to her.

"Good morning," she said in her husky voice. "Sit down."

"Thank you," Mr. Palmer said. He let himself down into the steeply slanting wooden chair and adjusted the knees of his slacks. "It *is* a good morning," he said slyly. "So quiet."

Mrs. Corson's thin neck jerked upward and backward in a curi-

ous gesture. Her throaty laughter was loud and unrestrained, and the eyes she turned on Mr. Palmer were red with mirth.

"That damned dog," she said. "Wasn't that something?"

"I thought I'd go crazy," Mr. Palmer said. "Whose dog was it, anyway?"

Mrs. Corson's rather withered, red-nailed hand, with a big diamond and a wedding ring on the fourth finger, reached down and picked up the cigarettes. The hand trembled as it held the pack out.

"No thank you," he said.

Mrs. Corson took one. "It was Mrs. Kendall's dog," she said. "She took it back."

"Thank God!" said Mr. Palmer.

Her hands nervous with the matchbox in her lap, Mrs. Corson sat and smoked. Mr. Palmer saw that her lips, under the lipstick, were chapped, and that there was a dried, almost leathery look to her tanned and freckled skin.

He slid deeper into the chair and looked out over the water, calm as a lake, the long light swells breaking below him with a quiet, lulling swish. Up the coast heavier surf was breaking farther out. Its noise came like a pulsating tremble on the air, hardly a sound at all. Everything tuned down, Mr. Palmer was thinking. Even the lowest frequency of waves on the beach. Even the ocean waited.

"I should think you'd bless your stars, having a place like this to wait in," he said.

One of Mrs. Corson's eyebrows bent. She shot him a sideward look.

"Think of the women who are waiting in boardinghouse rooms," Mr. Palmer said, a little irritated at her manner. "Think of the ones who are working and leaving their children in nurseries."

"Oh, sure," Mrs. Corson said. "It's fine for Anne, with the beach and yard."

Mr. Palmer leaned on the arm of the chair and looked at her quizzically. He wished any of these women would ever put away their reticence and talk about their waiting, because that was where their life lay, that was where they had authority. "How long has your husband been gone?" he asked.

"Little over two years."

"That's a long time," Mr. Palmer said, thinking of Penelope and her wait. Ten years while the war went on at Troy, ten more years while Ulysses wandered through every peril in the Mediterranean, past Scylla and Charybdis and Circe and the Cyclops and the iron terrors of Hades and the soft temptations of Nausicaa. But that was poetry. Twenty years was too much. Two, in all conscience, was enough.

"I shouldn't kick," the woman said. "Mrs. Kendall's husband has been gone for over three."

"I've noticed her," Mr. Palmer said. "She seems rather sad and repressed."

For a moment Mrs. Corson's eyes, slightly bloodshot, the pupils dilated darkly, were fixed questioningly on Mr. Palmer's. Then the woman shook herself almost as a dog does. "I guess," she said. She rose with a nervous snap and glanced at her watch. From the sand-pile the little girl called, "Is it time, Mommy?"

"I guess so," Mrs. Corson said. She laid the back of her hand across her eyes and made a face.

"I'll be getting along," Mr. Palmer said.

"I was just taking Anne down for her pony ride. Why don't you ride down with us?"

"Well . . ."

"Come on," Mrs. Corson said. "We'll be back in less than an hour."

The child ran ahead of them and opened the car doors, down in the widened part of the lane. As Mr. Palmer helped Mrs. Corson in she turned her face a little, and he smelled the stale alcohol on her breath. Obviously Mrs. Corson had been drinking the night before, and obviously she was a little hung over.

But my Lord, why not? he said to himself. Two years of waiting, nothing to do but sit and watch and do nothing and be patient. He didn't like Mrs. Corson any less for occasional drinking. She was higher-strung than either Mrs. Vaughn or Mrs. Kendall. You could almost lift up the cover board and pluck her nerves like the strings of a piano. Even so, she played the game well. He liked her.

At the pony track Anne raced down the fenced runway at a pink fluttering gallop, and Mr. Palmer and Mrs. Corson, following more slowly, found her debating between a black and a pinto pony.

"Okay," the man in charge said. "Which'll it be today, young lady?"

"I don't know," the girl said. Her forehead wrinkled. "Mommy, which do you think?"

"I don't care, hon," her mother said. "Either one is nice."

Pretty, her blonde braids hanging in front and framing her odd pre-Raphaelite face, Anne stood indecisive. She turned her eyes up to Mr. Palmer speculatively. "The black one's nice," she said, "but so's the . . ."

"Oh, Anne," her mother said. "For heaven's sake make up your mind."

"Well . . . the black one, then," Anne said. She reached out a hand and touched the pony's nose, pulling her fingers back sharply and looking up at her mother with a smile that Mr. Palmer found himself almost yearning over.

"You're a nitwit," her mother said. "Hop on, so we can get back for the mailman."

The attendant swung her up, but with one leg over the saddle Anne kicked and screamed to get down. "I've changed my mind," she said. "Not this one, the pinto one."

The attendant put her up on the pinto and Mrs. Corson, her chapped lips trembling, said, "Another outburst like that and you won't get on any, you little . . . !"

The pony started, led by the attendant who rocked on one thick-soled shoe. For a moment Mrs. Corson and Mr. Palmer stood in the sun under the sign that said "Pony Rides, 10 Cents, 12 for $1.00." They were, Mr. Palmer noticed, in the Mexican part of town. Small houses, some of them almost shacks with geraniums climbing all over them, strung out along the street. Down on the corner beyond the car was a tavern with a dusty tin sign. Mrs. Corson unsnapped her purse and fished out a wadded bill and held it vaguely in her hand, looking off up the street past the track and the pinto pony and the pink little huddle on its back and the attendant rocking along ahead on his one thick shoe.

"I wonder," she said. "Would you do me a favor?"

"Anything."

"Would you stay here five minutes while I go to the store? Just keep an eye on her?"

"Of course," he said. "I'd be glad to go to the store for you, if you'd like."

"No," she said. "No, I'd better get it." She put the crumpled bill into his hand. "Let her have all the rides she wants. I'll be back in a few minutes."

Mr. Palmer settled himself on a chair against the stable wall and waited. When Anne and the attendant got back he waved the bill at them. "Want another ride?"

"Yes!" Anne said. Her hands were clenched tightly in the pony's mane, and her eyes danced and her mouth was a little open. The attendant turned and started down the track again. "Run!" Anne cried to him. "Make him run."

The crippled hostler broke into a clumsy hop-skip-and jump for a few yards, pulling the pony into a trot. The girl screamed with delight. Mr. Palmer yawned, tapped his mouth, smiled a little as he smelled the powder-and-perfume smell on the dollar bill, yawned again. Say what you would, it was decent of the woman to come out with a hangover and take her child to the pony track. She must feel pretty rocky, if her eyes were any criterion.

He waited for some time. Anne finished a second ride, took a third, finished that and had a fourth. The attendant was sweating a little. From the fence along the sidewalk two Negro children and a handful of Mexicans watched. "How about it?" Mr. Palmer said. "Want another?"

She nodded, shaken with giggles and sudden shyness when she looked around and found her mother gone.

"Sure you're not getting sore?" Mr. Palmer patted his haunch suggestively.

She shook her head.

"Okay," the hostler said. "Here we go again, then."

At the end of the fifth ride Anne let herself be lifted off. The hostler went inside and sat down, the pony joined its companion at

the rail, cocked its hip and tipped its right hoof and closed its eyes. Anne climbed up into Mr. Palmer's lap.

"Where's Mommy?"

"She went to buy something."

"Darn her," Anne said. "She does that all the time. She better hurry up, it's getting mailtime."

"Don't you like to miss the mail?"

"Sometimes there's packages and things from Daddy," Anne said. "I got a grass skirt once."

Mr. Palmer rounded his mouth and eyes. "You must like your daddy."

"I do. Mommy doesn't, though."

"What?"

"Mommy gets mad," Anne said. "She thinks Daddy could have had shore duty a long time ago, he's had so much combat, but she says he likes the Navy better than home. He's a commander."

"Yes, I know," Mr. Palmer said. He looked up the street, beginning to be fretful. The fact that the woman spent her whole life waiting shouldn't make her quite so callous to how long she kept other people waiting. "We *are* going to miss the mailman if your Mommy doesn't hurry," he said.

Anne jumped off his lap and puckered her lips like her mother. "And today's a package!"

Mr. Palmer raised his eyebrows. "How do you know?"

"The fortune teller told Mommy."

"I see," the old man said. "Does your mother go to fortune tellers often?"

"Every Saturday," Anne said. "I went with her once. You know what she said? And it came true, too."

Mr. Palmer saw the girl's mother coming down the sidewalk, and stood up. "Here comes Mommy," he said. "We'd better meet her at the car."

"She said we'd get good news, and right away Daddy was promoted," Anne said. "And she said we'd get a package, and that week we got *three!*"

Mrs. Corson was out of breath. In the bright sun her eyes

burned with a curious sightless brilliance. The smell of alcohol on her was fresher and stronger.

"I'm sorry," she said as she got in. "I met a friend, and it was so hot we stopped for a beer."

On the open highway, going back home, she stepped down hard on the throttle, and her fingers kept clasping and unclasping the wheel. Her body seemed possessed of electric energy. She radiated something, she gave off sparks. Her eyes, with the immense dark pupils and suffused whites, were almost scary.

When they pulled up and parked in front of Mr. Palmer's gate, opposite the mailboxes, the little red flags on some of the boxes were still up. On the stone wall sat Mrs. Kendall, her son Tommy, and the pregnant girl, Mrs. Vaughn. "Late again," Mrs. Corson said. "Damn that man."

"Can I play, Mommy?" Anne said.

"Okay." As the child climbed out, the mother said, "Don't get into any fixes with Tommy. Remember what I told you."

"I will," Anne said. Her setter came up and she stooped to pull its ears.

Her mother's face went pinched and mean. "And stop abusing that dog!" she said.

Mr. Palmer hesitated. He was beginning to feel uncomfortable, and he thought of the pages he might have filled that morning, and the hour that still remained before noon. But Mrs. Corson was leaning back with the back of her hand across her eyes. Through the windshield Mr. Palmer could see the two women and the child on the wall, like a multiple Patience on a monument. When he looked back at Mrs. Corson he saw that she too was watching them between her fingers. Quite suddenly she began to laugh.

She laughed for a good minute, not loudly but with curious violence, her whole body shaking. She dabbed her eyes and caught her breath and shook her head and tried to speak. Mr. Palmer attended uneasily, wanting to be gone.

"Lord," Mrs. Corson said finally. "Look at 'em. Vultures on a limb. Me too. Three mama vultures and one baby vulture."

"You're a little hard on yourself," Mr. Palmer said, smiling. "And Anne, I'd hardly call her a vulture."

"I didn't include her," Mrs. Corson said. She turned her hot red eyes on him. "She's got sense enough to run and play, and I hope I've got sense enough to let her."

"Well, but little Tommy . . ."

"Hasn't had his hand out of mamma's since they came here," Mrs. Corson said. "Did you ever see him play with anybody?"

Mr. Palmer confessed that he hadn't, now that he thought of it.

"Because if you ever do," Mrs. Corson said, "call out all the preachers. It'll be Christ come the second time. Honest to God, sometimes that woman . . ."

Bending forward, Mr. Palmer could see Mrs. Kendall smoothing the blue sweater around her son's waist. "I've wondered about her," he said, and stopped. Mrs. Corson had started to laugh again.

When she had finished her spasm of tight, violent mirth, she said, "It isn't her child, you know."

"No?" he said, surprised. "She takes such care of it."

"You're not kidding," Mrs. Corson said. "She won't let him play with Anne. Anne's too dirty. She digs in the ground and stuff. Seven months we've lived in the same house, and those kids haven't played together once. Can you imagine that?"

"No," Mr. Palmer confessed. "I can't."

"She adopted it when it was six months old," Mrs. Corson said. "She tells us all it's a love-child." Her laugh began again, a continuous, hiccoughy chuckle. "Never lets go its hand," she said. "Won't let him play with anybody. Wipes him off like an heirloom. And brags around he's a love-child. My God!"

With her thin, freckled arm along the door and her lips puckered, she fell silent. "Love-child!" she said at last. "Did you ever look at her flat face? It's the last place love would ever settle on."

"Perhaps that explains," Mr. Palmer said uncomfortably. "She's childless, she's unattractive. She pours all that frustrated affection out on this child."

Mrs. Corson twisted to look almost incredulously into his face. "Of course," she said. Her alcoholic breath puffed at him. "Of

course. But why tout it up as a love-child?" she said harshly. "What does she think my child is, for God's sake? How does she think babies are made?"

"Well, but there's that old superstition," Mr. Palmer said. He moved his hand sideward. "Children born of passion, you know—they're supposed to be more beautiful . . ."

"And doesn't that tell you anything about her?" Mr. Corson said. "Doesn't that show you that she never thought of passion in the same world with her husband? She has to go outside herself for any passion, there's none in her."

"Yes," Mr. Palmer said. "Well, of course one can speculate, but one hardly knows . . ."

"And that damned dog," Mrs. Corson said. "Tommy can't play with other kids. They're too dirty. So she gets a dog. Dogs are cleaner than Anne, see? So she buys her child this nice germless dog, and then ties him up and won't let him loose. So the dog howls his head off, and we all go nuts. Finally we told her we couldn't stand it, why didn't she let it loose and let it run. But she said it might run away, and Tommy loved it so she didn't want to take a chance on losing the pup. So I finally called the Society for the Prevention of Cruelty to Animals, and they told her either to give it regular running and exercise or take it back. She took it back last night, and now she hates me."

As she talked, saliva had gathered in the corner of her mouth. She sucked it in and turned her head away, looking out on the street. "Lord God," she said. "So it goes, so it goes."

Through the windshield Mr. Palmer watched the quiet women on the wall, the quiet, well-behaved child. Anne was romping with the setter around the big stump, twenty feet beyond, and the little boy was watching her. It was a peaceful, windless morning steeped in sun. The mingled smell of pines and low tide drifted across the street, and was replaced by the pervading faint fragrance of ceanonothus, blooming in shades of blue and white along Mr. Palmer's walk.

"I'm amazed," he said. "She seems so quiet and relaxed and plain."

"That's another thing," Mrs. Corson said. "She's a cover-your-

self-up girl, too. Remember Margy Fisher, whose husband was killed a few weeks ago? You know why she never wore anything but a bathing suit? Because this old biddy was always after her about showing herself."

"Well, it's certainly a revelation," Mr. Palmer said. "I see you all from my window, you know, and it seems like a kind of symphony of waiting, all quiet and harmonious. The pregnant girl, too—going on with the slow inevitable business of life while her husband's gone, the rhythm of the generations unchanged. I've enjoyed the whole thing, like a pageant, you know."

"Your window isn't a very good peek-hole," Mrs. Corson said drily.

"Mm?"

"Hope's husband was killed at Dieppe," said Mrs. Corson.

For a moment Mr. Palmer did not catch on. At first he felt only a flash of pity as he remembered the girl's big steady brown eyes, her still, rather sad face, her air of pliant gentleness. Then the words Mrs. Corson had spoken began to take effect. Dieppe—almost three years ago. And the girl six months pregnant.

He wished Mrs. Corson would quit drumming her red nails on the car door. She was really in a state this morning, nervous as a cat. But that poor girl, sitting over there with all that bottled up inside of her, the fear and uncertainty growing as fast as the child in her womb grew . . .

"Some naval lieutenant," Mrs. Corson said. "He's right in the middle of the fighting, gunnery officer on a destroyer. You ought to hear Hope when she gets scared he'll never come back and make a decent woman of her."

"I'd not like to," Mr. Palmer said, and shook his head. Across the lane the placid scene had not changed, except that Mrs. Kendall had let Tommy toddle fifteen feet out from the wall, where he was picking up clusters of dry pine needles and throwing them into the air.

The figures were very clean, sharp-edged in the clear air against the blue backdrop of sea. An Attic grace informed all of them: the girl stooping above the long-eared red setter, the child with his hands in the air, tossing brown needles in a shower, the curving seat-

ed forms of the women on the wall. To Mr. Palmer's momentarily tranced eyes they seemed to freeze in attitudes of flowing motion like figures on a vase, cameo-clear in the clear air under the noble trees, with the quiet ocean of their watchfulness stretching blue to the misty edge. Like figures on a Grecian urn they curved in high relief above the white molding of the wall, and a drift of indescribable melancholy washed across the point and pricked goose-pimples on Mr. Palmer's arms. "It's sad," he said, opening the door and stepping down. "The whole thing is very sad."

With the intention of leaving he put his hand on the door and pushed it shut, thinking that he did not want to stay longer and hear Mrs. Corson's bitter tongue and watch the women on the wall. Their waiting now, with the momentary trance broken and the momentary lovely group dispersed in motion, seemed to him a monstrous aberration, their patience a deathly apathy, their hope an obscene self-delusion.

He was filled with a sense of the loveliness of the white paper and the cleanly sharpened pencils, the notebooks and the quiet and the sense of purpose that waited in his study. Most of all the sense of purpose, the thing to be done that would have an ending and a result.

"It's been very pleasant," he said automatically. At that moment there came a yowl from the point.

He turned. Apparently Anne, romping with the dog, had bumped Tommy and knocked him down. He sat among the pine needles in his blue play-suit and squalled, and Mrs. Kendall came swiftly out from the wall and took Anne by the arm, shaking her.

"You careless child!" she said. "Watch what you're doing!"

Instantly Mrs. Corson was out of the car. Mr. Palmer saw her start for the point, her lips puckered, and was reminded of some mechanical toy lightly wound and tearing erratically around a room giving off sparks of ratchety noise. When she was twenty feet from Mrs. Kendall she shouted hoarsely, "Let go of that child!"

Mrs. Kendall's heavy gingham body turned. Her plain face, the mouth stiff with anger, confronted Mrs. Corson. Her hand still held Anne's arm. "It's possible to train children . . ." she said.

"Yes, and it's possible to mistreat them," Mrs. Corson said. "Let go of her."

For a moment neither moved. Then Mrs. Corson's hands darted down, caught Mrs. Kendall's wrist, and tore her hold from Anne's arm. Even across the lane, fifty feet away, Mr. Palmer could see the white fury in their faces as they confronted each other.

"If I had the bringing up of that child . . . !" Mrs. Kendall said. "I'd . . ."

"You'd tie her to your apron strings like you've tied your own," Mrs. Corson said. "Like you tie up a dog and expect it to get used to three feet of space. My God, a child's a little animal. He's got to run!"

"And knock other children down, I suppose."

"Oh my God!" Mrs. Corson said, and turned her thin face skyward as if to ask God to witness. She was shaking all over: Mr. Palmer could see the trembling of her dress. "Listen!" she said, "I don't know what's the matter with you, and why you can't stand nakedness, and why you think a bastard child is something holier than a legitimate one, and why you hang onto that child as if he was worth his weight in diamonds. But you keep your claws off mine, and if your little bastard can't get out of the way, you can just . . ."

Mrs. Kendall's face was convulsed. She raised both hands above her head, stuttering for words. From the side the pregnant girl slipped in quietly, and Mr. Palmer, rooted uneasily across the lane, heard her quiet voice. "You're beginning to draw a crowd," she said. "For the love of mike, turn it down."

Mrs. Corson swung on her. Her trembling had become an ecstasy. When she spoke she chewed loudly on her words, mangling them almost beyond recognition. "You keep out of this, you pregnant bitch," she said. "Any time I want advice on how to raise love children, I'll come to you too, but right now I haven't got any love children, and I'm raising what I've got my own way."

A window had gone up in the house next to Mr. Palmer's, and three boys were drifting curiously down the street, their pants sagging with the weight of armament they carried. Without hesitating more than a moment, Mr. Palmer crossed the street and cut them

off. "I think you'd better beat it," he said, and pushed his hands in the air as if shooing chickens. The boys stopped and eyed him suspiciously, then began edging around the side. It was clear that in any contest of speed, agility, endurance, or anything else Mr. Palmer was no match for them. He put his hand in his pocket and pulled out some change. The boys stopped. Behind him Mr. Palmer heard the saw-edged voice of Mrs. Corson. "I'm not the kind of person that'll stand it, by God! If you want to . . ."

"Here," Mr. Palmer said. "Here's a quarter apiece if you light out and forget anything you saw."

"Okay!" they said, and stepped up one by one and got their quarters and retreated, their heads together and their armed hips clanking together and their faces turning once, together, to stare back at the arguing women on the point. Up the street Mr. Palmer saw a woman and three small children standing in the road craning. Mrs. Corson's voice carried for half a mile.

In the hope that his own presence would bring her to reason, Mr. Palmer walked across the lane. Mrs. Corson's puckered, furious face was thrust into Mrs. Kendall's, and she was saying, "Just tell me to my face I don't raise my child right! Go on, tell me so. Tell me what you told Margy, that Anne's too dirty for your bastard to play with. Tell me, I dare you, and I'll tear your tongue out!"

Mr. Palmer found himself standing next to Mrs. Vaughn. He glanced at her once and shook his head and cleared his throat. Mrs. Corson continued to glare into the pale flat face before her. When Mrs. Kendall turned heavily and walked toward the wall, the wren-like woman skipped nimbly around her and confronted her from the other side. "You've got a lot of things to criticize in me!" she said. Her voice suddenly, was so hoarse it was hardly more than a whisper. "Let's hear you say them to my face. I've heard them behind my back too long. Let's hear you say them!"

"Couldn't we get her into the house?" Mr. Palmer said to the pregnant girl. "She'll raise the whole neighborhood."

"Let her disgrace herself," Mrs. Vaughn said, and shrugged.

"But you don't understand," Mr. Palmer said. "She had a beer or so downtown, and I think that, that and the heat . . ."

The girl looked at him with wide brown eyes in which doubt and contempt and something like mirth moved like shadows on water. "I guess *you* don't understand," she said. "She isn't drunk. She's hopped."

"Hopped?"

"I thought you went downtown with her."

"I did."

"Did she leave you at the pony track?"

"Yes, for a few minutes."

"She goes to a joint down there," Mrs. Vaughn said. "Fortune telling in the front, goofballs and reefers in the rear. She's a sucker for all three."

"Goofballs?" Mr. Palmer said. "Reefers?"

"Phenobarb," Mrs. Vaughn said. "Marijuana. Anything. She doesn't care, long as she gets high. She's high as a kite now. Didn't you notice her eyes?"

Mrs. Kendall had got her boy by the hand. She was heavily ignoring Mrs. Corson. Now she lifted the child in her arms and turned sideways, like a cow ducking to the side to slip around a herder, and headed for the stone wall. Mrs. Corson whipped around her flanks, first on one side, then on the other, her hoarse whisper a continuing horror in Mr. Palmer's ears.

"What I ought to do," Mrs. Corson said, "is forbid Anne to even speak to that bastard of yours."

Mrs. Kendall bent and put the child on the ground and stood up. "Don't you call him that!" she shouted. "Oh, you vulgar, vicious, drunken, depraved woman! Leave me alone! Leave me alone, can't you?"

She burst into passionate tears. For a moment Mr. Palmer was terrified that they would come to blows and have to be pulled apart. He started forward, intending to take Mrs. Corson by the arm and lead her, forcefully if necessary, to the house. This disgraceful exhibition had gone on long enough. But the pregnant girl was ahead of him.

She walked past the glaring women and said over her shoulder, carelessly, "Mail's here."

Mr. Palmer caught his cue. He put out his hand to Anne, and walked her down across the mouth of the lane. He did not look back, but his ears were sharp for a renewal of the cat-fight. None came. By the time the man in gray had distributed the papers and magazines to all the battery of boxes, and was unstrapping the pack of letters, Mr. Palmer was aware without turning that both Mrs. Corson and Mrs. Kendall were in the background by the gray car, waiting quietly.

The Professor and the Poet

MARVIN MUDRICK

Q INCY TAYLOR was a New Englander, a Yale Ph.D.
(winner in 1940 of the Jonathan Pratt Peabody
Award for his dissertation on Emerson), Professor of
English and Chairman of the Department for four
years at a small but dignified California college, and not yet forty. The
town he lived in was, like most coastal California towns, a resort, but
dignified. The city elders held off heavy industry, kept the beaches
clear of hot-dog stands, and, to supplement the gatherings of the "old"
Californians (those who had come before the earthquake of '25), wel-
comed into their Spanish-tile-and-eucalyptus suburbs the families of
retired Eastern plumbing manufacturers. The sober newspaper ("All
the news without fear or favor") reported in tastefully brief items the
police-court antics of the Mexican inhabitants of the lower end of
town, found no space at all for accounts of local damage in the latest
earthquake or drunk-and-disorderly charges against members of the
old families, publicized the college ("Dr. Floyd Gudge, Professor of
Practical Arts, is attending a Conference of Western States Practical
Arts Teachers on improved methods of sharpening kitchen cutlery
. . ."), and featured a drama-music-literature-art section on Sunday.
A symphony orchestra visited three times a year, and, as in many
California towns, there was a thriving community theater.

Taylor and the town got on well together. As an Easterner, he was qualified to patronize the rawness of California. He subscribed to *The New Yorker*, the *New York Times*, and the *Saturday Review* ("Otherwise I'd never know what's going on in the *civilized* world"). As a graceful speaker, he could preside over classrooms, auditoriums, theater audiences, and monthly meetings of the Department or the Country Club or the Community Theater Group with authority and satisfaction.

California attracts and rewards people with flair. Taylor, with his ascetic figure, his politely sardonic smile, his agile step and platform manner, had a flair. At the college, students took "Taylor courses." To freshmen he brought Shakespeare. "In this scene I recall Katharine Cornell as Juliet, in a black cape that revealed a scarlet lining when she flung it open against the bare white backdrop." His Modern Poetry course was a sharing of the fabulous past. "I asked Robert Frost exactly what he meant by . . ." and "In those days Edna Millay looked" Every year, at the beginning of the fall semester, he opened the College Poetry Readings with a performance of *The Waste Land*. Students, faculty, and townspeople filled the chairs and sat cross-legged on the floor of the Women's Clubroom watching as his hands gestured, his bright actor's eyes moved over them, his voice intoned: "Un*real* City" His special knowledge was, of course, nineteenth-century American literature. To his advanced class, he lectured with a manner of brilliant, mobile impromptu from meticulously handwritten notes; a former student, son of a prominent local merchant and now playing bit parts on television, had written of Taylor in a college-days reminiscence for the local paper: "When he spoke of *Moby-Dick*, or *Hiawatha*, or the *Divinity School Address*, one felt that the slender man behind the desk had gradually risen several inches off the floor, suspended in his own severe exaltation." Taylor kept two copies, one at home and one in his desk at the college.

For the local theater group, he delighted capacity audiences and the local drama critic by playing the college professor, the witty old codger, the dreamy intellectual in ten-year-old Broadway hits, with his own postures or a set of carefully learned ones. Two or three

times a year he was given fifteen minutes over the local radio station (owned by the newspaper): he read poetry, or spoke of Emerson, Whittier, and Longfellow. He belonged to a liberal church of New England ancestry; once a year, at the request of the respectful pastor, he ascended black-robed, stern-eyed, and straight-faced to the pulpit, to deliver a "lay sermon" on the necessity of righteousness or the decay of gentility.

His tastes, he often said, were conservative. From *The New Yorker* he neatly scissored out stories which parodied highbrow techniques, and, from the *Times* and the *Saturday Review*, articles which assailed what Taylor called "the brand-new criticism." He handed them around among his colleagues for their sharply observed amusement, and then took them home to paste the scraps of paper into a large scrapbook of other people's follies.

Still, he enjoyed celebrities, even avant-garde poets, in person. Sean O'Shaughnessy, founder of the new Orgiastic School of British poetry, sketched with Shelleyesque curls by Augustus John and praised by Miss Sitwell, had been only a rather distasteful name to him; but when he read in the *Times* that O'Shaughnessy was touring the country for lecture fees and would shortly be in California, he hastened to notify the Committee on Lectures and Drama. Telegrams were exchanged; and soon the *Press-Gazette* informed its readers that Sean O'Shaughnessy, celebrated young poet, would on a certain date be reading from his own poetry in the college auditorium.

So far, so good. Taylor read of O'Shaughnessy's arrival in Los Angeles to fulfill an engagement at one of the universities there. The first cloud appeared in the form of a phone call from the chairman of the Committee on Lectures and Drama. This gentleman had received troubling news from the metropolis. The poet, it seemed, drank; he refused to stop drinking; he had read his poems drunk; and he had hurled a glass of water, glass and all, at a face—it turned out to belong to a Professor Emeritus of Education—which he afterwards said looked too offensively stupid to be endured. Would the college please send somebody at once to pick up and pack off the poet?

Taylor volunteered to go. He was himself an almost invulnerable drinker, and he felt confident. He kissed his wife, told her he would

be back the following afternoon, said a curt goodbye to his wife's son by her first marriage (the eight-year-old was overjoyed: Mama would let him come into bed with her in the morning while Quin, who forbade the practice, was gone), and set off by auto for Los Angeles.

Finding O'Shaughnessy was a job. Taylor had the name of his hotel, but he had not been there for more than twenty-four hours. Nobody at the university knew where he was, and it was implied that at this point nobody cared to know. Taylor called a few literary lights of his acquaintance in the city, but none had seen him. Finally, the chairman of the University's English Department, phoned at his home for possible clues, recalled the name of a downtown bar that O'Shaughnessy had mentioned with special approval in the course of his reading.

He was there, seated on a bar stool, drinking, staring up at the television image high in a corner of the room. Taylor recognized him from a recent photo in the *Times*, very different from the Shelleyesque sketch. In person he was less prepossessing still. He was rather dumpy, even fat; his features had a potato-like grossness; his very coarse dark hair lay tangled on his head and brow; his clothes had obviously been worn for an indefinite period through all kinds of personal weather. Taylor paused to let his momentary distaste pass away, then walked over and took an adjacent stool.

He ordered a drink. O'Shaughnessy kept staring upward. "Mr. O'Shaughnessy," said Taylor, "I have come to claim you." O'Shaughnessy did not turn his head. "Think of all the money they make," he said. "First the movies, now this thing. Do you know anybody who could get me a job writing for them?" "I do know a script writer in town," said Taylor. O'Shaughnessy turned around; his eyes were small and dull. "What college are *you* from?" Taylor told him. "Could you take me to see this writer?" Taylor said he could. They left after Taylor had phoned the writer, mentioned the famous name, and made an engagement.

The writer was a round bald Englishman in a pink stucco cottage in North Hollywood. He was delighted to see the poet (whom Taylor had meanwhile persuaded to wash up and put on a less grimy

jacket at the hotel), and he served the best Scotch. He talked about poets. He knew the British expatriates, at least well enough to tell amusing anecdotes about them. "Read the comics and trust in the Primate," said O'Shaughnessy. When he became rhetorical, his voice developed an impressive baritone richness. The writer was disconcerted: he was High Church himself. O'Shaughnessy wanted to know about Hollywood. The writer had anecdotes; so did Taylor, who knew a number of minor Hollywood actors. How do you meet the people who do the hiring?" asked O'Shaughnessy. Well, it was hard to break in and hard to stay in; luck had a lot to do with it; writing a successful play or novel helped; may I get you another drink? By two in the morning Taylor had managed to coax O'Shaughnessy to bed in his hotel and to fall asleep himself in a nearby room pondering and shaping the play he would write, a sort of variation on *Candida* . . .

Taylor found the ride back home exhilarating. He had not been able to prevent the poet's leisurely tour of bars in the vicinity, and they had not started till late in the afternoon; but O'Shaughnessy was comparatively rested, he brightened himself now and then with a draught from a bottle, and he told stories of London celebrities, of Osbert and Cyril and Uncle Tom the Deacon. Taylor took detailed mental notes. "O'Shaughnessy was saying it's common gossip in London . . ." He was still taking notes when they arrived at his home. He had O'Shaughnessy to himself that night for a late dinner Emily prepared, and for talk and drinks afterward. O'Shaughnessy was working on a close schedule, to make as much money, he explained, in as short a time as possible: tomorrow afternoon's reading at the college, the midnight Pullman to San Francisco for a reading there the following day. While Emily asked O'Shaughnessy about his family, Taylor phoned Gill Ross (Secretary of the Community Theater Group; old local family) and Alec Stillman (former Chairman of the Department; Yale Ph.D., 1931), tempted them with a few tidbits, and invited them to an after-dinner party on the following evening in honor of the poet, a farewell party. He rejoined Emily and O'Shaughnessy, who were talking about the wife and children left at home in London.

Morning at the college was pleasant. O'Shaughnessy was still safely in bed, and Emily had promised to keep him in the house until Taylor returned to pick him up for the reading. In the parking lot, he met one of his young instructors and mentioned casually that O'Shaughnessy was staying with him during the unfortunately brief visit. "Delightful fellow, no pretensions whatever," he said. At the office, Miss Brainerd responded with appropriate respect to the same information. Taylor, long convinced that his secretary adored him, treated her always with special blandness: she was, as a matter of fact, hopelessly in love with a dapper Associate Professor of Sociology, who drove a convertible, wore sports clothes and dark glasses with corrected lenses, and taught his predominantly female students crime and punishment in the fall semester and marriage and the family in the spring; but Miss Brainerd regarded Taylor's complacence as kindness, and they got on well together. His mail, already on his desk, was agreeable: a complimentary copy of a new anthology of American literature, a letter from a Columbia graduate student asking for a job ("You are aware, I am sure," Taylor would answer, "that at this time uncertainty as to future enrollments . . ."). He reminded his classes of the event in the afternoon, and urbanely commanded them to attend. Between classes, he dropped in on Alec Stillman and told him more about O'Shaughnessy. Stillman, whom Taylor had succeeded as chairman, was a large solemn man; but he belonged to the same church, and they both attended the local Yale Club dinners—"oases in the Great Western Desert," Taylor had once remarked as toastmaster (laughter and applause).

The *Press-Gazette* had been notified while Taylor was at the office and when he got home the newspaper's human-interest reporter was sitting with Emily and O'Shaughnessy. The reporter was a large, self-assured middle-aged woman, whose self-assurance had grown out of a round of musical evenings at the homes of the best families ("Last evening Mrs. Malvina Trinkle threw open her lovely home in the foothills to a small gathering of friends and music-lovers, who were privileged to hear a concert by . . .") and catch-in-the-throat stories about children at school and at play ("Could you, if you were asked just like that, name all the forty-

eight states? *And* the territories? Little Billy Myers could, and did . . ."). Emily and O'Shaughnessy had apparently been drinking together: the glasses, the water, and the well-started bottle were still there. After the flurry of politeness, Taylor listened. "Who are your favorite poets, Mr. O'Shaughnessy?" the reporter asked. "Shakespeare and Yeats, the poets of skin, blood, and lubricity." "Do you have any hobbies?" "Drinking." "What poem of your own is your favorite?" "They are all superb; but the best is my latest, 'The Impotent Centaur.'" "What is your ambition as a poet?" "To make a mint of money." "What do you think of our little city?" "I have seen very little of your little city, but it seems a hideous little picture postcard of a city."

She left finally, baffled, with her information. Taylor was annoyed: he did not like his wife to be drinking in the afternoon, though he knew she often did while he was gone and her son was at school; she got drunk and maudlin, and at last cataleptic, very easily. She was now maudlin, telling O'Shaughnessy how mean her first husband had been to her, how big and empty Texas was with a mean no-account husband, how kind and polite Quin had been to her when she first knew him in Austin, where he'd been teaching then. Taylor told her to tidy herself up before the boy came home, and left with O'Shaughnessy to drive to the college.

O'Shaughnessy had—Taylor the amateur actor recognized—the actor's sense for audience. He was charming. He was creaseless and soiled, his doughy little figure barely dominated the lectern, but his voice was a wonderful, almost human instrument. He held and unified the crowd of students, faculty, and townspeople; he made them laugh with the confidence of being proximate to greatness. "When I was younger and the war was on, I went where all poets go when they're naughty—the BBC. I did my bit by playing Hamlet for the boys." He read poems by Yeats, Stephens, and Joyce, all in the same apocalyptic incantatory tone: "Great English poets, all Irish." He read from "Anna Livia Plurabelle." He read, in conclusion, a group of his own poems: "Ruddy Wedding," "The White Thighs of the Drover," "Umbilicus," "The Hair of the Grass," "The Impotent Centaur." Afterwards, there was prolonged applause, and many people gathered

round to shake his hand, speak to him for a moment, collect his auto-graph. Taylor saw Gill Ross, red-faced with enthusiasm, press through to O'Shaughnessy's side, say something to him and shake his hand. Ross caught sight of Taylor and hurried over. "A great man!" he cried. "If we could only get him to play Hamlet for *us*!"

A great man; and given the opportunity to make his impression because Taylor had so tactfully kept him in hand. Taylor felt a comfortable gratification, an expansive altruism. He was not envious of O'Shaughnessy: there were poets and there were the interpreters of poets, and he was content to be one of these—interpreter, friend, and unobtrusive supervisor of poets. Even Emily failed to dent his euphoria when she served dinner in sulky alcoholic silence and retired to the kitchen with her son. O'Shaughnessy had been pleased by the response to the reading and, drinking his Scotch and water while Taylor ate, talked exuberantly about new ideas for poems, about a verse-play commissioned by the BBC, about a poem he had begun just the other day in Los Angeles. He showed a piece of yellow paper covered with minute handwriting. Taylor knew that he had to have it. "Is that your only copy?" No, there was a draft. "Might I have it as a memento?" "For the bed and the liquor," said O'Shaughnessy, handing it over. Taylor folded the paper and put it casually into his pocket.

By the time the Rosses arrived, Emily had made herself moderately presentable, and she even chatted for a moment with Jenny Ross. Gill Ross was cheerful with everyone, he introduced his wife to O'Shaughnessy and continued his congratulations of the afternoon. The Stillmans came, Isabel Stillman tall and frostily English-looking but with a gracious smile for the poet. For the first time O'Shaughnessy seemed somewhat uneasy; he sat down with finality on the sofa and went back to his drink, which he had carried from the dining room. Emily, relapsed into sullenness, brought in a snack tray, set it on the sideboard, and took to the sofa also. Taylor made the drinks and passed them around.

Polite provocation of O'Shaughnessy had no effect. They drank. They turned to theater talk: first about the new English playwrights (no response); then about the "serious" Broadway hits, which the

Rosses had seen in a recent trip to New York; then about the Community Theater's most recent production, in which Taylor had played the leading role. Isabel Stillman remarked on the finished quality of Quin's performance. Taylor, at Ross's insistence, did amusing imitations of the pansy director at work, the leading lady in a temper, the ex-Broadway ancient who enjoyed dressing down his juniors. The Rosses had taken minor parts and both were animated about the pleasures of realizing oneself in stagecraft, of "belonging to a whole." Taylor played a tape recording he had made of one of the scenes in rehearsal, his whimsical-philosopher scene; more reminiscence and compliments, except from Emily and O'Shaughnessy.

Ross, emboldened by all the talk, asked O'Shaughnessy about his acting on the BBC, and was answered in monosyllables, mostly indistinct. "There's nothing like that over here," said Ross, "nothing at all." "The English tolerate at least a token display of culture," said Taylor. "We have heard fine reports about the Third Program," said Stillman. "It's a dirty, dead and rotten country," said O'Shaughnessy; "no cash, no corpuscles, all starched front and scraggly behind." Isabel Stillman began to look professionally British, and Jenny Ross's social smile lost some of its voltage. Taylor said that perhaps with the infusion of new blood from Ireland England could be saved. Emily, who had been drinking without comment, looked up long enough to say that Quin, damn him, thought he could always smooth things over. "Thank you, my dear," said Taylor, who felt like Congreve in a constellation of lively drinking company. Emily added, "Smooth as a baby's ass."

They played charades. The Stillmans did *The Importance of Being Earnest*, the Rosses *You Can't Take It With You*, and Taylor (Emily refused) *The Way of the World.* O'Shaugnessy stood up, pounded his chest with both fists, rolled with hunched shoulders and bowed arms to the window, and jumped to hang by his hands from the ledge above it: he swung there for a moment grunting experimentally at various pitches. "*Tarzan,*" he announced at last in a creditably anthropoid voice, "*and the Apes,*" leaped at a nearby cord, and brought down a large Venetian blind and himself with his own dull thump and a reverberating clatter of thin metal. He crawled on all

fours to the middle of the room, turned a neat circle on his hands so that each quarter might observe the seat of his trousers, rose, brushed off his hands lightly on the shiny seat, and returned to the sofa.

Emily was almost inert beside him; even Taylor felt unusually warm and good-humored. O'Shaughnessy seemed now to be settling into a portentous sulk, and the others, relaxed and rosy, Emily with damp drowsy eyes, watched him in furtive compassion. "My wife and kids left back there, that hole of a flat, so I can earn a miserable bit for them over here, all alone, all of us." Tears started in his eyes. Suddenly his head was in Emily's lap and he was sobbing noisily; Emily sat bolt upright wide-eyed, then scandalized as a hand rose from the crumpled body and fitted itself to the jut of her bodice, then crying, "Quin, make him stop!" Taylor was himself surprised at the depth of his sympathy: "Don't be silly," he said sharply, "he's just lonely." "Quin!" she cried helplessly. "Let him alone," came the sad muffled voice from below, "yield to the voice of the womb, be the huge engrossing earth-mother." The spectators stared, trying to collect themselves into a suitable attitude. Emily pushed the hand down. "Let me tell you something about my husband," she said with heavy deliberateness, "he's no man out of bed or in." "Emily has her own notions of virility," said Taylor, "which are I am sure of no interest to anyone else."

O'Shaughnessy bethought himself of something, stirred, rose, moved irresolutely toward the hall unbuttoning himself, did not manage to avoid a slight mishap on the living-room carpet, but kept going. Jenny Ross was propelled out of her chair shrieking: she ran past him into the bedroom, emerged holding her husband's coat and violently putting on her own, and pulled Ross toward the door. A remote hostess-bell appparently began ringing in Emily's brain; she got up and tried vaguely to intercept them: "Must you go, Jenny?" she asked. "Get away from me!" Jenny screamed, and dragged her husband with her out into the night. Isabel Stillman had decided to be superciliously amused, but Stillman was shocked into a goggle-eyed sobriety; after an exchange of courtesies with Emily and with Taylor, who was savoring his own imperturbable courtliness to the very door, they departed.

O'Shaughnessy had come back and sat down to somebody's unfinished drink. "I'm going to bed," said Emily. "I'll join you after I take our guest to the train," said Taylor amiably. "You can go to hell," she said, leaving.

There was very little time, and Taylor brought in the volumes of O'Shaughnessy's poems he had bought earlier in the day. O'Shaughnessy autographed all of them: To Emily and Quin, With love, From Sean. The volumes would grace, carelessly, a table in the living room and his desk in the Department office. "Everything passes, art remains," said Taylor, driving O'Shaughnessy to the station. "We don't have to worry, do we," said O'Shaughnessy, "as long as we have people like you on our side." "Thank you," said Taylor, feeling moisture in his eyes. "Where will I get my liquor in San Francisco?" said O'Shaughnessy.

When Taylor returned to the house, he lingered for several minutes over the books, reading each inscription closely, observing the peculiarities of the handwriting, the bold initial T, the imperial S of the signature. He went into the bedroom at last. Emily was asleep and snoring. About to take off his suitcoat, he remembered. He took the piece of yellow paper out of his pocket and read carefully, in the doorway by the dim hall light, as much of the tiny scrawl as he could decipher. He replaced it reverently in the pocket and hung up the coat. He undressed and slipped into bed beside her. He thought of the poet at bay, and began to weep.

Old Spanish Days

JOHN SAYLES

I F A PATROL CAR or the Immigration came along there would be no one to look at but him. Amado hurries up State Street to work. It's always so empty, the shops not open yet, nothing moving. Jesús has been stopped, just walking, twice in the last month. But Jesús tries to look tough. And Jesús has his Green Card.

There are banners stretched across State for the Old Spanish Days parade. The other lavaplatos say that on Cinco de Mayo only the Mexicans celebrate, but for Old Spanish Days the whole town comes out.

Amado crosses the street to avoid the Fremont House. The old Anglos gone to drink are up and out at dawn, and sometimes they follow him and say crazy things he can't understand. They have their own tongue, the drunks, just like the ones in Durango.

The Fremont is the only brick building left on State. An earthquake took the others long ago, and when the Anglos rebuilt they decided to copy the original California settlement. Everything is adobe, or made to look like it. Stein's Drugstore, The Meating Place, the Great Lengths beauty parlor, Fat's Chow Mein, all the real-estate and travel agencies, the surf-and-turf restaurants. There aren't any Mexican restaurants on State, they're mostly wooden buildings across the freeway, on the East Side.

OLD SPANISH DAYS 1978

says the huge green-white-and-red banner above Amado—

¡VIVA LA FIESTA!

A patrol car eases up the deserted street. Amado makes a tunnel
with his eyes, walks stiffly into it.

*Beginning at eight o'clock at the Sambo's restaurant downtown,
comes the squawk from the sound truck cruising the West Side,
the Old Spanish Days Fiesta Costume Breakfast. Enjoy huevos
rancheros, hot chorizo and other authentic favorites. Costume
competition commences in the parking lot starting at ten-thirty.
Viva la Fiesta!*

"Qué pasa, nano?"
Luis stands outside the Golden Calf waiting for him, smiling
and holding the brooms. Luis is younger than Amado, maybe seven-
teen, but has been up for three years and tries to act older. They
sweep the empty parking lot.
"You hear what happen to Ortega?" Luis always sweeps too fast,
raising a lot of dust. He does everything too fast, Luis.
"La Placa. They got him."
Amado had been there, waiting in the back of the car in front of
the liquor store when the fight started. If the cop hadn't been right
around the corner it would have been nothing. Amado saw him first
and yelled, and the driver, who was illegal too, screeched away.
"I hear they pull him in," says Luis.
"That's right."
"I wonder what they do to him?"
Amado shrugs. "We should have gone to Rubio's. I told them we
should." He wants to remind Luis that he was there.
"Rubio charges more."
"Maybe. But you go down lower State at night, you just ask for
trouble."

When the parking lot is done they vacuum the dining rooms and the bar. It's Amado's favorite time at work, the restaurant all to themselves like they own it, like the soft, red carpet and cane furniture and leather bar-counter belongs to them. The liquor and food are kept locked till Mr. Charles comes, so all they can do is pretend. Luis sits at a corner table in the bar and snaps his fingers for service till Amado comes over and gooses him under the arm with the vacuum. Sometimes they find money customers have dropped, but the night shift gets most of that.

. . . La Misa del Presidente, at the Old Mission at eleven o'clock. Benediction by the Mission padres and the finals of the Miss Spirit of the Old Spanish Days contest. Admission free. Viva la Fiesta!

"Put lettuce in box," says Mr. Charles. "Put box in walk-in."

He always talks that way to them, Mr. Charles, even to Jesús who can sound like an Anglo.

"Then do chicken. Then do eggs," says Mr. Charles. He stands checking the produce off as it comes in from the delivery vans. "Armando do too. Armando help."

After correcting him the first dozen times, Amado has given up. It's like he's deaf to whatever they say, blind to the fact that they know where all the produce goes already. He calls Luis "Ruiz" and Ramiro "Ramirez."

"Your shift forgot to put the roast beef in yesterday," he says to Motown, the black cook. "We had to eighty-six the French dip."

"I'll have Ross put one in this morning."

"See that you do," says Mr. Charles. He talks regular English to Motown but never looks at him.

Amado and Luis transfer heads of lettuce from bags into plastic containers and lug them into the walk-in. Mr. Charles comes in the early morning to check the deliveries and then leaves till dinner. The night people get him all shift. Mr. Charles gets nervous if he sees anyone standing still and can invent new jobs on the spot.

"Take meat to freezer," he says when the butcher's truck arrives.

"Then get old bottles, put in box, we send back. Mucho work today, hurry, hurry, mucho work!"

> *. . . at the Beef and Brew, 1631 State Street, the annual Lions'*
> *Club Enchilada Luncheon. Guests in costume admitted half price.*
> *And on Embarcadero del Mar this afternoon, do your Old Spanish*
> *Days shopping at El Mercado, the Old World open market. All*
> *items are muy auténtico and the price is right. Viva la Fiesta!*

"Estoy ren*di*do!"

Jesús blows in a little after eight. He's the senior lavaplato and Motown is in charge of the time cards so it's all right.

"All last night I'm out with mi ruca," Jesús says. "Too much bullshit. Din get any sleep."

"Which was it?" Luis always wants to hear.

"Patty. The blond. She gonna wear me out, put me in the grave before my time. Good mornin, campesino!" He ruffles Amado's hair.

Amado tries to ignore him.

"I see you wearin shoes today, man. That's real progress. They not gonna believe it when you go home, tell em about paved roads and hot water an evrythin."

Amado has been up almost a year, used to live right in the city of Durango, can order a meal and read his pay slips in English, but still Jesús picks on him. Of course Parrando is newer and Jesús picks on him too, and he picks on Luis for being nervous and on Rudy for being fat and Motown for being black and Chow for being Chinese and old and on Ross for being stupid. Jesús picks on everybody he's bigger or louder than, which is just about everybody.

> *La mujer con el pelo negro*
> *Inflamando mi corazón,*
> *Su manera desahogado*
> *Despertando mi pasión—*

Jesús sings with a mariachi group in town, sings high and piercing and full of emotion. Even in rush times, with the radio on full

blast and the dishwasher going and the disposal grinding and the cooks and waiters shouting threats at each other, Jesús can make you wince with his voice.

"I'm singin tonight," he says. "First at the courthouse and then at the Steak-and-Grape and then at the Museum for the Daughters of the Golden West."

"Bunch of old ladies."

"Hey, they pay us good, Luis. You come by an see how it's done."

"When you at the courthouse," says Amado, "sing a song for Ortega."

Jesús makes a face. "That's true, then, huh? They got him up there?"

"That's true," says Amado. "I saw him catch."

"Pendejo. He should of known better. You can fight over on Castillo or Monte Perdido and they don bother you. But lower State, watch out man. Too much bullshit, this town."

"Well they got him."

Jesús scowls.

"How come you not singin at the Park?" asks Luis. "That's where evrybody gonna be."

"Cause they got some shitkickers from down South, Luis, that's why. Probly some neighbors of Amado's."

"Charles say Luis got to stay late today," says Amado. "Cause of Ortega's not here. Cause of Old Spanish Day."

"Old Spanish Days," says Jesús. "Too much bullshit."

... *Women's Club announces La Merienda, their annual Old Spanish Days party. And for your evenings, don't forget El Baile del Mar, nightly dancing under the stars in the El Encanto Restaurant parking lot. Viva la Fiesta!*

"Platos!"

Steam, clatter and curses, the cry goes up and Amado hustles plates across the line to Motown. Lunchtime. Motown grilling a ham-and-cheese, old Chow scowling over an omelette and Ross, the big, slow Anglo, making a mess of the prep work.

"Platos! Más platos! Let's *go!* "

Motown whipping his spatula in, under, flip! onto the plate and under the lights.

"Skip!" he yells out to the floor. "Yours!"

Jesús peeling and de-veining shrimp, telling what the smell reminds him of just loud enough so the two Anglo salad girls can hear as they shred coleslaw nearby. Luis wrestling pots clean at the deep sink. Whitney, Skip and Ernesto careening in with loads of plates and silverware, shouting out their orders, sweating, and Ross's radio nasal, blasting—

> *Drivin southbound out of Oxnard,*
> *Now how can I explain*
> *The vision of sweet loveliness*
> *Out in the passing lane?*

> *She has a four-speed stickshift,*
> *A set of radial tires,*
> *And all the specs and extras*
> *That every man desires—*

"Ham-and-swiss omelette, hold the peppers, side of fries!"

Whitney, the black maricón, glides in with a trayful. Amado at the wash counter—separates the silver and the plates, soaks the silver, scrapes the plates, then sprays—he wears a layer of trash liner under his shirt against the wet, bounces the spray off into the long sink. He loads plates onto the rack, slides it into the washer, flicks it on with a buzz—

> *And as we pass Tarzana,*
> *It's settled in my mind,*
> *The way she drives it's clear that she's*
> *Romantically inclined.*

"Dumb fucker!" screams Motown at Ross. "Where's the cheese? I'm all out here!"

They all tease Ross, it's hard not to, but only Motown screams at him. And Ross is the only one he screams at.

"Idiot, grate some up, hurry!"

"Sauté pan!" shouts Chow to Luis. "Gimme sauté pan!"

The old, sour Chinese watching the eggs in front of him, holding his hand out for a clean pan—

"Mi mariquita!" Jesús gooses Whitney on his way through, then makes a move for one of the salad girls—

"Avo-bacon burger, side of fries, BLT on toasted whole wheat, Garden Harvest," starts Skip from the window—

"Hands off!" cries Jennifer, swatting by reflex—

". . . and one side of mayo!"

"—guajira, one-sida-mayo," sings Jesús to "Guantanamera."

"One-sida-maaaaaaaayo!"

"The bacon, Ross, the bacon!"

Her ruby lips, her slender hips,
Her long and golden hair.
Her velvet-lined interior,
Equipped with fact-ry air.

The hungry look she gives me,
The seed of lust has sowed
My Vega and her GTO,
A romance of the road.

Amado dumping the silver, sorting it, knives, spoons, forks, into the plastic drainers, onto the rack, pushing the silver in, the plates out, hot wash of steam billowing. Steam, clatter, curses and smells— egg-sulfur, garlic, charcoal, grease, sizzling deep fat, even, shouts Jesús in his crude L.A. Spanish, Chow's middle-aged alky breath—

I have the inclination,
And boys, I've got the time,
But I also have three little kids
And a wife in Anaheim.

Meat sizzling on the grill, eggs sliding in the pan, vegetables chopped and torn, fries bubbling, orders thrown together, snatched away, then hurtling back at Amado, scraping the plates, meat, egg, vegetable, grease, into the barrel with the side of his hand. Steam, clatter, cursing, smells—

> *Yes the exit ramp's approaching now,*
> *And so we have to part.*
> *The San Diego Freeway*
> *Is stealing my heart.*

"Platos! Let's go! PLATOS!"

. . . for the kiddies, La Fiesta Pequeña, followed by Carnivál! The popular Old Spanish Days extravaganza tomorrow at noon at La Playa Stadium. Viva la Fiesta!

In the lull after lunch-rush they eat. Jesús and Motown have their hamburguesas, Jesús drinking a raw-egg chaser for virility. Ross just picks, not hungry after eating his mistakes all morning, and Chow drinks a beer. Amado, Luis and Ernesto heat up a panful of beef and peppers, warming their tortillas over a burner. Skip orders a vegetarian omelette that Chow cooks extra greasy for spite and the salad girls take some carrots to chew out at the bar. Jesús turns Ross's radio off.

"Too much bullshit, that station," he says. "Too much cuacha."

Parrando and Rudy Peña look in, dressed sharp, already a little high on their day off.

"Viva la Fiesta!" calls Rudy. "Viva la nalga!"

"Estoy bombo," grins Parrando, and blushes, pleased with himself. Parrando is up only a month, they call him El Cañón because he has such a big one.

"They got the floats all line up," says Rudy. "All them little girls ready to march. Ay de mi!" He smacks his lips.

"We decorate Parrando's chile," says Jesús, "put it in the parade, it wins first prize. All the ladies want to ride on it."

Parrando blushes again.

"At the Park they have Los Babies playin tonight," says Rudy. "They do it for real at the Park. All the women be there, get all hot. Even Luis get laid."

"I got to work tonight, double shiff."

"Why for?"

"Cause they get Ortega."

Rudy stops smiling.

"I heard that," says Motown from the other side of the line. "Got his ass busted. That's too bad."

"I thin they send him back." Luis eats so fast the meat squirts out of his tortilla onto the floor. "They check his paper, give him to La Migra. La Migra take him back down."

"Gachos gavachos," mutters Jesús.

"If Mr. Charles would put in a word he might be okay," says Motown. "Or even the boss, if he found out. Ain't no chance of that, though."

"Pinche jefe," says Jesús. "Pinche Mr. Charles."

"Old Ortega, up in the slammer. That's too bad."

"It's okay maybe, he goes back," says Amado. "He don like it here, is too fast. Ortega belong down South, nice an slow. Like Parrando." Parrando giggles, not understanding but hearing his name.

"Am not like you, huh?" Jesús flicks a cherry tomato at Amado. "Half here and half there. Ni aquí ni allá."

"Just the same, it can't be any picnic," says Motown, up to start the soup for dinner, "sittin up in the slammer."

Rudy and Parrando leave, quiet now, and the salad girls return from the bar. Motown is bummed out, starts to sing—

The high sheriff said to Stagolee,

—staring moody into the pot—

"Boy, why don't you run?"
"Well I don't run, white fokes,
When I got my forty-one."

And the rest of the verses while they ease back into work, putting things into shape for the dinner shift. The way Motown tells it, Stagolee is so tough the noose can't crack his neck, so the sheriff has to get Billy Lyons's widow to poison him to death. Amado likes it when Motown sings. He does the glasses that have piled up—

> Stagolee took that pitchfork,
> Laid it on the shelf,
> Said, "Jump back devil,
> I'monna rule Hell my bad old self!"

Motown singing sets Jesús off, wailing, serenading the salad girls with the tragedy of the outlaw Heraclio Bernál—

> Vuela, vuela, palomita,
> Encarámante a aquel nopal,
> Di que diez mil pesos ofrecen
> Por la vida de Bernál.

High and sweet, trying to catch their eyes. Jennifer scowls, thinking the verses must be something dirty, and Sheri deals with Jesús the way she always does, pretending he's not there—

> Y lloran todas las muchachas
> Del mineral de Mapami,
> "Ya matarón a Bernál,
> Ya no lo verán aqui."

High and sweet he sings, slicing mushrooms for the Veal Bonne Femme. And Ross, thinking he's been challenged, blurts out with

> 'Twas a dirty little coward who shot Mr. Howard
> And laid Jesse James in his grave—

but can't remember the rest.

. . . all you wranglers out there, the Competición de Vaqueros Rodeo and Stock Horse Exhibition at the Earl Warren Showgrounds Arena. Three nights of rumble-tumble action! And today at five, the Mayor's La Fiesta Hour, by invitation only. Viva la Fiesta!

Amado rubs his teeth clean with a slice of lime and salt. Jesús tells him it's time to clean the bathrooms.

"I do it yesterday. Is for Luis."

"Cabrón, Luis is busy. Go on an do it."

"No. I do it yesterday. We take turn." Every day Amado tries to win a little ground back from Jesús. He'll glare back at an insult or not laugh at a joke. If his English was better it would be much easier. Jesús always teases in English.

"Shoot fingers for it," calls Motown from the range. "I don't want to hear you bitchin at each other again."

Amado loses. He always loses. It's an American game, the fingers, he doesn't have a talent for it yet.

Amado is in a stall in the men's room, scouring the bowl, when Luis ducks his head in to whisper.

"Stay in there, nano! The cops come, they askin bout Ortega. They checkin for Green Card."

Amado locks the stall door, squats upon the lid so his feet don't show under, tries to breathe silently.

If only they had waited till quitting time, till his paycheck, he could have sent another money order home.

If only he had started the ladies' room first, he'd be safe.

If only Mr. Charles or the jefe would put in for him, he could get his Green Card.

If only Ortega had listened and gone to Rubio's.

Amado squats, listening hard for five long minutes. His knees ache. Someone comes in, uses the sink. Amado waits till the hand dryer is blowing to gasp for breath. The person leaves. More minutes. Then Luis, quietly—

"Come out, Amado. They go now."

. . . come all, to the El Desfile Histórico, Old Spanish Days historic
parade! Better find a place early, you won't want to miss a moment.
Viva la Fiesta!

Mrs. Lopert hands the pay slips out. They always fantasize about what she does in her little office alone all day. When Parrando punched the wrong time card and had to spend ten minutes in with her straightening it out, Jesús greeted him back in the kitchen with fire extinguisher in hand.

"We were comin after you, nano, and use this to get her off. Those old ones, they grab on, sometimes they don't wanna let go."

Amado thinks that she drinks all day and it makes him sad to look at her.

"What you gonna do with your pay, man?"

Amado shrugs. If he says he sends it home they laugh.

"Some I save. Some I spen."

He saves to visit at Christmas. He misses his mother and father, his little sisters. It costs two hundred to be smuggled back through La Migra. It costs nothing but the bus fare to go down.

. . . MacEvoy, please report to the reviewing stand. Will Donald
MacEvoy please report to the reviewing stand, your mother is
looking for you. Viva la Fiesta!

They stand in front of the Peaches Bargain Boutique, Rudy, Parrando, Amado, Rafael Torres and Angél from the busboys, stand together on the curb watching the parade, surrounded by Anglos. Anglos in sun hats and sunglasses, with nose cream and Kodaks and folding chairs. They stand apart with their arms folded across their chests, joking in Spanish, running down all the floats, all the tourists and marchers, and no one around them knows, no one understands.

First there are Marines, hard-heeling down the center of State, eyes front, each supporting a flag. Then a little girl in a white linen dress, like for First Communion, tossing flower petals from a basket.

Ladies and gentlemen, our lovely Little Miss Spirit of the Old Spanish Days, Cynthia Louise Bottoms! Viva la Fiesta!

An Old Spanish Days powder wagon, with four outriders in shining black-and-silver charro uniforms. Angél recognizes Mr. Lomax from the liquor store, who called the police about the fight. He looks younger on horseback, bald-patch under a broad, black hat.

Ladies and gentlemen. El Presidente de la Fiesta and his family, Mayor Thomas J. Kelso! Let's have an Old Spanish Days round of applause! Viva la Fiesta!

A group of families comes next on horse and mule, dressed as Anglo pioneers escorting a covered wagon. Then more local ranchers on their horses, leathery husbands and wives in matching spangled outfits.

"Roy Rogers!" cries Parrando. "Hopsalong Cossity!"

The marching bands come then, and Rudy leads the hissing and clucking at the baton girls in their sparkling pink tights, leads in teasing Parrando when the littlest ones, with their spit curls and spots of rouge and their mothers trailing on the sidelines, pass by.

"That's your speed, Parrando," they say in Spanish. "You have to start small and work your way up."

"Parrando's stick is taller than the girls," says Angél. "He'd scare them away."

"A gift like that to such a baby," says Rudy, shaking his head sadly. "If I had one like his I'd retire and let the women take care of me."

"How bout two inches for an amigo, Parrando? You got plenty to spare."

Parrando blushes, and Amado envies him a little. He never has to act hard, Parrando, the others accepted him after the first time he changed his pants in the laundry room.

A drum corps of black boys, whaling away in perfect time, marching tight and sharp, and then a float with a flamenco dancer, a Chicana. They cheer.

A colorful member of our Old Spanish Days celebration, Margarita Estrada will appear nightly at the Noches de las Estrellas pageant, under the stars on the Long Pier.

The County Sheriff's posse follows, and the Old Spanish Days Fire-Hose Cart and Engine Crew Bucket Brigade, the German Club float, the Town Assessor dressed as a Chumash Indian chief, the Elks Drum and Bugle Corps, and then, three flatbeds long, hung with paper lanterns, aglow with bougainvillea, camellias and hibiscus, fluttering with black lace fans, rustling with red and orange and yellow petticoats, comes the Native Daughters of the Golden West float and Mounted Honor Guard.

"Chingao!" says Angél.

The women offer bare, white shoulders to the sun, their hair piled high with combs, they smile and wave and click their castanets at the crowds lining State Street—

Old Spanish Days would not be complete without an evocation of the grace and splendor the Castilian Dons and Doñas preserved in their journey to the New World. This foundation of European culture has survived through the years to become our treasured heritage. Viva la Fiesta! Long live the Old Spanish Days!

—across Pedregosa, across Cota and Gutierrez and Salsipuedes, across Sábado Tarde Street to slow for pictures in front of the Peaches Bargain Boutique. Amado sees Mrs. Winters, who taught the night-school English class he was too tired to keep up with, dressed in scarlet. Little blond boys in white peon suits hold the trains of the longer dresses, while high-school boys in red sashes and bolero jackets mime playing instruments to a tape of a mariachi band. The women work their fans, click their castanets and wave to the flashing cameras, a beauty mark on every cheek.

At the very end come the low-riders.

After the last Spanish couple, the last pioneer family, the last child in pinned organdy strapped sidesaddle on a burro, comes the low-riders.

"Chingao!" cries Angél. "Low-riders!"

The Bronze Eagles rolling down the center of State, four abreast, dozens of them, looking bad. Jacking their front ends up and down, Chevys, Dodges, old shiny Fords, pumping their lifts in violent spurts, whush! whush! whush! flashing axle then letting it drop, nose to the pavement. Amado cheers with the others, whistles, stops, and they hear their countrymen scattered up and down the street. The Anglos have started to leave, chairs folded, cameras capped—they look back uncertainly, check their parade lists.

The Bronze Eagles rolling slow on State, four abreast, hissing, jerking, followed by a pair of poker-faced motorcycle cops wearing mirror-lensed shades.

"Viva la Fiesta!" cries Rudy. "Viva los low-riders!"

Twas there that I met her, my dark Señorita,
Black silken hair hanging down to her waist.
Her name was Lupita, she danced in a tavern,
A flash of her eyes and my youthful heart raced.

They have to pass by the Anglo block parties to get to Murieta Park. Lanterns strung, warm red light, people sitting or standing to the sides of the dance area, politely clapping time for the fast numbers. At one the old Anglos, the pensioners and retirees, are milling about to "Spanish Eyes." At the next middle-aged Anglos hop to a swing band playing "Rose of San Antone," and at the next, slightly younger Anglos slow-dance to an Italian singing "There is a Rose in Spanish Harlem." Amado, Rudy and Parrando skirt the parties, look for friends beneath the streetlights. They try to keep their bottle out of sight.

"Estoy bombo," grins Parrando. Parrando is weaving, smiling at everything, liquid. Rudy wants to ditch him and find girls but Amado is afraid he'll pass out somewhere and be arrested.

"Take it easy, hijo," he says to Parrando in Spanish. "In this town if you lay down on the walk, there isn't a neighbor to throw a blanket on you."

Parrando weaves.

They hear it way back on Milpitas Street, carrying in the night

air, welcoming. When they're a block away they see the banks of field lights beaming over the rooftops. Murieta Park, and everybody is there. The warm-up group for Los Babies is set up on the pitcher's mound, guitars, woodblock, congas throbbing, amplifiers cranked up full letting the whole town know about it. Dancers dance wherever they are, children chase across the infield, groups of boys and groups of girls cluster on opposite foul lines, then break off in twos and threes to cruise by each other. Farmworkers in straw Stetsons, already loaded, wander happily through it all while others huddle around bottles, getting there. People sing along with the music in the key that suits them, while others sing totally different songs, shouting out to the black beyond the field lights. There are booths for food and drink, tables for this cause and that, a blanket spread by home plate for sleepy kids too heavy for their parents' arms.

A patrol car glides along the four sides of the Park, never leaving, never stopping.

> *Cuatro palomitas blancas*
> *Sentadas en un alero.*
> *Unas a las otras dicen,*
> *"No hay amor como el primero."*

"Viva la Fiesta!" cries Rudy. "Viva la Raza!"

Amado, wine-high, gives a whoop. For the first time in so long he feels at home outside of the kitchen. He stretches his arms out wide, throws his head back and yelps to the sky. Parrando joins him, howling like a pair of coyotes, howling at the top of their lungs.

"Tas lucas," says Rudy, smiling but looking at them warily.

They meet Jesús and his Anglo girl. She isn't as pretty as Jesús has described, but she's just as blond, sun-and-seawater blond like Skip at work. When she smiles in greeting her gums show. Jesús rolls his eyes and tells them in Spanish what he's going to do to her, and how he'll come back later and find another, a Chicana.

"One for the belly," he says in Spanish, "and one for the soul."

Jesús sees Ramiro and Mendez and some others he knows who work at the Country Club and he takes his girl to show her off.

Mi amor, siempre libre,
Siempre silvestre,
Dígame con un beso,
Me sonríe, amor.
Tus ojos prometen
Mientra ta boca aguarda.

Rudy sees a girl he knows from the junior high school, walking with two friends. They wear high-waisted, bottom-hugging pants, long sweater-coats. Rudy's girl has streaks of red in her hair.

"This is my friend Amado Cruz," he says. "And that is Parrando."

Parrando waves in their direction.

Rudy is very smooth. Amado is glad to be with him. He pairs them up right away. Amado gets Celia, who is pretty. With a good shape at thirteen, brown and thin like Nalda Perez back home. Nalda a mother already. Parrando is left with the heavy, Indian-looking one. She doesn't seem pleased.

Celia has her black hair in a braid for the Fiesta, and a flower behind one ear. Under her sweater-coat she wears a white camisole top, with a small golden cross around her neck. When Amado talks to her in Spanish she doesn't understand.

"I used to know some," she says. "From my grandmother."

Amado struggles with the words as they walk, his stomach tight now.

"Is like Cinco de Mayo," he says, "like Cinco de Mayo down South."

"Yeah, we have that up here too, Cinco de Mayo. The Chicano Caucus puts it on. We have that and the Fourth of July. Lots of fire-works."

"Qué?"

"Fireworks. Boom-boom-boom," she mimes an explosion in the sky.

There is a rumbling, a roar, and a pair of low-riders screeches onto the street beside them, front hubs running inches from the ground. They hop the curb, drop even lower—Skreeeeeeek! a show-er of sparks from their plated bottoms, a cheer from the crowd in the Park, and then they cut hard and thunder away with the patrol car yowling after them.

Amado watches after, their sound fading slowly. "I save my pay," he says to Celia. "I buy one. A low-rider. I give you a drive." Celia says that would be nice.

> *Quiero dormir en tus brazos,*
> *Cara a cara.*
> *Quiero tus labios, ta ternura.*
> *Cuando los brazos mi tengo,*
> *Yo tengo en bronce*
> *Toda mi alma.*

The wine finished, Rudy gone off with his girl, Celia and the little one home to their mothers and the field lights shut down for the night. Amado steering Parrando, lost, but somewhere near the ocean. He hears the surf. He hears others still loose in the night, distant shouts, curses, glass shattering. The night hot, still charged with Fiesta but scary now. Amado thinks they're still on the West Side, he looks out for the train tracks—"If you ever get lost, campesino," Jesús always says, "go find the ocean, take a left turn, an just keep *walk*in."

"Estoy *bom*bo," Parrando's eyes are nearly shut now, he moves in a daze. "Stoy muy borracho."

"You ever drin before this, Parrando?"

"Nunca," smiles Parrando. "De ningún modo."

Surf breaking close by, the backs of hotels rising, then—

"Viva la Fiesta!" cries Parrando when he sees the floats.

"*Chist!*" hisses Amado. Parrando covers his mouth, giggling.

The floats are unattended, moonlit in the beach parking lot. Crowded together they seem like a small amusement park, towers and banners and platforms, pennants flapping in the night air. Parrando darts in among them, tearing at crepe and flowers, tosses the bits over his head.

"Viva la Fiesta! Viva Ol Hispanish Day!" he yips.

Amado catches him on the Native Daughters of the Golden West float, tackling him in a tangle of hibiscus, bowling over a trellis. Parrando giggles, agrees to come along quietly, but first he has to

pee. Amado has to also, they turn back to back, count five and let go, like duelists.

Amado is tapped and tucked when Parrando is just getting going. Amado stares, it really is huge. Parrando irrigates the bougainvillea, the hibiscus, the camellias, splatters the papier-mâché wall of the Old Spanish Days hacienda and is baptizing the throne of La Reina de la Fiesta when a strobe light flashes across his back and a loudspeaker crackles—

"STAY RIGHT WHERE YOU ARE."

Amado is off, sprinting into the dark, hurdling driftwood, the beach-sand slowing his flight like a bad dream, and dreamlike, the thoughts keep touching his mind—wait till I tell them in the kitchen. Parrando startled in the light, fumbling to stuff it all back in, reeling away with it still out, flapping—Even Jesús, who never laughs at the jokes of others, even Jesús would be laughing.

Amado sprawls into a runoff ditch behind the bathhouse, legs rubbery, wind sucking in through his ears. He swallows his wheezing, tries to hear them. Surf breaking. Others still loose in the night, cursing, crying, shattering glass. Amado will get overtime for a few days if they catch Parrando, both he and Luis doing double shifts till someone's brother or cousin just up comes to fill the opening. Parrando will be better off down South.

A spotlight plays across the sand, catches the breaking tips of waves. Amado squats in the ditch, presses tight to the wall. Maybe he'll see his family before Christmas.

K.590

NICHOLSON BAKER

T HE FOUNTAINBLUE HOTEL and Apartments distin-
guished itself from the rest of the apartment courts in
Isla Vista—a town composed almost entirely of students
at UC Santa Barbara—by the fact that it had housed the San
Francisco 49ers during their summer training the year before. The
team had practiced on the enormous brown field nearby (brown
except for several lush spots of bright green, where the recessed water
sprinklers leaked continuously); but apparently had also rehearsed at
least some of their plays in their rooms at the Fountainblue, for after
they had left (in two air-conditioned buses), Mrs. Warner, the man-
ager, found many enigmatic dents and lesions in the walls, which
seemed to have been created by blunt instruments such as shoulder
pads or elbows. Six doorknobs had been twisted out of their sockets.
Whenever Mrs. Warner thought of her ruined doorknobs she shook
her head at the callous forces of destruction in the world.

The Fountainblue was also notable in that it actually had a blue
fountain. It adjoined the kidney-shaped pool in the courtyard:
hexagonal, with four artificial rocks of cast concrete spray-painted
silver submerged around the pump, and a sprig of plastic seaweed
bobbing on the surface. The inside of the fountain was painted an
intense, Pacific Pool Supplies blue. It was very impressive when

turned on, but Mrs. Warner, economical about electricity, saved it for special occasions—as when she was showing around prospective tenants, or when she felt depressed and needed something beautiful to soothe her. The water, when the fountain was on, made a lovely sound that recalled the short chirps of hundreds of small birds.

Mrs. Warner had already finished vacuuming the gold carpeting in the lobby, and was now going over the turquoise indoor/outdoor carpeting around the pool. She had chosen all the Fountainblue carpeting herself, as well as a good deal of the furniture. The apartment desk chairs, for example, had off-white textured vinyl pads and a cluster of artificial rubies inset into the backs. But the carpeting, her pride and joy when it had first been installed, was now a source of deep distress, for ever since the oil spill it had been accumulating hundreds, perhaps thousands, of ineradicable tar spots. Mrs. Warner had put a sign at the entrance, CHECK YOUR FEET FOR TAR! with a rag and some kerosene, but it had failed to generate interest.

The situation was at its most serious in the Refreshment Room, for which she had chosen pink shag carpeting to go with the purple Moorish-style trim. Chunks of tar had imbedded themselves among the shag fibers like ticks, feeding on the pinkness. Seeing her carpeting grow ugly day by day filled Mrs. Warner with a sense of tragedy.

But on that particular summer morning, right there in the Refreshment Room along with the pink shag, the Moorish trim, and the wood-grained vending machines, a *string quartet*, of all things, was rehearsing Mozart's K.590 in four of the ruby-studded chairs. K.590 is the third quartet dedicated to King Frederick William II, and the last Mozart composed (1790, or 179 years before the oil spill): a witty work with spots of great lyric beauty. The quartet was, still is, in F major, whereas Mrs. Warner's vacuum cleaner played a steady B-natural with occasional rises in frequency when she pressed the wand hard into the poolside carpeting. This creates for us, in the position of hearing both, a harmonic tension that must be resolved. The young Mozart himself once got out of bed to resolve a similar interval when someone had played it on the piano, or so the story goes. The musicians were working on the first movement. Suddenly the first violinist stopped playing and waved his bow.

"Hold it, hold it. Stop," he said, and the music trailed off near the end of the development section. The vacuum cleaner was faintly audible. "We're getting really harsh-sounding here, I think. It needs to stay more light, more calm. Especially you, Steve"—looking at the second violinist—"I think it should be more . . . joyful, more *joyful* at that spot near G."

"More joyful," said the second violinist irritably. "I felt joyful. That's an incredibly hard passage to play joyfully, you know."

"I agree, though," said the cellist. "We'll hold back there, then you kind of sing that run, *deedledeedledeedledeedle-dah poof!*" He waved his fingers like cilia in the air. "Just super light, super clean."

"Fine," said the second violinist. "I'm going to be super light and more joyful the next time through, as simple as that." He pulled a loose hair from his bow, frowning. The cellist shrugged.

"I had an idea about that section," said the violist. "Eight after G, where it modulates, wouldn't it be effective if we got a little *calando* just before it picks up again?"

"Ah, *calando* schmalando," said the second violinist. "I doubt Mozart even knew that word."

"A *calando* sounds good to me," said the cellist.

"Okay, look," said the first violinist, marking his part. "Why don't we do that whole section. We'll try Myron's mysterioso idea, and we'll try in general to keep it less agitated-feeling."

"And I'm going to be deeply joyous," said the second violinist.

The first violinist made an upbeat with the neck of his violin and they started. The second violinist, who was wearing sandals, clenched his toes to the rhythm. By some freak the pink shag carpeting and Moorish trim made for nearly perfect acoustics. The quartet played well: They frowned, they swayed with the phrase in their ruby-studded chairs, their fingers, fantastically bent, moved like the jointed legs of large arachnids over the strings. While they were playing a man walked in for a pack of cigarettes. His flip-flops made an interesting sequence of peeling and slapping sounds against his heels. The violist got distracted and missed an entrance.

"Boy," said the second violinist, "I'll tell you right now, if we play it like that at the Coleman Competition there will be zero

chance of us winning anything." There was a silence. Mrs. Warner's vacuum cleaner was faintly audible.

"David, is there any other place we could rehearse?" asked the cellist. "I think this environment is getting us down."

The first violinist took his instrument from under his neck. "There's the laundry room, but (a) there's too much noise from the washers and (b) the humidity would ruin the instruments. Case closed." He began inspecting his left index finger, pressing it tenderly with his right thumb.

"How's your callus doing?" the cellist asked.

"Professor Belanyi said to file it down, so I just took a nail file and zapped the hard part off." He extended the finger. There was a yellowish area on the end that had been flattened by a file. "It hurts when I start playing, but then the skin warms up and it gets flexible."

The cellist said, "You know that Miriam's callus on her middle finger split once just before a concert, and she had to play the whole Lalo concerto with a Band-Aid on?"

"Can we rehearse?" said the violist. The pitch of the vacuum cleaner rose suddenly, perhaps an obstruction, then resolved to tonic.

"The thing is," said the first violinist, "we're all trying too hard with this movement. We're playing it *agitato* when what we need is to be more relaxed, sunny, sprightly. You know?"

"Joyous," said the second violinist. "You've made that clear."

The first violinist counted off a slightly faster tempo and they started playing. Identical moments of great lyrical beauty transpired, but a little faster. They were already into the recapitulation when two girls walked in with towels around their necks. One was carrying an orange Frisbee. The cellist got to a difficult chromatic section and played it perfectly, bunching his mouth and flaring his nostrils, although he wasn't aware of this. One of the girls stuck a coin in the cold-drink machine. It made a series of complex clicks and scraping sounds, then came to rest. Another coin was introduced: more clicks and scrapes, slightly varied. The first violinist played a cascade of descending thirds in G minor. *Sprite* was pushed. There was a loud click followed by distant thunder: The pop can rocked once, then lay tranquil in the orifice. The violist answered the violinist with

more descending thirds, in C major. The other girl invested in a Tab and a Mars Bar. The music sounded really nice, so they both stopped to listen. The quartet passed the double bar, and the first violin and cello had a witty interchange moving to tonic that was abruptly punctuated by two sharp hisses, followed by sounds of tearing metal. Both girls put their pull tabs on the first joint of their middle fingers. They leaned against the large window, through which the pool was partly visible, sipping waves of carbonated beverage and listening to the music. The movement ended and the quartet was all smiles.

"Hey, that was beautiful that time!" said the cellist.

"And we kept right on it at the *deedledeedledee* section," said the violist. "I really think the bouncier tempo helped it."

"That sounded really nice," said one of the girls. The first violinist looked over his shoulder and said thanks.

"We were supposed to be rehearsing in this joker's apartment," said the cellist, pointing to the first violinist. "But his roommate decided to get sick this morning."

"Oh," said the girl. No one could think of anything else to say. There was a scream and a splash from the pool. The vacuum cleaner had been turned off.

The violist began tuning. "Why don't we work a little on the second movement, since the first seems to be jelling pretty well, and then call it a day."

The other three players tuned, and then they started the second movement. One of the girls began eating her Mars Bar. She heard the repeating chords of the accompaniment over the wet, seaside sounds of chewy caramel. The other girl smiled and tapped the orange Frisbee lightly against her thigh. Complex polyrhythms.

Just then the door opened and Mrs. Warner came in, holding her vacuum cleaner. She meant to vacuum the pink shag carpeting, for you have to keep things looking as nice as you can, even though its complex geography of tar spots never failed to depress her. But here was a string quartet playing nice, calm, graceful music in the Refreshment Room. The two barefoot girls from 178 already listening. She stood still for a moment. The door hissed shut behind her

and tapped her lightly on the elbow. All four of them were weaving the sounds together like that, so light, so joyful; it was just right for the Moorish trim, it made the shag beautiful again, newly pink. She was filled with a complicated emotion and sat down to listen in a chair near a decorator trash can, holding her vacuum cleaner by the handle in the manner of a cello. Very lovely music, she thought. But why don't they seem to be enjoying it?

She watched the players bob and sway. She noticed the cellist's sharp endpin, putting a hole in her carpeting. This pained her, but then everything is compromise and where are you going to find perfect beauty except in front of the blue Fountainblue fountain? The first violinist came to a melody that reminded her of singers on old 78 records, very nice, pressing his fingers into the strings and rapidly shaking his left hand.

"Hey!" interrupted the second violinist, getting angry all of a sudden. "David! Stop! I hate it when you turn on that fast machine vibrato: *eh-eh-eh-eh-eh-eh-eh*. No one else in this quartet uses Fritz Kreisler vibrato!"

"Well, goddamnit!" said the first violinist, getting angry back. "That's my conception of the melody!"

"Let's try to be rational," said the violist.

"And anyway you haven't been marvelously in tune today, Steve, or very easy to rehearse with," said the first violinist.

"How can I be in tune when you're laying on that Fritz Kreisler vibrato right next to me?"

The two girls gave each other a surprised look. The one with the Frisbee said, "Sorry to interrupt your little argument, but I'm a waitress at Borsodi's Coffee Emporium, down there two blocks?"

The first violinist turned around and nodded yes.

"Well, I'm a waitress there, and we have a classical music night every Wednesday, and I know Mr. Borsodi would really love it if you guys came and played because it sounds really nice."

"How much?" said the second violinist.

"Ignore him," said the cellist.

"Well, I mean it's not really paying, it's just for people who want to play, *you* know," said the girl.

"I'm through with freebie charity engagements!" said the second violinist, clutching his violin by the neck. "We've got one of the finest quartets you're likely to hear in a long time, and we certainly aren't going to sweat out Mozart for a bunch of mellow organic-food people sitting around drinking Arabian coffee."

"He's like this," said the cellist. "Doesn't really mean it."

"No, I'm dead serious," said the second violinist. "This is the kind of crap that ticks me off. I'm sitting here trying to play Köchel 590 staring at a row of vending machines. It's pathetic."

"So that's why we want to win the competition, Steve," said the cellist, to placate.

The girls smiled at each other and shrugged. But Mrs. Warner, still sitting quietly next to the trash can, was saddened that four young men who played such nice music together could get along so poorly. Not only that, but when the violist took his instrument from under his chin she noticed a large pink callus where the chin rest rubbed against the jawbone, built up over years of practice. Ugliness.

"Come on, Steve, everybody," the violist said. "Let's calm down and rehearse. I don't have much time, and we keep getting distracted."

They started from C, reluctant at first, then wholly committed. Mrs. Warner closed her eyes. Without the sight of the cellist grimacing and flaring his nostrils the music was much better. It was so graceful. She thought of her daughter before she went off to school, when she was still doing her baton twirling, and could toss it high in the air where it glittered in the sun and then catch it deftly behind her sequined back. She sat, smiling slightly, eyes closed.

While the quartet played, one of the girls noticed a deposit of tar on the smooth curve of her arch. Frowning, she picked up her foot and examined the thick black spot. She attempted to dislodge it by picking at it with her pop-can tab. Mrs. Warner opened her eyes. The girl's back was to her, and she watched in horror as the pop-can tab scraped off a large shaving of tar that fell on the carpeting.

The quartet continued playing. Mrs. Warner jumped up. Here was one of her tenants participating in the destruction of her carpeting right in front of her eyes, yet if she cried out, if she seized her by

the shoulders and shook her, if she yelled at her about the callous forces of destruction in the world, the music would stop, and the four young men would think of Mrs. Warner as a callous force of destruction herself. The girl lowered her foot. Mrs. Warner felt such outrage and hurt that she left the Refreshment Room quickly, wheeling her Hoover behind.

She walked past the pool, shaking her head. She needed something beautiful to soothe her, so she put the vacuum cleaner away, went into the office, and flipped the switch that said FOUNTAIN in turquoise Dymo labeling tape. From the pump surrounded by the silver-painted rocks there rose four trembling silver plumes of water that began interlacing in complex trajectories of great formal beauty. The plastic seaweed bobbed hypnotically on the water. Mrs. Warner sighed and sat down in the office with the door open so she could see and hear the fountain yet remain in the shade. All tar spots dissolved from the world. The watery noise of hundreds of small birds drowned out any Mozart that might have been audible from the Refreshment Room. The pump motor, by pure coincidence, hummed a slightly sharp B-natural.

Twenty minutes later the two girls left the Refreshment Room, squinting and laughing, along with the four musicians, each of whom held an instrument case in one hand and a soft drink in the other. The second violinist noticed the fountain and stopped in his tracks.

"Oh lordy," he said. "What have we here? What an amazingly tacky fountain!"

"I know, I know," said the first violinist ruefully. "It was hard to take at first. But actually now I kind of like it. It's got its own integrity."

"California's poisoning your blood is what's happening," said the violist.

"Are we going to Borsodi's for coffee, or are we not going to Borsodi's for coffee?" said the cellist.

"Come on," said the girl with the Frisbee.

"Fine," said the second violinist. "We'll go to Borsodi's for coffee. Anyplace is better than this shrine to chintz."

As they left, the hum of the pump motor stopped, stunned, and the four weaving plumes of water slowly dropped back to pool level.

Later that day came night, twinkling oil derricks and all. The only light in the Refreshment Room glowed from the vending machines, and the four ruby-studded chairs were lost in shadow. But on the enormous field carpeted with greenish-brown turf where the 49ers had practiced the summer before, fifty recessed water sprinklers abruptly poked their heads above the grass, and plume after plume, fountain after fountain sprouted and rose up over the playing field, triumphantly vindicating the Fountainblue. The sound of the rushing water made a gentle, distant white noise in the air.

The Girl in White

Dennis Lynds

THE BARTENDER served his martini with a twist of lemon. A first class hotel. The dark stone floors and cool corridors like some medieval Spanish place.

"Why," he asked the bartender, "is it always a strange town when a client stands you up?"

"Ain't it the way. That's three-fifty."

"Put it on my room. Harrison Flint, 204. So what does a stranger do in Santa Barbara with an afternoon and evening?"

"They got a tourist place downtown."

"No monuments or missions, thanks anyway."

"Play golf?" the bartender considered. "There's the ocean, and we got a pool across the road. There's movies downtown."

"A movie maybe tonight," he said.

A movie in daylight made him look like some shabby failure. No one played golf alone. Drinking in an empty daytime cocktail lounge was for old men with nothing to do.

He swam in slow circles in the center of the large blue pool. A swim in an outdoor pool in March was a luxury for an Easterner. An event. Privileged.

A girl in a white tank suit sat high on the diving tower. She swung long legs. The white suit rippled with her body.

Cabanas faced both sides of the pool. Club members and hotel guests lounged in deck chairs, dozed in the warm sun.

The girl in the white tank suit stood balanced at the edge of the tower. The arc of her body an unbroken curve downward.

The beach was outside a wire fence. He walked beneath a high bluff that curved away toward the city itself. An abandoned gazebo tilted precariously on the edge of the bluff. He spread his towel on the sand, watched the sea.

The large islands some fifteen miles out seemed close enough to touch. Brown pelicans skimmed low above the sea. Small boats sailed offshore even in March. The girl in white played volleyball up the beach. Boys all blond and quick. Girls in bikinis, their thighs too heavy.

The sun moved down toward evening. In New York the sun set to the west over the land. This sun was also setting over the land. That was wrong. This sun should set far out over the sea. The sun was in the wrong place. Or the sea.

The volleyball bounced along the beach. The girl in white ran past, kicked sand.

"Angela!"

The woman was alone on a blanket. Blonde in a black bathing suit, a book open on her lap.

"No damage," he said.

"Nothing seems to make her think. I'm sorry."

"The enthusiasm of youth. Your girl?"

"My sister." The woman closed her book. "Our parents died when she was still in junior high, so I raised her. My husband and I did, that is. Now I have her all to myself. Lucky me."

The girl in white carried the volleyball back across the sand. The tank suit curved over her hard buttocks and high breasts.

"I always wonder what they're thinking," he said.

"Judging," the woman said. "Watching and waiting and judging."

He picked up his towel, walked across the sand.

"I'm Harrison Flint. From New York."

"Sarah Foster." Her bathing suit stretched over the full circle of her hips as she moved to make room for him. "On a vacation with your family?"

"Business trip. My afternoon appointment and dinner turned up busy so I'm a fish on the beach."

"Abandoned," she said. "I know how it feels. I've been divorced two years now." She twisted her long blond hair into a bun. "We lived up in San Francisco, and afterwards I felt beached for months. No one up there I really knew or wanted to know. He's still up there, Ted, but I had to come back here." Her hands were long in the sun as she manipulated her hair. "Ted's company asked him to travel a lot. So he travelled. Whatever his company asked him to do."

"My wife doesn't care how much I travel."

She uncoiled her hair. "We never did anything. Somehow, it all just happened to us. Whatever we did just happened."

The girl in white dropped down onto the sand beside the blanket, kicked her legs.

"That suit just has to be rented."

"Borrowed from the hotel."

"Are you an out-of-town tycoon on a big business deal?"

"How did you guess?"

"I'm smart."

"Anyone can see that."

"Are you a vice president or something?"

"Yes."

"Really?"

"Really."

"I like him, sis. You can keep him."

The girl ran back to the volleyball game. Her afternoon shadow ran before her. A boy met her shadow. The long blond hair of the woman framed the girl down on the distant sand with the boy.

"I have to stay until tomorrow night," he said. "A sales meeting with our California salesmen."

"We give a concert at the hotel tonight. String quartet, I play cello. We're all from the university except me."

"I used to play the violin. When I was a boy."

"It's at eight-thirty in the reading room."

"Playing the cello's hard work."

"Ted always said it was the damnedest instrument for a woman. The bow between my legs, back and forth, in and out."

The volleyball players sat all around him on the sand. The boys seemed younger than the girls.

"You know the kind of people who quit work on the dot, go home, never think about the job again. Never think about the work they're doing, its importance, only about their paycheck. An easy life, maybe, but small. You can't make a mark that way, help move the country."

"How do you get to be a vice president?" the girl in white, Angela, asked.

The girls sat on their heels in the sand, legs under them, bodies erect to display the high breasts and flat bellies.

"You get to be a vice president by working hard and using your brains. Take me. I trained as a chemist. After college I took a job in the laboratory of a cosmetics company. It wasn't going to win me a Nobel Prize, but it paid the best. In ten years I was head of the laboratory. I was proud. Then I saw that salesmen with half my training were making twice my pay and would go three times as far in the company. The leaders of the company had reached the top through sales or finance. That hadn't always been true, but in my time the road to the top was through the marketplace. So I quit the laboratory and went into sales. Now I'm a vice president. With luck I'll be president before I retire. I'll run the company until it's time for someone to take over from me."

The woman picked up her book. He helped her fold her blanket. Horns from the shore road summoned the girl in white and her friends.

"You must be a good salesman," she said.

"I like talking to kids."

She shook the sand from her blanket.

"I took violin lessons for years," he said. "I went to the opera with my mother, listened to the Philharmonic on Sunday afternoons. I'm not sure when I stopped. In college, I suppose."

"Ted hated my cello. It showed I didn't think right."

"I'd like to go to your concert," he said.

"I'll leave a ticket at the door."

"What do you do until eight-thirty?"

"Eat dinner. Have a drink or two."

"Why not with me? Drinks and dinner?"

"I'll go home and change. It's not far."

There was a view of the sea and the distant islands.

"What do they call you? Harrison? Harry?"

Her drink was a margarita.

"Flint. I never liked my first name."

She said, "My maiden name was Lynd. I once read a book with a story in it about a place in England called The Forest Of The White Hart from a legend of King Henry the Third's time. The legend told about a Thomas de la Lynd killing a white hart the king had run down in a hunt but had ordered spared. De la Lynd was given a heavy fine."

"Flint's English too. There's a pirate captain in *Treasure Island.*"

His drink was a martini.

"Why did he kill the deer?" she said. "Because the king shouldn't have ordered it spared? The king was wrong? Why did the king only fine him? A knight who defiled a king. Did he pay his fine? Was it worth it? Or did he refuse to pay, take to his horse and the forest? An outlaw, hunted down and hacked to pieces in some dark cave?"

"The king should have killed the deer," he said. "A leader can't be too different from his men."

They both ordered the special of the day.

"You've got big hands like Ted," she said. "I like men to have big hands. Your face is longer, and your hair's lighter. When I saw you on the beach you were seeing the distance out to sea. Ted never saw the distance."

They both ordered coffee.

"When I told Ted about Thomas de la Lynd and the white hart he said that de la Lynd had been crazy. He wasn't really interested. There weren't any white harts or kings anymore."

Neither of them wanted dessert.

"They were still savages in those days," he said. "Spears and battle axes and funeral pyres."

"At my parents' funeral there was this old friend of my father. A tall man with almost white hair. He came into the church, walked straight down the aisle to my father's coffin, kneeled for maybe five minutes, stood up, and walked back out without a word to anyone. We talked about him for hours."

They walked to her house.

"Savages," she said. "Out of the fogs and the swamps of the north. There were chiefs, but everyone spoke up, decided their own lives. How did they become us?"

In her bedroom she had a queen-sized bed. Afterward, he talked in the dark of the bedroom.

"I took a trip up north on the *Empire Builder*. Chicago to Seattle, heavy snow all the way. We ran late, no way to make the down-the-coast connection in Seattle. Everyone who had the connection would be bussed from Pasco, Washington, to meet the train in Portland, Oregon. At two A.M. they woke everyone up— except the sleeping car passengers. Me and another guy. The conductor finally remembered and came running, but someone else had goofed too, the bus was already gone. So there I was—two A.M., cold and wet on the empty platform of a godforsaken town in the Washington boondocks, not even a cup of coffee, the train and the bus both gone."

He lit two cigarettes, gave one to her.

"They had to rent us a car, and off we went with me driving because the other guy couldn't. We stopped for breakfast in some greasy spoon and were nearly poisoned. It started to rain buckets. I got lost. We nearly crashed on a Portland parkway. Everything was closed because it was Sunday. The coast train was two hours late, and they didn't have my room reservation. They finally found me an overheated roomette, and after the worst day of my life I went to the

dome lounge for a good stiff drink. Anything to forget that day and that trip."

His cigarette was a point of red light in the dark.

"I sat with that drink and suddenly I realized that it hadn't been the worse day at all. It had been the best day, the best trip. I'd been places I'd never seen. I'd seen sights I'd never seen. Those rolling brown hills of eastern Washington. The Snake River where it meets the Columbia, and all the way down the Columbia for two hundred and fifty miles. The high dams. The old river towns. The Indians fishing for salmon. The same river cliffs Lewis and Clark wrote about. And the whole way down the river the peak of Mount Hood ahead looking like pictures of Fuji in Japan. A city I'd never seen before, empty on a wet Sunday so I could walk around and see more than at any other time. A wonderful trip."

Her cigarette glowed hot, faded in the night.

"This time," he said, "I was stranded, stood up for dinner, a whole wasted day. Now there's tonight, you and me. The best day. If that buyer hadn't cancelled I wouldn't be here. We'd never even have met."

"We can go somewhere later," she said. There's a new disco at the Santa Barbara Inn. After the concert we can dance and dance."

"I'll stay over. At least a couple of days. After my salesmen leave. Maybe I can stay a week."

"Ted never stayed over anywhere," she said. "He didn't care about the white hart of Henry the Third. He didn't know what I was talking about. There are no white harts or kings, not for Ted."

"Play for me," he said. "Get your cello and play for me just like we are. You and me and the music."

White against the gleam of the curving cello between her naked legs. Her thighs open for the instrument. Shining wood and full, swinging breasts in the dim light. Enormous between her legs. The bow, thrusting. Dark sound and white thighs and the glisten of polished wood.

The white hart enormous in her. She watched the knight rise on his great white horse above the ancient forest. She raised her arms and

opened herself. Mounted, Thomas de la Lynd rode the white horse in the bright dark forest, the white hart across his saddle. Naked.

She rode the great horse through the green and swaying trees. Alone on her flying horse with the king and his court in hot pursuit. The shafts of sunlight that smoked with the dust of the forest. A silent forest the texture of the silk of Cathay, the spun gold of the distant land of Prester John. The ferocious forest. I am a hunter, Sire. There must be a result. *The hunt must have its end, or what am I? A hunter, Seigneur, is not a clown, the king's jester.*

She rode the sunlit forest beyond King Henry the Third. She spoke a strange language she did not know. She passed through an unknown land. Time did not move. Only space. She rode her horse with the sky. An outlaw who lived on stolen deer and clean air. Hunted like the white hart. To be spared with the indulgent gesture of contempt, of mockery. *You have bought them with castles and incense, Seigneur, with ceremonies and village fairs, with the warm rugs of Araby to cover gray stone walls. Made them think they must have silk and perfumes.*

"You're nothing like Ted. I have to stop comparing all men to Ted. Ceremonies and village fairs."

"I'll stay at least through the weekend this time."

"You're nothing at all like Ted. Ted hated the weekends. I ruined the weekends."

"You can teach me to play the violin again. Why not?"

"Tonight I'll play just for you. Ted never looked at me when I played. I'll watch you when I play."

She wore her black evening dress with the high neck and the long leg slit.

The double doors of the reading room were open for the slow-moving men and the women in flat shoes to come from the lobby and the lounges across the small library ante-room to sit on the rows of folding chairs. She waited on the platform with the cello between her legs. Tomorrow she would buy a new dress. The first violinist tapped. The cello tuned warm between her thighs.

Angela and her friends stood in the small library room outside the double doors. Angela had changed into a white dress. The boys were cowboys without horses—jeans, colored shirts and sueded boots, blond smiles. The other girls were triplets in tight pants and T-shirts. She heard the suppressed laughter of the boys among the people coming into the concert. The muffled whispers and the bursting giggles.

She watched him come across the small library toward the double doors into the concert. Watched, and saw him stop. Saw him turn to a shelf and take down a book.

He stood with the book open in his hands as if that was what he had come into the small library room for. He saw that the girl in white, Angela, wore a dress now, short above her bare young legs. He saw her squat to play an imaginary cello, watched the boys tear at their hair and imitate the violent bowing of crazy violinists. He saw the other girls cover their ears as if enduring great pain.

She saw him return the book to the shelf outside the double doors, walk to Angela and her friends, stand among them.

She watched the doors close, heard his laugh above the tenor of the boys, the high-pitched squeals of Angela and the other girls. She lay awake in her bed and Ted went on sleeping, sleeping. Breathing. The breathing of the darkness. Breathing of the audience. She listened to the sound of the night. Footsteps on a soft, wet earth. Her arms thick and heavy. The bow in and out between her legs and her skirt and the bows of the violins and the viola. In and out among the thousand eyes of the room. Where the white hart lay dead. Thomas de la Lynd rode. The king laughed. The hart pranced, trotted with its tail high and mocking. Swung its tail in lewd derision above its broad female hips, protected by the laughter of the king.

She saw him on the lounge couch among the young people. Saw him stand and come toward her across the width of the lounge with an explanation in his quick smile and uncertain eyes.

She stepped out of her black evening dress with the high neck

and the long leg slit. Removed her underwear. Naked in the sudden rising voices of the large lounge. The noise and the loud breathing. The laughter that faded into a long silence.

The bellboy's uniform jacket reached below her knees. In the manager's office someone had already called the sheriff. The sheriff had dispersed the curious and called her doctor. Her doctor explained to the sheriff that it must have been a combination of the tranquilizers he had prescribed for her since her divorce and the alcohol she had had at dinner. The sheriff understood. Her doctor took her home and gave her a sleeping pill. Her doctor told her to leave the light on in her bedroom all night.

He had two martinis at the hotel bar and went up to his room to make a few notes for his sales meeting tomorrow before going to bed. Below, on the beach, the girl in white and her friends danced around a giant fire, their enormous shadows intertwined, capering.

Yardwork

SHEILA GOLBURGH JOHNSON

I T IS THE EYES I can't see that get to me. He is facing directly into the line of cars that stream down State Street in the near noon rush. His forehead is bunched over heavy, pale brows, and he is squinting so hard that you can't see his eyes. Just a mass of squeezed flesh, with two slits. He doesn't look angry. He looks as if he were suffering.

In the same glance I read the cardboard sign he holds up. WILL WORK FOR FOOD it says in red letters on one line. On the next line it says VIETNAM VET.

I turn right into the shopping center and pass him, careful not to touch bumpers with the car that is waiting to exit onto the street. I scan the rows of parked cars for an empty space, but his face is still in front of me, with that awful clenched mass of flesh where his eyes should be. The glittering automobiles blur and shimmer in the tears that flood my eyes.

I blink them away, and turn up another row of parking spaces, all filled. Damn it all to hell, I mutter. It gets worse and worse. I head for the exit at the other end of the lot and turn left at the street that will take me home. Forget the extra stop for fancy rye. It's not worth it. Forget the vet.

The drive home is peaceful once I'm a few blocks north of the

city heading up towards the foothills where I live. I watch the blue flanks of the Santa Ynez Mountains rise in the distance from the brush-covered hills as I drive through alternating swaths of sunshine and shade. But again that awful squint, and the scarlet words, WILL WORK FOR FOOD. My God, don't they get any benefits?

The bushes on both sides of our driveway scrape against the paint of our two-year-old Volvo when I turn in. It is time for the spring clearing. We live so far up in the foothills that our property, never landscaped, blends in with the national forest behind it. But native brush threatens to take over; it has to be cut back every year after the growing season. Here in the Southwest, the native plants grow only as long as there's moisture in the ground. During the long dry season they dig in their roots, curl their leaves, and try to survive. Just as he is trying to do.

John hears the sound of the car and comes out to help me. "It didn't take you long for a Saturday," he says. "Traffic must be light."

"It was just picking up, so I cut it short," I say. And then, because I can't help it, "John, there was this man at San Roque Plaza. He had a sign, WILL WORK FOR FOOD. He was a vet. I wanted to bring him home."

"You wouldn't have gotten home," he says, piling grocery sacks in his arms. "Give it up, Barbara. You can't save the world."

"But we have plenty of work for him to do."

"You can't just pick people up off the street."

"Oh, I know it isn't safe. I didn't bring him home, did I? But isn't there some way . . . maybe take him to the police station and register him first, so that if anything happens . . ."

"There's always a line of men in front of the employment office downtown on Guerrero Street," John says. We walk into the house. "They're registered for day labor. If nobody comes to hire them, they go home."

"John, his face hurt me. The man looked in such pain."

He doesn't say anything. He places the milk and sour cream in the refrigerator and stacks the fresh vegetables beside the sink to wash. "Asparagus already?"

"Yes. Isn't it lovely? It seems to come in earlier every year. We'll have it with salmon for dinner."

I can't forget a face like that. I study faces, because I do illustrations for children's books. It's something I fell into when I penned a few sketches for a friend's manuscript and the editor liked them. Children pass the night with my monsters lumbering through their dreams. I draw ogres and trolls, ice princesses and hairy-eared giants, but they all have eyes. Maybe that is why I can't forget him.

I see him again about two weeks later, at the same spot. It is a weekday. The traffic is lighter and he stands with that bunched face peering into the flow of cars just as he did before. The same sign. I notice a dun-colored tee shirt over muscular arms, shabby but clean blue jeans. I can't bear it. I pull over quickly, fling open the door of the passenger side, and beckon. He climbs in, tosses his sign in the back seat, and slams the door.

"I have yardwork to do," I say. I look straight ahead. "Tree trimming, brush cutting, clipping ivy and pulling weeds. That kind of thing."

I feel him nod. "I've cut my way through jungles."

"There might be . . . ah, some payment. I mean money, as well as food." I curse myself for my clumsiness.

"Thank you, ma'am."

"Do you mind waiting in the car while I pick up one or two things?" Does he *mind*? It has to be better than standing on the curb with his sign begging work from a procession of strangers as they speed by.

"No."

Inside Von's Market, the air-conditioning hits me like a cold wave of reason. I'm going to take him home, to my secluded house in the woods, and show him what to do. Then I'm going to lead him to the shed and give him his choice of weapons. Lopping shears, hand clippers, saws, edgers. There's even a pitchfork in there. And John is at work.

I order a half pound of low-salt ham, a quarter pound of Swiss sliced thin, and a pound of potato salad. I stand in the longest check-out line I can find.

I must be crazy. God knows what his time in Vietnam has done to him. He is *used* to seeing people killed, maimed, cut up. Missing limbs, bloody holes where nose or ears should be. If only I could see his eyes. You can tell, surely, by looking in someone's eyes, if they are sane or not.

I pay for my purchases and walk back to the car. I place the package on the back seat and clamber into the driver's seat. I look at him. "What's your name?"

"Ron Drake. Want my serial number?"

"No. Oh, no." I draw my breath. Is that a joke? I look at him carefully. He looks straight ahead out the windshield, still squinting, or scowling, into the sunshine. This close, I can see the pale, grayish lashes that curl from his lids. His hair is the same color, but it is impossible to tell if it is gray or dirty blond. His hands rest lightly on his thighs.

I have a sudden thought that if I start the car, I am lost. There is no place to go but home. I feel moisture gathering under my arms with a slight itchy sensation, but habit takes over where common sense fails. Or am I trying to prove something? I turn the key and step on the accelerator.

"Nice place you have, ma'am," he says, when I pull into the driveway. It is a relief after the long silence.

"Thank you. My name is Barbara." I drop the shopping bag in the woodbox beside the front door. "Shall I show you what to do?"

"Okay."

I point out the ivy that had sent long runners over the bricks that make a neat walk around the house. I show him the dead limbs on the oaks that need to be cut off, and the bushes that sprang up too close to the house and have to be taken out. I wave at the native grasses that are almost knee high. "You'll want to use a weed whip for that."

"Okay."

I tell him I will have dinner ready for him at six-thirty. "And I'll pay you fifteen dollars an hour, too. Is that all right?"

"Thank you," is what he says.

Still that ferocious squint that hides his eyes. I point to the shed. "All the tools you'll need are in there. It's not locked. If you have any questions, I'll be in the house."

With relief and a kind of glee, I unlock the front door and lock it behind me. John will be surprised and pleased when he comes home and finds our annual clearing chores already underway. Yes, he will complain about the fifteen dollars an hour, he will tell me he could have found a student to do it for less, but he will know that's not the point. John is a kind man, even though he is too cautious.

I put away the cold cuts and potato salad. I can already hear the clicking of shears outside. I go to the glass door in the living room and I see Ron hunkered on the wooden steps made of railroad ties that descend from the patio. The ivy has grown so much over the winter that it completely covers the steps. Methodically, Ron is cutting the tough stems on each side and tossing the leafy vines into a neat pile at the bottom. It is a pleasure to watch him. He has a certain grace and economy of movement that I have never seen before in the casual labor that does our yardwork.

Everyone likes chicken. I decide to make a chicken fricassee for dinner. I get busy slicing onions and carrots, I brown the chicken and mix up the dough for dumplings. Suddenly, a crash outside. That must be Ron trimming the dead branches off the oaks. They hang down from the trunks with all the leaves gone, tapering off in tangles of dead twigs that look like veined hands. They are called witches.

Another crash, and I can't help going to the window to look. As I watch, he carefully places the long pole with the saw at the end on the ground. He starts to pull down the tough ivy tendrils that have climbed up the trunk. If you don't take it off, the ivy will eventually strangle the tree. I forgot to mention this, and I am pleased that he thought of it.

In profile with his blunt nose and bunched brow, draped with the long vines of ivy that fall on him, he looks more than ever like a troll I might draw for one of my picture books. But a nice troll. I always like to think that even though my monsters look frightening, the children know they have kind hearts and would never actually

hurt them. I believe my monsters absorb some of the children's fears of the dark and turn them into something they can recognize.

With the fricassee bubbling away on the stove, I set the table for three. He'll want to wash, I think, and I arrange fresh towels in the bathroom. I fill a glass with ice for John's usual Scotch, and wonder what our guest will drink with dinner. I look out the windows in back and don't see him, but I can hear the rhythmic snap of cutting shears. I unlock the front door and there he is, his back to me, trimming the hedge that lines our front walk.

"Ron!" I call softly, not wanting to startle him. He is so intent on his work, or so absent, that he doesn't hear me. I walk up behind him. At that same moment I step on a branch that snaps beneath my shoe, I call "Ron!" a little louder.

So swiftly that my eyes cannot follow his movement he whirls and faces me, knees slightly bent, hands brandishing the shears upward, their sharp, gleaming blades aimed at my face, their pointed tips a few inches from my eyes. My tongue goes dry in my open mouth and I cringe. Then every muscle locks, and I am unable to move.

He thrusts his head forward and I can see the glint of blue eyes in that fist of a face. They look crazed like the finish on certain ceramic glazes that play havoc with light.

His mouth twists in a grimace and his voice is a snarl. "Did I frighten you? Did you think I would cut you?" He shakes the shears at me. "Don't you think I've had enough? Would I hurt one more?" His tone drops to a whisper. "What will convince you?"

He stretches one hand around both handles of the shears so that the other is free. He holds up his empty hand, fingers and thumb stretched wide. He places the end of his thumb in the mouth of the gaping shears, and I choke a ragged sound through my dry throat. He cuts off the tip.

In the long hush I hear the wind rustling the leaves and the sound of John's car pulling into the drive, but I am transfixed. I watch the pale face of the wound turn pink, then scarlet, then bloom like a poppy and spill crimson petals to the ground.

The Man Within

SHELLY LOWENKOPF

ASHER COULD NOT bear to face those assembled in the room although he knew as he cast his eyes down that his gesture would be mistaken for modesty. Let them think what they would. He feigned preoccupation with his notebook, cheeks smarting from the rush of blood.

"Our congratulations to Mr. Asher," Ms. Cash said. "His triumph is a lesson to all of us."

"A story," Naomi Bloom said. "A story would have been better. There's something elegant, even noble about a story."

Asher winced.

Ms. Cash stepped from behind the lectern smiling and assured, her paisley scarf a jaunty reminder of her good taste. "I agree with you, Mrs. Bloom. A story is a wonderful form, but the essay is no less valid a literary creation—and Mr. Asher does have a poetic turn of phrase. Which publication is it, Mr. Asher, that has accepted your article?"

He could not bring himself to look at Ms. Cash. "The—"

"Speak up, please, Mr. Asher."

"*The Tri-Counties Senior's Reader.*"

Ms. Cash nodded and presented a fine jaw line that Asher had heard many of the women in the group describe with envy. "Please

bring in a copy when it appears. I'll post it on the bulletin board so everyone who comes to Casa Jocasa Senior Citizens' Center is able to see what fine work our writing group does."

"*The Tri-Counties Senior's Reader,*" Naomi Bloom said. "Isn't that one of those throw-away papers?"

"They have good two-for-one coupons," Ira Blau said.

"You have to wonder about their taste," Naomi Bloom said. "It's a far cry from *The Paris Review.*"

Ms. Cash spread her hands. "I think," she said, "this is a good time for a break."

Treating himself to a coffee at the Golda Meir honor bar snack shop, Asher was trying to fend off congratulations from some of his classmates and regain a semblance of composure when Ira Blau appeared, his owlish eyes refracting admiration through thick glasses with somber black frames. Blau's grin was bigger now than when Asher, counting on Blau's inability to keep a hold on exciting information, had told him about the acceptance by *The Tri-Counties Senior's Reader.*

"You old finesser," Blau said. "Don't ever try to get me into a card game with you."

"What finesser?"

"I see right through your stratagem, Asher. You used me. You got me to tell Ms. Cash. That way, it wouldn't seem like it was coming from you." He winked. "All in the noble cause of love. For that I don't mind."

Asher watched him, noncommittal. He took a sip of coffee. Could he have underestimated Blau?

"From the very beginning your plan worked. How can you be so calm about it now? She practically threw herself at you. Did you see how she stood up for you? Only a fool could fail to recognize—"

"Blau, what are you talking about?"

"Janet Cash. Your plan to enlist her sympathies—your plan to— You are a very devious man, do you know that?"

"And you," Asher said, "are a lunatic. Cash is married."

"As my grandchildren are fond of reminding me, this is the Nineties we're living in."

"Happily married. And even if she were interested, I have perhaps twenty years' head start on her."

Blau shook his head. "I didn't realize she was so old." Then his eyes blinked in recognition. He took a gulp of air. "A day late and a dollar shy, but now I get it." His voice rose with excitement. "Naomi Bloom."

Asher grabbed for Blau's collar, missed, and grabbed again for his arm. "I swear it, Blau, if you say so much as a word to her—if you say a word to anyone—"

"You're not interested in Ms. Cash at all, it's Naomi Bloom you did this for."

At his first sight of Naomi Bloom, Asher set down the coffee he had been drinking at one of the three window tables at Langer's Bakery and Deli. He grabbed at his chest as though he had been wounded. Indeed, Kroll, who had a small coffee in the same building as Asher, and with whom Asher now sat engaged in a game of chess, was moved to ask if the problem was with Asher's heart.

"It may well be." Asher moved to the door and thrust forth into the sunny late afternoon in the direction Naomi Bloom had taken toward the upper part of Milpas Street, where ethnic diversity and small mom-and-dad ventures such as Langer's had begun to lose out to the encroachment of urban renewal.

A short woman with shiny auburn hair wound into a shape reminding Asher of a round knotted loaf of egg bread, Naomi Bloom exuded purpose, striding with shoulders back, head at a defiant angle.

Asher had not the slightest notion what he would say to her, only that he must say something. Perhaps it would be to explain to her that an area of himself of which he had at best a scanty knowledge had seemed to open up at the sight of her as she passed the window of Langer's in an A-line dress worn over black Danskins tights, bright violet socks and an equally intense pair of pink Reebok aerobic shoes.

But even this inchoate strategy was doomed by Asher's discovery that Naomi Bloom had been fast enough to move beyond his vision.

He waited for several moments, hoping to see her emerge from one of the shop fronts. After a time, some inner voice told him his quest was hopeless and the outer voice of Willie Langer wondered at some volume if Asher wanted he would put his unfinished Danish in the refrigerator until tomorrow.

Dispirited, Asher returned to his table and sank into his chair. "Tell me I wasn't dreaming."

"You weren't dreaming." Kroll moved his knight to a point where he had a particularly powerful fork on two of Asher's key pieces. "That was the answer. What was the question?"

"That woman who passed. I don't know when I've ever seen a more remarkable woman. She made me realize something I'd completely overlooked."

Kroll grinned. "Speaking of overlooked—" He used his strategic knight to take Asher's rook. In celebration he swirled the last of his cheese Danish into his coffee and plunked it in his mouth. "You mean Naomi Bloom?"

"That's her name? Naomi?"

Chewing, Knoll nodded.

"Is she married?" Asher brought up his own knight to take a pawn.

"Not a very good exchange, a pawn for a rook. So. Naomi Bloom. She made you realize you are a man?"

Asher felt his face redden. "What's wrong with that? By the way," he said, "that's mate in three moves."

Kroll studied the board, swore. "She's in her mid-fifties."

"But her body is like forty-five."

Knoll dabbed at his jowl with a paper napkin. "A widow. At least three years. He was some overachiever from L.A." His eyes flickered with revenge. "A CPA. His ticker gave out."

"Not all accountants are Type A personalities," Asher said evenly.

"Is that so?" Kroll nodded. "Okay, you give me a fact, so I'll return the favor. Mind you, I have no first-hand information, but there are reasons to believe she has a lover."

"This calls for a celebration." Asher motioned to Willie Langer for fresh coffees and baklavas for himself and Kroll, who began

shaking his head, not at being stood a round of coffee and pastry but at the larger issue. "I don't get it," he said. "He comes down here in his usual lugubrious fashion for a game of chess. In the space of minutes, he sees the woman of his dreams, he learns she may already have a lover, and he's suddenly pleased with life."

Asher made a dismissing gesture, "Competition is nothing to me. It's the opportunity I'm interested in."

He began to spend more time at Langer's, hoping for another glimpse of Naomi Bloom, at first lingering over his coffee and *Wall Street Journal,* then lapsing into handwritten correspondence with a favored nephew at the Wharton School of Business, and finally extending to first drafts of tax forms or business plans for clients.

Waiting for the reappearance of Naomi Bloom, Asher even began to skim volumes from a Great Books by Correspondence course he'd enrolled in, underlining passages with relevance for him in a bright yellow highlighting pen and making notes in his crabbed Spencerian hand on the backs of old ledger sheets.

This could all have been done from his apartment, the master bedroom of which had been furnished with a long table from Cost Plus Imports and numerous shelves and institutional chairs from a used school furniture shop in Ventura. But going to an office was the habit of a lifetime. While clients seemed to come to him rather than his seeking them, Asher was still not at the stage where he could with comfort pursue life from his residence.

The one time Asher remained in his office to work on a quarterly tax report, Naomi Bloom actually entered Langer's, directing Willie to a complex order of sandwiches and salads. Asher arrived just in time to see her leave, her purchases thrust into two net bags from which protruded the necks of wine bottles, a long loaf of French bread, and bright splotches of Gerbera daisies.

From this circumstantial evidence Asher knew with a jealous ache that Naomi Bloom was going to meet her lover.

He set forth at a discreet distance as she moved toward the industrial tract on lower Milpas, puzzled by her destination until he realized there was a short cut across undeveloped flatlands and railroad sidings, leading to Cabrillo Boulevard and the beach. The trou-

ble with following her, even at a great remove, was the openness and a lack of other persons on foot, inviting her suspicion if not outright discovery if she should see him.

Torn between his interest in watching the rhythmic undulations of her hips and his curiosity at seeing the man whom she was going to meet, Asher shortened his stride and tried to feign interest in the railroad tracks, as if to legitimatize his presence and dilute some of the prurience from his purpose. After some time he saw a man of about his own height emerging from behind a windowless tar-papered shed and set off on a course that would intercept Naomi Bloom.

Asher felt stirrings along the lower regions of his spine. Even though it was impossible for the intruder to see with any exactitude the contents of the string bags Naomi lugged, it was easy for Asher to imagine the man, probably one of the street people or transients who frequented the area, seeing Naomi's bags as a target of opportunity. Stepping up his pace, Asher moved forth with the adrenalined certainty of a confrontation. Just as the man was on a collision vector with Naomi, so too did Asher set forth, thrilled with the thought that he would formally meet her as her rescuer.

The man wore a duckbilled cap and a formless khaki jacket that flapped behind him. He called out to Naomi Bloom, who stopped in her tracks, turning to face him, letting the bags slip from her hands as she extended her arms.

Asher watched, a shard of agony flashing through him like a crackle of lightning on a summer evening. This was no goddamned assault on Naomi, no street person literally stealing groceries from a helpless widow; this was Naomi Bloom's lover, clasping his arms about her waist, his hands now taking large bold portions of those very buttocks Asher had not long before begun to admire.

The sight of Naomi Bloom with the man in the duckbilled cap told Asher much of what he wanted to know about her but more than he was able to bear with calmness. He turned away from them, sat on the sun-cracked adobe soil, removing an imaginary rock from his shoe, looking over his shoulder at what he considered appropriate intervals to see if they had parted from their greeting. After several minutes, the couple was underway again, each carrying in their

outer arm one of the bags of provender for the picnic, their inner arms wound about each other.

Asher replaced his shoe and set forth after them at a careful distance as they headed for Cabrillo Boulevard and the park extending along the beach, thinking the site for the picnic might be at one of the wooden plank tables scattered in the area beyond the volleyball courts.

He soon realized they meant to continue around the slope of foothill directly west of the old cemetery to one of the many small secluded coves between the cemetery and the Biltmore Hotel. The man who could spot Kroll the smaller triumph of his knight fork in order to engineer a larger plan, Asher moved out onto Channel Drive, then took the steep road up past the front of the cemetery, arriving at the crest of the hill from which he could see the ocean. More important, he had a good view of the coves on the beach below, and a place to watch from which he had little likelihood of being seen.

Turning up the collar of his thin sports coat, Asher settled in to watch the sun, hurrying to its nadir over the section of Santa Barbara called the Mesa, and to wait for the two picnickers.

When the lovers came into view, they continued to clasp each other about the waist, a fact that was beginning to give Asher pangs of jealousy, until it became apparent they were not in agreement about the precise site for the picnic, the man wanting a large segment of conglomerate that had once been a wall somewhere and had years since been dumped here as a breakwater to protect the hill above them against ravages of incoming tides. Naomi wanted a spot farther back, where they could lie in the sand. Asher was beginning to think he would have sided with her.

A compromise was effected at a spot agreeable to both of them as a half-way mark. The man spread a large cotton blanket. Naomi placed the Gerbera daisies in an empty bottle and began removing from a series of small containers the feast Willie Langer had prepared. Using a corkscrew on his knife, the man opened a bottle of wine, then poured two paper cups. When he handed one to Naomi and tipped his against hers, she grew playful and knocked off his cap, again inciting Asher's jealousy. When he saw how Naomi's lover

combed his long bushy sidelocks to cover an advanced stage of male-pattern baldness, Asher felt more charitable considering his own less pronounced bald spot and receding hairline.

He settled in to wait, not precisely sure what he was waiting for. A growl in his stomach reminded him that whatever it was he sought to discover, he would be better able to cope with it if he had one of Willie Langer's roast beef sandwiches on thick rye bread, with Russian dressing. The secret, of course, was a layer of coleslaw between the bread and meat.

As the sun continued its downward arc and caused long shadows, Asher watched in mounting fascination as Naomi and her lover, seated close together, exchanged bits of the feast and sipped wine. At one point, as they playfully tossed olive pits first at each other and then at marauding curlews and godwits, Asher understood that they were waiting for some semblance of darkness in which to make love. Now he was faced with moral and aesthetic dilemmas—whether to stay or leave before the onset of their activity expanded from its current culinary foreplay.

His first attack at the problem came in the form of closing his eyes, imagining it was he who was now dining with Naomi Bloom, his insensitivities being assuaged instead of those of the semibald man. This approach became so successful that Asher was undone. Leaning back against the sheltering side of his perch, offering Naomi Bloom a dream-cast messalina olive which she put between her teeth and then dared him to remove without, of course, the use of his hands, he promptly fell asleep.

Asher underwent the hazy erotic sleep of a man transfixed, bewitched, entombed in his own needs. He was aware of the fall of darkness and the distant tinkle of laughter mingled with the cackling sound of the retreating tide over a floor of small rocks.

Ultimately the membrane of sleep was broken by the sense of the celebration below being over and a new resident attitude prevailing—anxiety. Asher opened his eyes, momentarily disoriented, knowing only that he was cold and hungry. A woman's voice came out of the darkness behind him. "If I miss that bus—"

A man's answer was gruff and indistinct.

"It's you and your overweening pride," the woman countered.

Asher stood rooted to the spot as Naomi Bloom stormed by, not twenty-five feet away, her wispy hair bedraggled. The man with the duckbilled cap followed, lugging the remains of the picnic. They crossed the Channel Road, heading toward the bus stop.

"I shouldn't have to put up with this, Harvey," Naomi Bloom said. "I get it from you on one side and the kids on the other. I'm too old for this kind of game. I shouldn't have to sneak home. I should be able to come and go as I please."

At first Asher could not make out the man's response. Naomi Bloom, who could make it out, took exception to it. "What?" She said, turning on the man. "What did you say?"

Asher, positive she was looking directly at him, sought refuge in the shadow of a tree.

"I wondered," the man said, "if you thought you were some kind of Emma Goldman with your goddamn independence."

"That's what I thought you said." Naomi Bloom wrested a string sack from him and extracted a flute of French bread, which she brandished, swordlike, advancing at him. "Mr. G. Harvey Bigshot has his own car, but can he use it to take his girlfriend home?"

"We talked about that, Naomi. That car is my home. I don't drive it, I sleep in it. I work in it."

Naomi poked the man in the sternum. "I can't live like this anymore," she said, "and stop telling me to calm down. You *always* tell me to calm down. If you're so interested in a calm girlfriend, go find one and let *her* take the bus home." She said this as the bus growled up the grade and veered in toward the curbside at her signal.

"You'll come around," the man said as Naomi Bloom boarded the bus. "Mark my words. Two, three days without, you'll be happy to see me."

Naomi Bloom swept her skirt about her and boarded the bus, pausing in the entry well. "So for two, three days, I'm a free woman. Get lost, Harvey."

The bus whisked away, accelerating up the grade as Naomi Bloom's lover stood in its wake, muttering to himself and then declaiming to the cosmos. "Ungrateful broad. You'll rue the day."

Standing in the shadows, Asher was nearly tempted to answer on her behalf.

The next day Asher was at Langer's, pantomiming a description of Naomi Bloom, asking impulsive questions about her in a manner uncharacteristic of him—incomplete sentences. "That woman. Yesterday. The picnic. Naomi Bloom."

Willie Langer gave a broad wink while folding spindly arms on the deli counter. "It is said she lives with her children."

"This is not an exercise in Talmudic argument. *Where* does she live with her children?"

"You want to deliver her next picnic, is that it?"

"Goddammit, Langer."

A look of confidentiality came into his face. "Well, I tell you, Asher. A clever man like you, he could probably make important discoveries at the Casa Jocasa."

"That's—that's a senior citizens' center."

"You see," Willie Langer smiled. "Already you have learned something."

Half an hour later, Asher was in the Casa Jocasa, a large cinder-block building with a thick coat of Navajo white paint, numerous trellises, flowerpots, and other indifferent or whimsical attempts to somehow look like part of Santa Barbara's Spanish heritage. After paying a birdlike woman with close-cropped hair four dollars, Asher was given a Casa Jocasa membership card and led to a large bulletin board which bore a hand-lettered sign, ACTIVITIES. Here he soon discovered that Naomi Bloom was indeed a member, enrolled in the Tuesday night Great Books of the Western World Discussion Group and the Thursday night Creative Writing Group.

He bought a spiral-bound notebook and a copy of *The Poetry of Robert Browning,* both of which he carried as props that first Thursday night. Freshly barbered, wearing neat khaki pants, a checked shirt that had been steamed into submission, and a gray herringbone jacket, Asher took the added measure of applying Lilac Vegetal after-shave.

The writing group met in the David Ben-Gurion room, which may have been the living room of the residence that had become

Casa Jocasa. Asher arrived early and stood about the entryway, hopeful of being able to sit next to Naomi Bloom and make an auspicious beginning. But when Janet Cash called the class to order promptly at seven, Naomi Bloom had yet to arrive. Asher was drawn to the front by Janet Cash, so that she could introduce him to the others. He was placed next to Ira Blau. An empty chair remained on Asher's other side but it was soon taken by Mitzi Berlin. Well after Asher's introduction, Naomi Bloom swept into the room and settled noisily into a seat in the rear as Ms. Cash was commending the so-called little or literary magazines to the attention of the class.

Asher strained to listen, sensing that others as well were interested in the thrust of Ms. Cash's commentary, but a rather persistent grumbling—or was it muttering?—seemed to become a counterpoint, issuing from the rear of the room. Mitzi Berlin puckered her face in distaste and hissed for quiet. "The literary critic," Mitzi Berlin whispered to Asher. "Always with the comments."

"Who?" Asher mouthed the word.

"You're new. You'll see," Mitzi Berlin nodded.

"I think it might be helpful," Ms. Cash said, "if we all stood, took a few deep breaths, and stretched."

Mitzi Berlin sneered. "A minor in psychology. You can always tell." When she saw Archer was puzzled, she explained. "The teachers they send here, regardless of the subject, you can always tell when they minored in psychology. Whenever there's a disagreement or someone asks an embarrassing question, they want you to stand up and stretch. Unkefer from the ceramics class? A psychology minor. Conrad from life drawing? A psychology minor. Only Lynds from Szechwan cooking and Shelton from Exploring the Film Noir don't make you get up and stretch."

During the break, Asher approached Naomi Bloom, his heart aflutter as he introduced himself. This was as close as he'd been to her; wisps of hair fell in random array about her angular face, her topaz eyes blazed, and he noticed a sprinkling of tiny freckles across her upper cheeks and nose.

"Howard Asher," she said. "Big deal."

Asher was positive he was in love. He noticed flecks of grass on

her skirt. It had been four days since her picnic with the man in the duckbilled cap.

After what he had already begun to think of as The Debacle, Asher sought to buffer the sting of his misdirected debut as an author by going to Riparetti's, a neighborhood bar near the Casa Jocasa. Some solace was due. Not even Naomi Bloom's approaching him after class had a positive effect.

"I should not let personal attitudes influence my response to your news of publication," she told him. "I am undergoing what you might call the trauma of withdrawal and I lashed out at the closest thing. I am an emotional woman, yes—but not inconsiderate."

At Riparetti's Asher cursed his own shortsightedness. Why had he not invited her for a drink? Why had he not asked her about her own reasons for taking Ms. Cash's class?

"Was that yes or no to another drink?" the bartender asked above the blare of a jukebox loaded with the Latino equivalent of Country Western.

"What?" Asher said.

"Yes, sir. One Coors, coming up."

Asher did not want the next beer. Nor did he want the three others to follow, but the litany of complaint about his failure to recognize splendid opportunities served to blunt his defenses to their arrival. Midway through the last beer, it came to Asher that a course of action was still open. The seven-block walk to the residential area where Naomi Bloom lived with her son, his wife, and their children did nothing to blunt his resolve and in fact gave him the opportunity to try out his gambit in the intimacy of the chilly, overcast night, giving his voice a husky cast.

Naomi Bloom lived in an older neighborhood, where mature stone pines and jacaranda buckled the sidewalk with their overgrown roots; yards with arbors, trellises, and rock gardens reflected idiosyncratic pride of ownership; it was also an area known for guest cottages or mother-in-law apartments, outbuildings added surreptitiously, even cynically, to produce extra rental income in a city gone mad over property values.

Shambling along Mason Street, Asher found the house he

THE MAN WITHIN • 125

sought and moved by slowly to reconnoiter. A woody swath of flowering pear and oleander separated the house where Naomi lived from its neighbor. The ground was covered with granulated cedar bark, leaves, and the needles from nearby pines. Asher darted for the cover of the oleander, pleased to note he made no crunch or other tell-tale noise. With the exception of a few lights in one of the front rooms, the main house was in darkness, but there, just beyond the garage was a small outbuilding. What might have been a night light glowed dimly in the darkness. As Asher moved closer, he made out the somber excesses of the second movement to Tchaikovsky's symphony, the *Pathétique.*

It was a small building, probably one large room, a modular stall shower and toilet in some convenient corner, a modest closet, and the thing that would make it especially illegal in Santa Barbara—a small kitchen.

Asher scooped up a handful of cedar granules and tossed one at the window. With a speed that startled him, the door opened. Naomi Bloom appeared, framed in the dim light. She spoke in a whisper. "You've got a lot of nerve, coming here."

Asher brought his reply down to the same conspiratorial tone. "I had to see you."

"Sure you did."

"You don't understand," Asher called across the night dampness.

"I understand plenty. It's seven, eight days, the shoe's on the other foot, now you're the one with the itch. I've told you. No more. I'm free of you. I don't look back."

Asher tried to inject a plaintive, needful note. "I'm not who you think I am."

"Who among us is what the other thinks. I got that right out of the used-book store edition of Sartre you gave me for my birthday, you cheap son of a bitch."

"It's Howard. Howard Asher."

Naomi Bloom broke all pretense at a whisper. "Oh, for Christ's sake."

A floodlight erupted into life at the rear of the main house. "Mama," a reedy male voice called. "Are you all right?"

Naomi Bloom lowered her voice. "Quick," she whispered. "Get in here." She opened the door and stood aside. Asher burst from his cover and reached the door in several strides, running low. As he passed Naomi, time seemed to suspend. He was aware of her hair, longer than he'd ever seen it; she wore a simple flannel gown, and smelled faintly of lavender.

He was not expecting a comfortable reading chair near the door nor its companion footstool, which tripped him and brought him down in a heap about six feet beyond her on a large braided rug which skidded with his momentum. "I'm fine," Naomi Bloom called. "Nothing more than one of those radio call-in shows I like."

"You're sure, Mama?" the reedy voice persisted.

An edge came to her response. "I'm positive, Marshall. You should only be so positive about your own activities." She paused for a moment and sighed. "Thank you for asking."

Asher clambered to his feet. Closing the door, Naomi Bloom turned to him, giving him the same critical scrutiny she used when considering the purchase of a Sabbath chicken. "What are you doing here, Asher?"

Before he could answer, she shook her head. "I know what you're doing here. It won't work. I've already been married to you—and you died, three years ago. Why should I make the same mistake with you again?"

"I'm not the same," Asher said. "I swear it."

"An accountant, no?"

"An accountant, yes, but different."

When Naomi Bloom hooted, Asher advanced, reaching for her hand. "That man with the duckbilled cap. Are you really through with him?"

Naomi yanked her hand free. "What do you know about him?" She made for the edge of the hide-a-bed, protruding from a sofa like an extended tongue. She sat, seemed to consider this was an invitation for him to sit next to her, rose, and made for the reading chair.

"I followed you."

Naomi laughed, but Asher was enough pained by its ironic note

to know it was not the combustive laughter of conciliation. "Why me?" she said.

"I don't completely understand it yet, myself."

"I'm not asking you," Naomi snapped. "I'm asking the cosmos. You think you're Mr. Different? My husband followed me until he wore me down. That man with the duckbilled cap, as you call him, G. Harvey Prell, he followed me, sometimes with tears in his eyes until I gave my heart to him. Do you know who he is?"

Asher shook his head.

"No, of course you don't. That's the way he wants it—nobody knows but me."

Taking a canvas-backed director's chair from the small dining table, Asher sat, fascinated as Naomi Bloom spoke of Prell's one hundred sixty-seven appearances in literary and quality magazines with short stories of bitter, minimalistic irony, and his fabled reputa-tion, already causing printed speculation from the academics. "He signs himself G. Prell. The G is for Gershon, but using just the letter like that makes him feel a kinship to B. Traven."

"I'm sorry." Asher asked.

"At least you're honest, Howard Asher. B. Traven was a writer, a secretive, misanthropic man who valued his privacy above all else." She paused for a long sigh, examining her bare feet as though there were some existential instructions for happiness printed on them. "Sometimes when Prell had too much wine, he would—"

"Yes?"

"He would put his head in my lap and tell me he felt like he is the Jewish B. Traven." She spoke of Prell's past. "Once he owned a chain of motels, all up the coast. Ventura, San Luis Obispo. Atascadero. Monterey. A wife and three children. Then he read *The Moon and Six-pence*. The character Charles Strickland, who was based on the painter, Gauguin, you understand, spoke to him and then Harvey knew what he must do. Now he lives in a black 1978 AMC Pacer and types his stories on a manual typewriter he found in a pawnshop." She watched Asher with suspicion. "My husband felt an ideological affinity for John Maynard Keynes. Who speaks to you, Howard Asher?"

"You do." Asher was suddenly aware of bright light from the

outside, and the voice of Naomi Bloom's son. "Mama, is everything okay?"

Naomi shook her head. "How can anyone say there is no ruling force in the universe when there are sons who feel the need to do this one or more times a night? How can anyone speak to the randomness of nature when of all the possible choices available to him, my son marries a woman named Ruth?"

"Are you all right, Mama?"

Naomi pointed to the small two-doored closet near the stall shower. "In there," she said.

Asher took refuge in a darkness suffused with a combination of cedar fumes, lavender sachet, and a musky aroma that was probably pure Naomi, given off from her clothing. He was aware of the pounding of his heart and the sounds of his own breathing. A wave of excitement spread over him.

"Well, Marshall, now what is it?"

"Ruth was worried."

"Only Ruth, not you?"

"We want you to be happy."

"Do you have any idea what it would take to make me happy, Marshall?"

"Look, Ma, I know things haven't been easy for you since Dad died—"

"That's what you think? That's all? How about this? How about my having a life of my own with friends of my choosing?"

"A trip. They have these lovely seniors cruises you take with people of like interests."

Naomi trumpeted scorn. "A seniors tour to some godforsaken place, jammed in with a bunch of old barracudas who line up an hour early for the buffet?"

"It's important to keep active at your age."

"Marshall, it comes to me that you are torn by the ambivalence of wondering if I have a gentleman friend hiding under the bed and hoping that I don't."

"Mama, that's not fair."

"I'll show you fair. Here, look."

Asher heard the sound of springs compressing and realized Naomi was lifting the hide-a-bed.

"There. No one. You see? No one. Now please go back to your earnest wife and your concerned children and tell them I am safe and secure, maintaining a healthy interest in my surroundings thanks to the miracle of talk radio. I am even thinking of raising tropical fish and possibly knitting or crocheting."

"Mama, that wasn't necessary."

There was an awkward silence during which Asher was fearful his breathing would be heard. In the close fragrant excitement of Naomi Bloom's closet, he had a protracted sense of embracing her in the darkness.

"Mama, what is it? Why are you looking that way?"

"You're absolutely right," Naomi Bloom said. "None of this is necessary. I shouldn't be doing this, not any of it. I should be my own person in surroundings of my own choosing."

"When Dad died we agreed—"

"You agreed. You and your brother and sister agreed—and in what I thought was my grief, I let you do it."

"Mama, there's no need to shout. Everything is all right."

Naomi Bloom laughed. "Have I got news for you, sonny boy. Sit down. For this, you'll need to sit down. No? You won't sit down? Then take your enlightenment standing up." Her voice raised. "Asher, you can come out now."

Asher froze, wondering if any future with Naomi was at stake on this cast of her whim. Should he emerge now, or let her play out her gambit?

"You've made your point, Mama. I'm going now."

"Marshall, I am deadly serious. At this very moment there is someone in my closet, a man named Howard Asher who has an enormous erection and who wishes to become my lover."

In the darkness, Asher erupted in a grin.

Jeannette

GAYLE LYNDS

S HE LIKED TO MOVE through life unnoticed, and for that
she needed respectability. She wore attractive clothes, but
not alluring. She was married to a young professional.
She had two sons who caused few problems and earned adequate
grades. She was a patient and devoted daughter.

Then, two months ago, she took a lover. They met in Montecito
in a cabin under towering oaks.

"I want you," he said.

"I want you," she said.

"You're going to be trouble."

"What does that mean?"

He held her close, his breath warm and sweet. He was long and
muscular, his hair thinning, his eyes intense. He smelled of sex. Life
was one long cliche.

"You don't know, do you?" he said.

In the foothills above Santa Barbara, she did the dishes, swept the
floor, drove on field trips for her sons. She kept the house tidy, the
meals nutritious, and the yard fertilized and clipped.

She saw her psychiatrist.

"Can you give him up?" he said.

He was portly, dignified, wise from other people's problems. His own marriage was falling apart.

"I can't. I won't."

"And your family?"

"I'm not ready to leave them."

"What will you do?" He watched her curiously.

She looked at her hands. "See him secretly."

She was tired when her husband wanted her. Exhausted when he kissed her. Dead to the world when he touched her. He was puzzled, then hurt. He had wet dreams at night and she changed the sheets in the morning.

He told her his other dreams.

"I had a dream last night," he said, "about rowboats and fish, but I couldn't find my gear. The fish jumped into the boat and out again. I wasn't fast enough to grab them. What do you suppose it means?"

"I don't know," she said.

He had put on weight, and lines were beginning to etch his face. He walked with trust through life. He preferred it to reality.

"I wish I could tell you," she said, "but I just don't know."

She wrote short stories, stories that seemed to come from nowhere. They left her feeling exhausted and out of control.

She showed them to her lover.

"You're not thinking," he said. "You're lazy. You have to think hard about what you really want to say. Listen to yourself. Know what you think."

"I don't think. I feel."

She went home, sat before her typewriter, hands folded in her lap. She wanted to write another story. It was close to her, closer than her own skin, but she was afraid to find the words.

She went shopping in El Paseo, looked for fabrics that were smooth to touch, for tailoring that showed her figure. She smiled at sales clerks and talked with friends.

In her house, she heard the telephone ringing.

"Will you come home this summer?" Her mother's voice was sweet, distant, an echo of her own.

"I'll try."

"I'm old," her mother said. "I just realized it. I got my first Social Security check."

She explained, "The boys have baseball and soccer camps this summer. Then we'd planned to take them to Europe. Our first trip. All of us together. A family."

"People stand up and give me their seats in the doctor's office," her mother said. "When I was there, I looked in the mirror by accident and saw this old woman. White hair. God, she looked awful. It was me."

"I'll try to come home, Mama."

She wrapped her respectability around her and went to parties on the arm of her husband. He talked to men. She talked to men. Women didn't interest her. She ate canapes and drank blood-red wine and thought about her lover and her short stories.

She stood beside a man who smiled at her then looked off above her head.

"I heard an owl behind our house last night," she offered.

"I understand you write," the stranger said, his gaze settling on her. "I took literature classes in college. I wrote, too, and all my friends said my stuff was good, but nobody would buy it. My friends lied." He looked at her. "They didn't want to hurt my feelings."

"Maybe they didn't know. Maybe you didn't. Maybe the editors didn't."

He laughed. "I didn't know then, but I know now."

"What did you do?"

"Quit. It was the only sensible thing to do."

"I see."

He spread his hands, looked at his new wedding band. "Of course I'm not always sensible. Otherwise I would've got my divorce ten years ago. So much wasted time, Jeannette. Every time I walked into a room with her, to a party like this, I'd look around and wonder why I wasn't with this woman or that woman or any other woman." He shook his head. "I'll never live like that again."

"How did you feel?"
"Terrible!"

Her elder son awoke in the middle of the night with stomach flu. Green-faced, confused, he couldn't find the bathroom.

She held his head and sang to him and tucked him into his bunk.

"You're the best Mommy in the whole world," he said. He was blond and freckled, in love with her.

She held him close, breathed his hot moist hair. "I love you, too."

Her bathrobe swinging, she walked down the hall, turned out lights. The house's darkness was warm. She thought of her lover and remembered that she liked the smell of his sweat. She thought of her writing, and sighed. The thinking of it was difficult. Only the longing was familiar.

She walked onto the back patio and listened for the owl. No owl that night, but crickets and katydids and the gentle feel of a mountain breeze. The Santa Barbara night was soft and comforting, alluring, a trap.

The next morning she strode past her office and into the family room. She turned off the television, handed sack lunches to the boys, and kissed them out the door to school. She carried their dirty pajamas back to the washer in the kitchen.

"No breakfast for me," her husband said, waited. "Just coffee and you." He pulled her to him, nuzzled her neck.

She felt the solidness of his body, the compactness that gave him a veneer of certainty. She touched his face. He trembled, and she held him tightly, wished she could still love him, wished and feared that he would discover that he didn't love her.

She said, "Don't forget to take the car in."

He dropped his arms, stepped back. "I won't." Went to the door. "You know," he said, "I can't go on living like this forever."

She stood at the window and watched him drive away. She waited in case he came back, her hand on her chest, her heart thundering.

She liked to move through life unnoticed, and for that she needed respectability. She wore attractive clothes, but not alluring. She was married to a young professional. She had two sons who caused few problems and earned adequate grades. She was a patient and devoted daughter.

She sat at her typewriter, hands folded in her lap, and said these things to herself.

The Four of Us

SALVATORE LaPUMA

H E WAS STANDING there like the shower curtain, so straight and still," Lisa says. "And so pale."

Lisa and Ken can't be held accountable for meeting in the bathroom in the dark. But they have to give up on each other someday soon. There's no other choice. Until then, I have to sweat it out. Still, to encourage her to push Ken out the door for good, I say, "Lisa, I'm really tired of Ken coming here."

"When I got up to get a drink of water," she says, "there he was, in the bathroom." Now her face brightens. "But listen, Tony," she says, "he really wasn't *in* the bathroom." She taps a painted fingernail on her head. "It's really in here I saw him, not *in there*."

"Why do you have to see him *at all?*" I say in a voice I usually use when my sixth-graders get out of hand. "At night when *I* go to the bathroom, I never find Jessie in there. Jessie stays exactly where she is. So it's hard to understand why Ken can't stay exactly where he is."

Her orange-pink fingernails gather a sheer stocking into soft folds. She holds the stocking and sits in a chair on her side of the bed, then points one foot into the stocking. Orange-pink are her toenails too. For years, for Ken, she said, she painted her toenails, until Ken no longer noticed them. For me, I said, Jessica, too, had

painted her toenails until I no longer noticed them. Now Lisa paints hers again. And I notice them again.

Weekday mornings Lisa is all business diving into pants and sweaters, rushing off to third grade at Peabody School, where I teach too. But this morning, as on most other Sunday mornings, Lisa, putting on her clothes, is as erotic as a burlesque queen. To move myself closer to her, I drop crosswise on the bed. The bed is from when she was married to Ken. It has a high headboard with an outer rail of walnut rising to a rounded peak. The center is tufted in a small Victorian print. The mattress, too, is great—nice and firm. So when we first moved in together, I didn't say we had to have a new bed. It was where we first made love. And its prior history never held us back.

"It's about the fourth time," I say, "you've seen Ken in this apartment." I try to look serious as I lie across the bed looking at her putting on her stockings. But I'm afraid the pleasure I feel is revealed in my voice. "Lisa, I can't believe he followed you *here*. He never lived *here*. If he absolutely has to come back, I'd think, where he lived last would be where he'd come back."

"Tony, you can't be jealous. It's Ken who has a right to be jealous," she says. "Ken said last night he can't understand why, just six weeks after he was gone, we found each other." In her mid-thirties Lisa still has a child's round face, and when it suits her purpose, like now, she erases from that face all her thoughts and feelings, as from a blackboard, and puts on a mask of child-like innocence. I'm never convinced of her innocence, but I always like to look at her innocent face. It disarms me of my suspicions, which burden me more than they do her.

"The next time you see him, Lisa, why don't you just wake me up," I say and pout. "Maybe, for coming here, I'll take a swing at him." I'm not sure if I'm kidding or not.

"Tony, to get Jessie out of your own head, you had two whole years," Lisa says. "Although, often enough, it seems to me, Jessie, too, is right here. Right here in the middle of our conversation. Do you think I'm *eager* to hear about Jessie? Even those comparisons where she fails, I'm not thrilled to hear about." Now Lisa, too,

pouts. "Instead of two of us, Tony, it's the four of us who seem to live here." Her stockings snapped on, she goes to the closet, undecided between a red blouse to go with a black leather skirt, or a white blouse with a beige wool skirt.

Lisa is solidly in my life. There's no doubt about it. Yet I still want her as if there is still more to want. It isn't that she holds anything back. Everything Lisa is, Lisa gives to me. She even tells me things she didn't tell Ken: when she at twelve broke her mother's antique Chinese vase, it was on purpose; when years ago it was suddenly clear as water to her why her older brother who crushes my hand in a handshake has never had a girlfriend. After Lisa empties herself out, I know a little more about her. The next day she's filled up again with new things to say simply because, she says, "You, Tony, want to hear it all."

The red blouse is it. And I go to button her up just for the pleasure of standing close to her, and to play a part in the show business of her dressing herself. Then, to let in the morning air, I open the windows and prop open one window with a book. From our upstairs rooms in this old Mediterranean-style apartment house from which terra-cotta roof tiles sometimes fly off in heavy winds, I look down on Garden Street and neighbors headed for church.

Then I help Lisa make the bed.

We go out and stroll to Figueroa Street to Angelo's Pastry Shop. At a small round marble table, we peel fresh tangerines and eat cannoli. And have two cups of black coffee each, two cubes of sugar in each cup, laced with a shot of anisette.

Then we amble down toward the beach, toward Cabrillo Boulevard, where, on Saturdays and Sundays, there's something called Sábado Domingo, a lot of arts and crafts. To go for a walk with Lisa is a married thing to do even though we're both uncertain we want to get married again.

We hold hands and window-shop and look around at the tourists. We talk about kids in our classes and try to figure them out. When now we stop at a dress-shop window, Lisa says, "That's a color I like—a sort of peeled peach. Isn't it a wonderful color for summer? I have to get some new summer dresses. Along with Ken's clothes, I gave away most of my own."

"Did you really care about Ken, I mean, a lot?" I say, for the hundredth time.

"Tony, I didn't even kiss another man in the nine years we were married. Yes, of course, I cared about Ken," she says in a low voice, "and deeply too." Then she cheers up to add, "But it was different than it is for us. It wasn't as steamy."

"Do you think, Lisa, that you could avoid seeing him when I'm asleep at night? It sort of bothers me," I say. "I know it's foolish of me, the guy gone and all, but could you?"

"If he shows up again, I'll call you, Tony. And you can tell him to leave. Okay?" To reassure me now, she kisses my cheek. Then we cross the street in front of traffic at the light. "You might even tell him," she says, "he has your permission, if he feels he needs it, to look Jessie up, if he can find her. There must be skillions of souls over there. It must be like at the Rose Bowl, a mob scene. If, in fact," she says, stopping for eye contact, "you yourself can let go of Jessie. And it's *me* you want to spend eternity with."

"For all I care, he can have Jessie. It's just fine with me," I say. But there's a shiver on my spine. It isn't that I still want Jessie. It's Lisa I want. But I'm not sure I want to hand Jessie over to Ken.

"I'm not sure Ken would want Jessie," I say. "She isn't his type. She crunched numbers and only believed in what came up on her screen. Your Ken was an actor," I say with a hint of dislike, "and even now he's trying to steal the show. However, Lisa—and you can tell him yourself—if he wants her, and she wants him, they have my blessing.

"Mine too," Lisa says.

Now she begins to step up the pace. "At Domino's should we have anchovies or mozzarella?"

"Would it be excessive," I say, "to have both?"

She Wasn't Soft

T. Coraghessan Boyle

S HE WASN'T TENDER, she wasn't soft, she wasn't sweetly
yielding or coquettish, and she was nobody's little woman
and never would be. That had been her mother's role, and
look at the sad sack of neuroses and alcoholic dysfunction *she'd*
become. And her father. He'd been the pasha of the living room, the
sultan of the kitchen, and the emperor of the bedroom, and what
had it got him? A stab in the chest, a tender liver, and two feet that
might as well have been stumps. Paula Turk wasn't born for that sort
of life, with its domestic melodrama and greedy sucking babies—
no, she was destined for something more complex, something that
would define and elevate her, something great. She wanted to com-
pete and she wanted to win—always shining before her like some
numinous icon was the glittering image of triumph. And whenever
she flagged, whenever a sniffle or the flu ate at her reserves and she
hit the wall in the numbing waters of the Pacific or the devilish
winds at the top of San Marcos Pass, she pushed herself through it,
drove herself with an internal whip that accepted no excuses and
made no allowances for the limitations of the flesh. She was twenty-
eight years old and she was going to conquer the world.

On the other hand, Jason Barre, the thirty-three-year-old surf-
and-dive-shop proprietor she'd been seeing pretty steadily over the

past nine months, didn't really seem to have the fire of competition in him. Both his parents were doctors (and that, as much as anything, had swayed Paula in his favor when they first met), and they'd set him up in his own business, a business that had continuously lost money since its grand opening three years ago. When the waves were breaking, Jason would be at the beach, and when the surf was flat he'd be stationed behind the counter on his tall swivel stool, selling wax remover to bleached-out adolescents who said things like "gnarly" and "killer" in their penetrating, adenoidal tones. Jason liked to surf and he liked to breathe the cigarette haze in sports bars, a permanent sleepy-eyed, widemouthed California grin on his face, flip-flops on his feet, and his waist encircled by a pair of faded baggy shorts barely held in place by the gentle sag of his belly and the twin anchors of his hipbones.

That was all right with Paula. She told him he should quit smoking, cut down on his drinking, but she didn't harp on it. In truth, she really didn't care all that much—one world-beater in a relationship was enough. When she was in training, which was all the time now, she couldn't help feeling a kind of moral superiority to anyone who wasn't—and Jason most emphatically wasn't. He was no threat and he didn't want to be—his mind just didn't work that way. He was cute, that was all, and just as she got a little frisson of pleasure from the swell of his paunch beneath the oversized T-shirt and his sleepy eyes and his laid-back ways, he admired her for her drive and the lean, hard triumph of her beauty and her strength. She never took drugs or alcohol—or hardly ever—but he persuaded her to try just a puff or two of marijuana before they made love, and it seemed to relax her, open up her pores till she could feel her nerve ends poking through them, and their lovemaking was like nothing she'd ever experienced, except maybe breaking the tape at the end of the twenty-six miles of the marathon.

It was a Friday night in August, half past seven, the sun hanging in the window like a piñata, and she'd just stepped out of the shower after a six-hour tuneup for Sunday's triathlon, when the phone rang. Jason's voice came over the wire, low and soft. "Hey, babe," he said, breathing into the phone like a sex maniac. (He always called

her "babe," and she loved it, precisely because she wasn't a babe and
never would be—it was their little way of mocking the troglodytes
molded into the barstools beside him.) "Listen, I was just wondering
if you might want to join me down at Clubber's for a while. Yeah, I
know, you need your sleep and the big day's the day after tomorrow
and Zinny Bauer's probably already asleep, but how about it? Come
on. It's my birthday."

"Your birthday? I thought your birthday was in December?"

There was the ghost of a pause during which she could detect
the usual wash of background noise, drunken voices crying out as if
from the netherworld, the competing announcers of the six different
games unfolding simultaneously on the twelve big-screen TVs, the
insistent pulse of the jukebox thumping faintly beneath it all. "No,"
he said, "my birthday's today, August twenty-sixth—it is. I don't
know where you got the idea it was in December . . . But come on,
babe, don't you have to load up on carbohydrates?"

She did. She admitted it. "I was going to make pancakes and
penne," she said, "with a little cheese sauce and maybe a loaf of that
brown-and-serve bread . . ."

"I'll take you to the Pasta Bowl, all you can eat—and I swear I'll
have you back by eleven." He lowered his voice. "And no sex, I
know—I wouldn't want to drain you or anything."

She wasn't soft because she ran forty-five miles a week, biked two
hundred and fifty, and slashed through fifteen thousand metres of
the crawl in the Baños del Mar pool. She was in the best shape of
her life, and Sunday's triathlon was nothing, way less than half the
total distance of the big one—the Hawaii Ironman—in October.
She wasn't soft because she'd finished second in the women's division
last year in Hawaii and forty-fourth over all, beating out a thousand
three hundred and fifty other contestants, twelve hundred of whom,
give or take a few, were men. Like Jason. Only fitter. A whole lot fit-
ter.

She swung by Clubber's to pick him up—he wasn't driving, not
since his last D.U.I., anyway—and, though parking was no prob-
lem, she had to endure the stench of cigarettes and the faint sour

odor of yesterday's vomit while he finished his cocktail and wrapped up his ongoing analysis of the Dodgers' chances with an abstract point about a blister on somebody or other's middle finger. The guy they called Little Drake, white-haired at thirty-six and with a face that reminded Paula of one of those naked drooping dogs, leaned out of his Hawaiian shirt and into the radius of Jason's gesticulating hands as if he'd never heard such wisdom in his life. And Paula? She stood there at the bar in her shorts and Lycra halter top, sucking an Evian through a straw while the sports fans furtively admired her pecs and lats and the hard-hammered musculature of her legs, for all the world a babe. She didn't mind. In fact, it made her feel luminous and alive, not to mention vastly superior to all those pale lumps of flesh sprouting out of the corners like toadstools and the sagging abrasive girlfriends who hung on their arms and tried to feign interest in whatever sport happened to be on the tube.

But somebody was talking to her—Little Drake, it was Little Drake, leaning across Jason and addressing her as if she were one of them. "So, Paula," he was saying. "Paula?"

She swivelled her head toward him, hungry now, impatient. She didn't want to hang around the bar and schmooze about Tommy Lasorda and O.J. and Proposition 187 and how Phil Aguirre had broken both legs and his collarbone in the surf at Rincon; she wanted to go to the Pasta Bowl and carbo-load. "Yes?" she said, trying to be civil, for Jason's sake.

"You going to put them to shame on Sunday, or what?"

Jason was snubbing out his cigarette in the ashtray, collecting his money from the bar. They were on their way out the door—in ten minutes she'd be forking up fettuccine or angel hair with black olives and sun-dried tomatoes while Jason regaled her with a satiric portrait of his day and all the crazies who'd passed through his shop. This little man with the white hair didn't require a dissertation, and, besides, he couldn't begin to appreciate the difference between what she was doing and the ritualistic farce of the tobacco-spitting, crotch-grabbing "athletes" all tricked out in their pretty unblemished uniforms up on the screen over his head, so she just smiled, like a babe, and said, "Yeah."

Truly, the race was nothing, just a warm-up, and it would have been less than nothing but for the puzzling fact that Zinny Bauer was competing. Zinny was a professional, from Hamburg, and she was the one who'd cranked past Paula like some sort of machine in the final stretch of the Ironman last year. What Paula couldn't fathom was why Zinny was bothering with this small-time event when there were so many other plums out there. On the way out of Clubber's, she mentioned it to Jason. "Not that I'm worried," she said, "just mystified."

It was a fine, soft, glowing night, the air rich with the smell of the surf, the sun squeezing the last light out of the sky as it sank toward Hawaii. Jason was wearing his faded-to-pink 49ers jersey and a pair of shorts so big they made his legs look like sticks. He gave her one of his hooded looks, then got distracted and tapped at his watch twice before lifting it to his ear and frowning. "Damn thing stopped," he said. It wasn't until they were sliding into the car that he came back to the subject of Zinny Bauer. "It's simple, babe," he said, shrugging his shoulders and letting his face go slack. "She's here to psych you out."

He liked to watch her eat. She wasn't shy about it—not like the other girls he'd dated, the ones on a perpetual diet who made you feel like a two-headed hog every time you sat down to a meal, whether it was a Big Mac or the Mexican Plate at La Fondita. No "salad with dressing on the side" for Paula, no butterless bread or child's portions. She attacked her food like a lumberjack, and you'd better keep your hands and fingers clear. Tonight she started with potato gnocchi in a white sauce puddled with butter, and she ate half a loaf of crusty Italian bread with it, sopping up the leftover sauce till the plate gleamed. Next it was the fettuccine with Alfredo sauce, and on her third trip to the pasta bar she heaped her plate with mostaccioli marinara and chunks of hot sausage—and more bread, always more bread.

He ordered a beer, lit a cigarette without thinking, and shovelled up some spaghetti carbonara, thick on the fork and sloppy with sauce. The next thing he knew, he was staring up into the hot green

gaze of the waitperson, a pencil-necked little fag he could have snapped in two like a breadstick if this weren't California and everything so copacetic and laid back. It was times like this when he wished he lived in Cleveland, even though he'd never been there, but he knew what was coming and he figured people in Cleveland wouldn't put up with this sort of crap.

"You'll have to put that out," the little fag said.

"Sure, man," Jason said, gesturing broadly so that the smoke fanned out around him like the remains of a pissed-over fire. "Just as soon as I"—puff, puff—"take another drag and"—puff, puff—"find me an ashtray somewhere . . . you wouldn't happen"—puff, puff—"to have an ashtray, would you?"

Of course the little fag had been holding one out in front of him all along, as if it were a portable potty or something, but the cigarette was just a glowing stub now, the tiny fag end of a cigarette—fag end, how about that?—and Jason reached out, crushed the thing in the ashtray and said, "Hey, thanks, dude—even though it really wasn't a cigarette but just the *fag* end of one."

And then the waiter was gone and Paula was there, her fourth plate of the evening mounded high with angel hair, three-bean salad, and wedges of fruit in five different colors. "So what was that all about? Your cigarette?"

Jason ignored her, forking up spaghetti. He took a long swig of his beer and shrugged. "Yeah, whatever," he said finally. "One more fascist doing his job."

"Don't be like that," she said, using the heel of her bread to chase the beans around the plate.

"Like what?"

"You know what I mean. I don't have to lecture you."

"Yeah?" He let his eyes droop. "So what do you call this, then?"

She sighed and looked away, and that sigh really irritated him, rankled him, made him feel like flipping the table over and sailing a few plates through the window. He was drunk. Or three-quarters drunk, anyway. Then her lips were moving again. "Everybody in the world doesn't necessarily enjoy breathing through a tube of incinerated tobacco, you know," she said. "People are into health."

"Who? You maybe. But the rest of them just want to be a pain in the ass. They just want to abrogate my rights in a public place"— abrogate, now where did that come from?—" and then rub my nose in it." The thought soured him even more, and when he caught the waitperson pussyfooting by out of the corner of his eye he snapped his fingers with as much pure malice as he could manage. "Hey, dude, another beer here, huh? I mean, when you get a chance."

It was then that Zinny Bauer made her appearance. She stalked through the door like something crossbred in an experimental laboratory, so rangy and hollow-eyed and fleshless she looked as if she'd been pasted onto her bones. There was a guy with her—her trainer or husband or whatever—and he was right out of an X-Men cartoon, all head and shoulders and great big beefy biceps. Jason recognized them from Houston—he'd flown down to watch Paula compete in the Houston race only to see her hit the wall in the run and finish sixth in the women's while Zinny Bauer, the Amazing Bone Woman, took an easy first. And here they were, Zinny and Klaus Olaf, or whoever—here in the Pasta Bowl, carbo-loading like anybody else. His beer came, cold and dependable, green in the bottle, pale amber in the glass, and he downed it in two gulps. "Hey, Paula," he said, and he couldn't keep the quick sharp stab of joy out of his voice—he was happy suddenly and he didn't know why. "Hey, Paula, you see who's here?"

The thing that upset her was that he'd lied to her, the way her father used to lie to her mother, the same way—casually, almost as a reflex. It wasn't his birthday at all. He'd just said that to get her out because he was drunk and he didn't care if she had to compete the day after tomorrow and needed her rest and peace and quiet and absolutely no stimulation whatever. He was selfish, that was all, selfish and unthinking. And then there was the business with the cigarette—he knew as well as anybody in the state that there was an ordinance against smoking in public places as of January last, and still he had to push the limits like some cocky immature chip-on-the-shoulder surfer. Which is exactly what he was. But all that was forgivable—it was the Zinny Bauer business she just couldn't forgive.

Paula wasn't even supposed to be there. She was supposed to be at home, making up a batch of flapjacks and penne with cheese sauce and lying inert on the couch with the remote control. This was the night before the night before the event, a time to fuel up her tanks and veg out. But because of him, because of her silver-tongued hero in the baggy shorts, she was at the Pasta Bowl, carbo-loading in public. And so was Zinny Bauer, the last person on earth she wanted to see.

That was bad enough, but Jason made it worse, far worse—Jason made it into one of the most excruciating moments of her life. What happened was purely crazy, and if she didn't know Jason better she would have thought he'd planned it. They were squabbling over his cigarette and how unlaidback and uptight the whole thing had made him—he was drunk, and she didn't appreciate him when he was drunk, not at all—when his face suddenly took on a conspiratorial look and he said, "Hey, Paula, you see who's here?"

"Who?" she said, and she shot a glance over her shoulder and froze: it was Zinny Bauer and her husband, Armin. "Oh, shit," she said, and she lowered her head and focused on her plate as if it were the most fascinating thing she'd ever seen. "She didn't see me, did she? We've got to go. Right now. Right this minute."

Jason was smirking. He looked happy about it, as if he and Zinny Bauer were old friends. "But you've only had four plates, babe," he said. "You sure we got our money's worth? I could go for maybe just a touch more pasta—and I haven't even had any salad yet."

"No joking around, this isn't funny." Her voice withered in her throat. "I don't want to see her. I don't want to talk to her. I just want to get out of here, O.K.?"

His smile got wider. "Sure, babe, I know how you feel—but you're going to beat her, you are, no sweat. You don't have to let anybody chase you out of your favorite restaurant in your own town—I mean, that's not right, is it? That's not in the spirit of friendly competition."

"Jason," she said, and she reached across the table and took hold of his wrist. "I mean it. Let's get out of here. Now."

Her throat was constricted, everything she'd eaten about to come

up. Her legs ached, and her ankle—the one she'd sprained last spring—felt as if someone had driven a nail through it. All she could think of was Zinny Bauer, with her long muscles and shaved blond stubble of her head and her eyes that never quit. Zinny Bauer was behind her, at her back, right there, and it was too much to bear. "*Jason*," she hissed.

"O.K., O.K.," he was saying, and he tipped back the dregs of his beer and reached into his pocket and scattered a couple of rumpled bills across the table to cover the checks. Then he rose from the chair with a slow drunken grandeur and gave her a wink as if to indicate that the coast was clear. She got up, hunching her shoulders as if she could compress herself into invisibility, and stared down at her feet as Jason took her arm and led her across the room—if Zinny saw her, Paula wouldn't know about it, because she wasn't going to look up and she wasn't going to make eye contact, she wasn't.

Or so she thought.

She was concentrating on her feet, on the black-and-white checked pattern of the floor tiles and how her running shoes negotiated them as if they were attached to somebody else's legs, when all of a sudden Jason stopped and her eyes flew up and she saw that they were hovering over Zinny Bauer's table like casual acquaintances, like neighbors on their way to a PTA meeting. "But aren't you Zinny Bauer?" Jason said, his voice gone high and nasal as he shifted into his Valley Girl imitation. "The great triathlete? Oh God, yes, yes you are, aren't you? Oh, God, could I have your autograph for my little girl?"

Paula was made of stone. She couldn't move, couldn't speak, couldn't even blink her eyes. And Zinny—she looked as if her plane had just crashed. Jason was playing out the charade, pretending to fumble through his pockets for a pen, when Armin broke the silence. "Why don't you just fock off," he said, and the veins stood out in his neck.

"Oh, she'll be so thrilled," Jason went on, his voice pinched to a squeal. "She's so adorable, only six years old, and, oh my God, she's not going to believe this!"

Armin rose to his feet. Zinny clutched at the edge of the table

with bloodless fingers, her eyes narrow and hard. The waiter—the one Jason had been riding—started toward them, crying out, "Is everything all right?" as if the phrase had any meaning.

And then Jason's voice changed, just like that. "Fuck you, too, Jack, and your scrawny fucking bald-headed squeeze."

Armin worked out, you could see that, and Paula doubted he'd ever pressed a cigarette to his lips, let alone a joint, but still Jason managed to hold his own—at least until the kitchen staff separated them. There was some breakage, a couple of chairs overturned, a whole lot of noise and cursing and threatening, most of it from Jason. Every face in the restaurant was drained of color by the time the kitchen staff came to the rescue, and somebody went to the phone and called the police, but Jason blustered his way out the door and disappeared before they arrived. And Paula? She just melted away and kept on melting until she found herself behind the wheel of the car, cruising slowly down the darkened streets, looking for Jason.

She never did find him.

When he called the next morning, he was all sweetness and apology. He whispered, moaned, sang to her, his voice a continuous soothing current insinuating itself through the line and into her head and right on down through her veins and arteries to the unresisting core of her. "Listen, Paula, I didn't mean for things to get out of hand," he whispered, "you've got to believe me. I just didn't think you had to hide from anybody, that's all."

She listened, her mind gone numb, and let his words saturate her. It was the day before the event, and she wasn't going to let anything distract her. But then, as he went on, pouring himself into the phone with his penitential, self-pitying tones as if he were the one who'd been embarrassed and humiliated, she felt the outrage coming up in her: didn't he understand, didn't he know what it meant to stare into the face of your own defeat? And over a plate of pasta, no less? She cut him off in the middle of a long digression about some surfing legend of the fifties and all the adversity he'd had to face from a host of competitors, a bloodsucking wife, and a fearsome backwash off Newport Beach.

"What did you think?" she demanded. "That you were protect-
ing me or something? Is that it? Because if that's what you think, let
me tell you I don't need you or anybody else to stand up for me—"

"Paula," he said, his voice creeping out at her over the wire,
"Paula—I'm on your side, remember? I love what you're doing. I
want to help you." He paused. "And yes, I want to protect you, too."

"I don't need it."

"Yes you do. You don't think you do, but you do. Don't you see:
I was trying to psych her."

"Psych her? At the Pasta Bowl?"

His voice was soft, so soft she could barely hear him. "Yeah."
And then, even softer: "I did it for you."

It was Saturday, seventy-eight degrees, sun beaming down unmolest-
ed, the tourists out in force. The shop had been buzzing since ten,
nothing major—cords, tube socks, T-shirts, a couple of illustrated
guides to South Coast hot spots that nobody who knew anything
needed a book to find—but Jason had been at the cash register right
through lunch and on into the four-thirty breathing spell, when the
tourist mind tended to fixate on ice-cream cones and those pathetic
sidecar bikes they pedalled up and down the street like the true gup-
pies they were. He'd even called Little Drake in to help out for a
couple of hours there. Drake didn't mind. He'd grown up rich in
Montecito and gone white-haired at twenty-seven, and now he lived
with his even whiter-haired old parents and managed their two
rental properties downtown—which meant he had nothing much to
do except prop up the bar at Clubber's or haunt the shop like the
thinnest ghost of a customer. So why not put him to work?

"Nothing to shout about," Jason told him, over the faint hum of
the oldies channel. He leaned back against the wall on his high stool
and cracked the first beer of the day. "Little stuff, but a lot of it. I
almost had that one dude sold on the Al Merrick board—I could
taste it—but something scared him off. Maybe Mommy took away
his Visa card, I don't know."

Drake pulled contemplatively at his beer and looked out the win-
dow at the parade of tourists marching up and down State Street. He

didn't respond. It was approaching that crucial hour of the day, the hour known as cocktail hour, two for one, the light stuck on the underside of the palms, everything soft and pretty and winding down toward dinner and evening, the whole night held out before them like a promise. "What time's the Dodger game?" Drake said finally.

Jason looked at his watch. It was a reflex. The Dodgers were playing the Pods at five-thirty, Nomo against Benes, and he knew the time and channel as well as he knew his ATM number. The Angels were on Prime Ticket, seven-thirty, at home against the Orioles. And Paula—Paula was at home, too, focusing (do not disturb, thank you very much) for the big one with the Amazing Bone Woman the next morning. "Five-thirty," he said, after a long pause.

Drake said nothing. His beer was gone, and he shuffled behind the counter to the little reefer for another. When he'd cracked it, sipped, belched, scratched himself thoroughly, and commented on the physique of an overweight Mexican chick in a red bikini making her way up from the beach, he ventured a query on the topic under consideration: "Time to close up?"

All things being equal, Jason would have stayed open till six, or near six anyway, on a Saturday in August. The summer months accounted for the lion's share of his business—it was like the Christmas season for everybody else—and he tried to maximize it, he really did, but he knew what Drake was saying. Twenty to five now, and they still had to count the receipts, lock up, stop by the night deposit at the B. of A., and then settle in at Clubber's for the game. It would be nice to be there, maybe with a tall tequila tonic and the sports section spread out on the bar, before the game got under way. Just to settle in and enjoy the fruits of their labor. He gave a sigh, for form's sake, and said, "Yeah, why not?"

And then there was cocktail hour, and he had a couple of tall tequila tonics before switching to beer, and the Dodgers looked good, real good, red hot, and somebody bought him a shot. Drake was carrying on about something—his girlfriend's cat, the calluses on his mother's feet—and Jason tuned him out, ordered two soft chicken tacos, and watched the sun do all sorts of amazing pink-and-salmon things to the storefronts across the street before the gray

finally settled in. He was thinking he should have gone surfing today, thinking he'd maybe go out in the morning, and then he was thinking of Paula. He should wish her luck or something, give her a phone call, at least. But the more he thought about it, the more he pictured her alone in her apartment, power-drinking her fluids, sunk into the shell of her focus like some Chinese Zen master, and the more he wanted to see her.

They hadn't had sex in a week. She was always like that when it was coming down to the wire, and he didn't blame her. Or yes—yes, he did blame her. And he resented it, too. What was the big deal? It wasn't like she was playing ball or anything that took any skill—and why lock him out for that? She was like his overachieving, straight-arrow parents, Type A personalities, early risers, joggers, let's go out and beat the world. God, that was anal. But she had some body on her, as firm and flawless as the Illustrated Man's—or Woman's, actually. He thought about that and about the way her face softened when they were in bed together, and he stood at the pay phone seeing her in the hazy soft-focus glow of some made-for-TV movie. Maybe he shouldn't call. Maybe he should just . . . surprise her.

She answered the door in an oversized sweatshirt and shorts, barefooted, and with the half-full pitcher from the blender in her hand. She looked surprised, all right, but not pleasantly surprised. In fact, she scowled at him and set the pitcher down on the bookcase before pulling back the door and ushering him in. He didn't even get the chance to tell her he loved her or to wish her luck before she started in on him. "What are you doing here?" she demanded. "You know I can't see you tonight, of all nights. What's with you? Are you drunk? Is that it?"

What could he say? He stared at the brown glop in the pitcher for half a beat and then gave her his best simmering droopy-eyed smile and a shrug that radiated down from his shoulders to his hips. "I just wanted to see you. To wish you luck, you know?" He stepped forward to kiss her, but she dodged away from him, snatching up the pitcher full of glop like a shield. "A kiss for luck?" he said.

She hesitated. He could see something go in and out of her eyes, the flicker of a worry, competitive anxiety, butterflies, and then she

smiled and pecked him a kiss on the lips that tasted of soy and honey and whatever else was in that concoction she drank. "Luck," she said, "but no excitement."

"And no sex," he said, trying to make a joke of it. "I know."

She laughed then, a high, girlish tinkle of a laugh that broke the spell. "No sex," she said. "But I was just going to watch a movie, if you want to join me—"

He found one of the beers he'd left in the refrigerator for just such an emergency as this and settled in beside her on the couch to watch the movie—some inspirational crap about a demi-cripple who wins the hurdle event in the Swedish Special Olympics—but he was hot, he couldn't help it, and his fingers kept wandering from her shoulder to her breast, from her waist to her inner thigh. At least she kissed him when she pushed him away. "Tomorrow," she promised, but it was only a promise, and they both knew it. She'd been so devastated after the Houston thing she wouldn't sleep with him for a week and a half, strung tight as a bow every time he touched her. The memory of it chewed at him, and he sipped his beer moodily. "Bullshit," he said.

"Bullshit what?"

"Bullshit you'll sleep with me tomorrow. Remember Houston? Remember Zinny Bauer?"

Her face changed suddenly and she flicked the remote angrily at the screen and the picture went blank. "I think you better go," she said.

But he didn't want to go. She was his girlfriend, wasn't she? And what good did it do him if she kicked him out every time some chickenshit race came up? Didn't he matter to her, didn't he matter at all? "I don't want to go," he said.

She stood, put her hands on her hips, and glared at him. "I have to go to bed now."

He didn't budge. Didn't move a muscle. "That's what I mean," he said, and his face was ugly, he couldn't help it. "I want to go to bed, too."

Later, he felt bad about the whole thing. Worse than bad. He didn't know how it happened exactly, but there was some resentment there,

he guessed, and it just snuck up on him—plus he was drunk, if that was any excuse. Which it wasn't. Anyway, he hadn't meant to get physical, and by the time she'd stopped fighting him and he got her shorts down he hadn't even really wanted to go through with it. This wasn't making love, this wasn't what he wanted. She just lay there beneath him like she was dead, like some sort of zombie, and it made him sick, so sick he couldn't even begin to apologize or excuse himself. He felt her eyes on him as he was zipping up, hard eyes, accusatory eyes, eyes like claws, and he had to stagger into the bathroom and cover himself with the noise of both taps and the toilet to keep from breaking down. He'd gone too far. He knew it. He was ashamed of himself, deeply ashamed, and there really wasn't anything left to say. He just slumped his shoulders and slouched out the door.

And now here he was, contrite and hung over, mooning around on East Beach in the cool hush of 7 A.M., waiting with all the rest of the guppies for the race to start. Paula wouldn't even look at him. Her mouth was set, clamped shut, a tiny little line of nothing beneath her nose, and her eyes looked no further than her equipment—her spidery ultra-light weight bike with the triathlon bars and her little skullcap of a helmet and water bottles and whatnot. She was wearing a two-piece swimsuit, and she'd already had her number—23—painted on her upper arms and the long burnished muscles of her thighs. He shook out a cigarette and stared off past her, wondering what they used for the numbers—Magic Marker? Greasepaint? Something that wouldn't come off in the surf, anyway—or with all the sweat. He remembered the way she'd looked in Houston, pounding through the muggy haze in a sheen of sweat, her face sunk in a mask of suffering, her legs and buttocks taut, her breasts flattened to her chest in the grip of the clinging top. He thought about that, watching her from behind the police line as she bent to fool with her bike, not an ounce of fat on her, nothing, not even a stray hair, and he got hard just looking at her.

But that was short-lived, because he felt bad about last night and knew he'd have to really put himself through the wringer to make it up to her. Plus, just watching the rest of the four hundred and six fleshless masochists parade by with their Gore-Tex T-shirts and Lycra

shorts and all the rest of their paraphernalia was enough to make him go cold all over. His stomach felt like a fried egg left out on the counter too long, and his hands shook when he lit the cigarette. He should be in bed, that's where he should be—enough of this 7 A.M. They were crazy, these people, purely crazy, getting up at dawn to put themselves through something like this—one mile in the water, thirty-four on the bike, and a ten-mile run to wrap it up, and this was a walk compared to the Ironman. They were all bone and long lean muscle, like whippet dogs or something, the women indistinguishable from the men, stringy and titless. Except for Paula. She was all right in that department, and that was genetic—she referred to her breasts as her fat reserves. He was wondering if they shrank at all during the race, what with all that stress and water loss, when a woman with big hair and too much makeup asked him for a light.

She was milling around with maybe a couple of hundred other spectators—or sadists, he guessed you'd have to call them—waiting to watch the crazies do their thing. "Thanks," she breathed, after he'd leaned in close to touch the tip of his smoke to hers. Her eyes were big wet pools, and she was no freak, no bone woman. Her lips were wet, too, or maybe it was his imagination. "So," she said, the voice caught low in her throat, a real smoker's rasp, "here for the big event?"

He just nodded.

There was a pause. They sucked at their cigarettes. A pair of gulls flailed sharply at the air behind them and then settled down to poke through the sand for anything that looked edible. "My name's Sandra," she offered, but he wasn't listening, not really, because it was then that it came to him, his inspiration, his moment of grace and redemption: suddenly, he knew how he was going to make it up to Paula. He cut his eyes away from the woman and through the crowd to where Paula bent over her equipment, the take-no-prisoners look ironed into her face. And what does she want more than anything? he asked himself, his excitement so intense he almost spoke the words aloud. What would make her happy, glad to see him, ready to party, celebrate, dance till dawn, and let bygones be bygones?

To win. That was all. To beat Zinny Bauer. And in that moment, even as Paula caught his eye and glowered at him, he had a vision of Zinny Bauer, the Amazing Bone Woman, coming into the final stretch with her legs and arms pumping, in command, no problem, and the bright-green cup of Gatorade held out for her by the smiling volunteer in the official volunteer's cap and T-shirt—yes—and Zinny Bauer refreshing herself, drinking it down in mid-stride, running on and on until she hit the wall he was already constructing.

Paula pulled the red bathing cap down over her ears, adjusted her swim goggles, and strode across the beach, her heartbeat as slow and steady as a lizard's on a cold rock. She was focused, as clear-headed and certain as she'd ever been in her life. Nothing mattered now except leaving all the hotshots and loudmouths and macho types behind in the dust—and Zinny Bauer, too. There were a couple of pros competing in the men's division and she had no illusions about beating them, but she was going to teach the rest of them a hard lesson, a lesson about toughness and endurance and will. If anything, what had happened with Jason last night was something she could use, the kind of thing that made her angry, that made her wonder what she'd seen in him in the first place. He didn't care about her. He didn't care about anybody. That was what she was thinking when the gun went off and she hit the water with the great thundering herd of them, the image of his bleary apologetic face burning into her brain—date rape, that's what they called it—and she came out of the surf just behind Zinny Bauer, Jill Eisen, and Tommy Roe, one of the men's pros.

All right. O.K. She was on her bike now, through the gate in a flash and driving down the flat wide concourse of Cabrillo Boulevard in perfect rhythm, effortless, as if the blood were flowing through her legs and into the bike itself. Before she'd gone half a mile, she knew she was going to catch Zinny Bauer and pass her to ride with the men's leaders and get off first on the run. It was preordained, she could feel it, feel it pounding in her temples and in the perfect engine of her heart. The anger had settled in her legs now, a bitter, hot-burning fuel. She fed on the air, tucked herself into the

handlebars, and flew. If all this time she'd raced for herself, for something uncontainable inside her, now she was racing for Jason, to show him up, to show him what she was, what she really was. There was no excuse for him. None. And she was going to win this event, she was going to beat Zinny Bauer and all those hundreds of soft, winded, undertrained, crowing, chest-thumping jocks, too, and she was going to accept her trophy and stride right by him as if he didn't exist, because she wasn't soft, she wasn't, and he was going to find that out once and for all.

By the time he got back to the beach, Jason thought he'd run some sort of race himself. He was breathing hard—got to quit smoking—and his tequila headache was heating up to the point where he was seriously considering ducking into Clubber's and slamming a shot or two, though it was only half past nine and all the tourists would be there, buttering their French toast and would you pass the syrup please and thank you very much. He'd had to go all the way out to Drake's place and shake him awake to get the Tuinol—one of Drake's mother's six thousand and one prescriptions to fight off the withering aches of her seventy-odd years. Tuinol, Nembutal, Dalmane, Darvocet: Jason didn't care, just so long as there was enough of it. He didn't do barbiturates anymore—probably hadn't swallowed a Tooey in ten years—but he remembered the sweet numb glow they gave him and the way they made his legs feel like tree trunks planted deep in the ground.

The sun had burned off the fog by now, and the day was clear and glittering on the water. They'd started the race at seven-thirty, so that gave him a while yet—the first men would be crossing the finish line in just under three hours, and the women would be coming in at three-ten, three-twelve, something like that. All he needed to do now was finesse himself into the inner sanctum, pick up a stray T-shirt and cap, find the Gatorade, and plant himself about two miles from the finish. Of course, there was a chance the Amazing Bone Woman wouldn't take the cup from him, especially if she recognized him from the other night, but he was going to pull his cap down low and hide behind his Ray-Bans and show her a face of

devotion. One second, that's all it would take. A hand coming out from the crowd, the cup beaded with moisture and moving right along beside her so she didn't even have to break stride—and what was there to think about? She drinks and hits the wall. And if she didn't go for it the first time, he'd hop in the car and catch her a mile farther on.

He'd been watching one of the security volunteers stationed outside the trailer that served as a command center. A kid of eighteen, maybe, greasy hair, an oversized cross dangling from one ear, a scurf of residual acne. He was a carbon copy of the kids he sold wetsuits and Killer Bees Wax to—maybe he was even one of them. Jason reminded himself to tread carefully. He was a businessman, after all, one of the pillars of the downtown community, and somebody might recognize him. But then so what if they did? He was volunteering his time, that was all, a committed citizen doing his civil best to promote tourism and everything else that was right in the world. He ducked under the rope. "Hey, bro," he said to the kid, extending his right hand for the high five—which the kid gave him. "Sorry I'm late. Jeff around?"

The kid's face opened up in a big beaming half-witted grin. "Yeah, sure—I think he went up the beach a ways with Everardo and Linda and some of the press people, but I could maybe look if you want—"

Jeff. It was a safe bet—no crowd of that size, especially one consisting of whippets, bone people, and guppies, would be without a Jeff. Jason gave the kid a shrug. "Nah, that's all right. But hey, where's the T-shirts and caps at?"

Then he was in his car, and forget the DUI, the big green waxed cup cold between his legs, breaking Tuinol caps and looking for a parking space along the course. He pulled in under a huge Monterey pine that was like its own little city and finished doctoring the Gatorade, stirring the stuff in with his index finger. What would it take to make the Bone Woman's legs go numb and wind up a Did Not Finish without arousing suspicion? Two? Three? He didn't want her to pass out on the spot or take a dive into the bushes or anything, and he didn't want to hurt her, either, not really. But four—

four was a nice round number, and that ought to do it. He sucked
the finger he'd used as a swizzle stick to see if he could detect the
taste, but he couldn't. He took a tentative sip. Nothing. Gatorade
tasted like such shit anyway, who could tell the difference?

He found a knot of volunteers in their canary-yellow T-shirts
and caps and stationed himself a hundred yards up the street from
them, the ice rattling as he swirled his little green time bomb around
the lip of the cup. The breeze was soft, the sun caught in the crowns
of the trees and reaching out to finger the road here and there in
long slim swatches. He'd never tell Paula, of course, no way, but he'd
get giddy with her, pop the champagne cork, and let her fill him
with all the ecstasy of victory.

A cheer from the crowd brought him out of his reverie. The first
of the men was cranking his way around the long bend in the road,
a guy with a beard and wraparound sunglasses—the Finn. He was
the one favored to win, or was it the Brit? Jason tucked the cup
behind his back and faded into the crowd, which was pretty sparse
here, and watched the guy propel himself past, his mouth gaping
black, the two holes of his nostrils punched deep into his face, his
head bobbing on his neck as if it weren't attached right. Another guy
appeared around the corner just as the Finn passed by, and then two
others came slogging along behind him. Somebody cheered, but it
was a pretty feeble affair.

Jason checked his watch. It would be five minutes or so, and
then he could start watching for the Amazing Bone Woman, tireless
freak that she was. And did she fuck Klaus, or Olaf, or whoever he
was, the night before the big event, or was she like Paula, all focus
and negativity and no, no, no? He fingered the cup lightly, remind-
ing himself not to damage or crease it in any way—it had to look
pristine, fresh-dipped from the bucket—and he watched the corner
at the end of the street till his eyes began to blur from the sheer con-
centration of it all.

Two more men passed by and nobody cheered, not a murmur,
but then suddenly a couple of middle-aged women across the street
set up a howl, and the crowd chimed in: the first woman, a woman
of string and bone with a puffing heaving puppetlike frame, was

swinging into the street in distant silhouette. Jason moved forward. He tugged reflexively at the bill of his hat, jammed the rims of the shades back into his eyesockets. And he started to grin, all his teeth on fire, his lips spread wide: Here, take me, drink me, have me!

As the woman drew closer, loping, sweating, elbows flailing and knees pounding, the crowd getting into it now, cheering her, cheering this first of the women in a man's event, the first Ironwoman of the day, he began to realize that this wasn't Zinny Bauer at all. Her hair was too long, and her legs and chest were too full—and then he saw the number clearly, No. 23, and looked into Paula's face. She was fifty yards from him, but he could see the toughness in her eyes and the tight little frozen smile of triumph and superiority. She was winning. She was beating Zinny Bauer and Jill Eisen and all those pathetic jocks laboring up the hills and down the blacktop streets behind her. This was her moment, this was it.

But then, and he didn't stop to think about it, he stepped forward, right out on the street where she could see him, and held out the cup. He heard her feet beating at the pavement with a hard merciless slap, saw the icy twist of a smile and the cold triumphant eyes. And he felt the briefest fleeting touch of her flesh as the cup left his hand.

From Out There

JOHN M. DANIEL

WALTER BRADY got dust in his eye as he walked
across State Street Monday evening. Momentarily
blinded, he stood still with his face in his hands,
waiting for tears to flush his eyeballs. When cars began honking at
him, his sweaty back went into spasm, and he fell down on all fours
on the blazing pavement, groping for the curb. A stranger helped
him to his feet, and he staggered to the door of Joe's Cafe.

Walter Brady had been drinking gin at Joe's Cafe every evening
for a week. Walt had two serious problems at the time, and although
gin didn't seem to cure either one of them, it did appear to offer
temporary relief. Besides which, Joe's was air-conditioned, and dur-
ing that last week of June 1990, Santa Barbara, like the rest of
Southern California, was going through a heat spell that wouldn't let
up. Every evening the Santa Ana winds revved up and blew dry,
dangerous air down from the mountains and onto the city streets.
Sundowner winds, the *News-Press* called them. Every evening that
week, just as Walt Brady was getting off work at the Schooner Inn at
six o'clock, turning the front desk over to Irv, the sundowner would
begin to growl, and Walt's bad back would start to spazz (problem
number one) and he'd leave the Schooner, walk across wind-baked
Lower State Street, and take a stool at the bar in Joe's and order a

cold martini from Diana, the moon-faced melancholy bartender (problem number two).

Walt was ready to admit that he was in love with big, sad-eyed Diana Pearson. In fact he had admitted it to Irv a week ago. "Irv," he'd said as they changed the guard at the front desk, "I'm afraid I've got a fearsome case on that bartender across the street."

"Diana?" Irv replied, shaking his sad face slowly. "Not a chance."

"Is she seeing somebody?" Walt asked.

"She's in mourning," Irv told him. "About a year ago she got dumped by this piano player she was living with."

"She should be over that by now, shouldn't she?"

"Should be," Irv agreed, "but ain't. She attempted suicide, is what I heard. Believe me, forget Diana. She's out there."

"I could make her happy," Walt offered.

"No way," Irv answered.

But Walt couldn't forget Diana. After managing a transient hotel for an eight-hour day, there was nothing he wanted more each evening than to sit in the dark tavern across the street, watching Diana tend bar in her black tee shirt and blue jeans.

She was middle-aged and tall and a bit overweight, and she moved with the grace of a truck, her long blond ponytail jerking awkwardly back and forth behind her. But she had a generous face, with wise, kind eyes. For that matter Walt was overweight and middle-aged (he had a ponytail, too), though he liked to think that in spite of his recent divorce—he was in mourning too, for Christ's sake—and in spite of the bad back that wouldn't let him surf anymore, he still had plenty of fun left in him. And somehow he knew that Diana, in spite of her sad eyes, had fun left in her, too. Walt felt that if he could rescue this looser from depression, he himself would lose weight in the bargain, then the two of them would be graceful ever after.

So he decided Irv was a pessimist, which he already knew, and that he, Walt, stood a chance with Diana. That was a week ago. He had marched right across Lower State and into Joe's, had sat at the empty end of the bar, away from the televised Dodgers game and male laughter, had ordered a martini, and had said to the gloomy

barmaid, "Diana, I have something to tell you. I have a crush on you that won't go away."

Diana slapped the bar with her dishtowel and said, "Walt, that's the nicest thing I've ever heard. Now please don't ever say it to me again. How's your back?"

The hot pliers tightened on Walt's spine, but he forged ahead. "I'm serious, Diana. How about we go out some night? Don't you ever want some company, maybe go to a, I don't know, movie?"

Diana smiled that compassionate smile and said, "I don't go out, Walt. I work seven nights a week, and that's the way I like it. Who needs more trouble?"

"But—"

"I'm always glad to see you in Joe's, honey. But that's the only place you'll ever see me. Period. I do not date. Don't feel bad, I've said the same thing to half the men sitting at the bar right now. Now drink your nice martini." She flipped her ponytail and shuffled away, mopping the bar as she went. God, she had a nice big butt.

Walt's lower back was on fire and he could feel the pain all the way to his heels, but he stuck to it. He ordered another martini and tried again.

"How about we meet in the daytime, then?" he asked her as she poured. "I could switch shifts with Irv. You and I could walk on the beach."

"No."

"Go grocery shopping. Come on, everybody grocery shops. Where do you grocery shop?"

"No, Walter."

Walt finished two more martinis without bothering her again. He ate a steak and drank a beer and watched the Dodgers game. Then, his back numb and his heart still crooning, he shuffled back across the street to the Schooner Inn, climbed the stairs with the help of the banister, and went to bed with the bathroom light on as usual.

But he was back the next night with the same question: "Diana, where do you buy your groceries?"

"Walt, sweetheart, do leave me alone."

"Sorry, Diana, but I've really got a case on you, and it's doing me no good." He grimaced for real: true confessions are murder on the back.

She shook her head sadly.

Every night that week she shook her head sadly, smiled, patted his cheek, and told Walter Brady to take a hike.

"Have mercy, Diana! Can't you see I'm suffering?"

"Honey, you don't know anything about suffering."

But Monday, the evening he staggered into Joe's with tears in his eyes, hunched over like a gnome, feeling too awful even to hit on her, Diana brought him a martini without asking, told him it was on the house, and even reached across the bar and held his hand. "Walt, honey, are you all right?"

"It's my fucking back," he said. "My non-fucking back. I'm afraid I'm in serious trouble."

"Poor baby," she said. "Maybe you should see someone."

"I'm trying to," he answered, "but she doesn't date."

"Get real, Walt. I mean you should see a doctor."

"Doctor," Walt snorted. "Give me a break. I've already spent a thousand dollars on doctors since October. I went to the med center, they sent me to an orthopedist. The orthopedist sent me to a neurologist, who said I should see a psychiatrist. I said the hell with that and went to a chiropractor. When that didn't work I tried acupuncture, acupressure, shiatzu, everything but rolfing and golfing, which I don't do like you don't date. Ow!"

"Maybe it's kidney stones?" Diana offered.

"No way. That's the first thing they checked for at the med center. Definitely not kidney stones. Diana, I only have a thousand dollars left. I can't afford an MRI. I'm afraid you're going to have to come over to the hotel and give me an ice-cube massage. Tonight."

Diana held both his hands with both of hers. "Walter Brady, you know I can't do that." She stared into his eyes and smiled, the corners of her kind mouth turning down with compassion, even affection.

Walt felt the electric current behind his waist—it was always the worst when he knew what a fool he was making of himself. "I don't mean now, of course. I mean when you get off work."

She squeezed his hands and let go. "Maybe you should meet my roommate," she said. "I gotta go pour some drinks."

When she got back she said, "So, do you know how to get to my place?"

"Are you inviting me to your house?" Walt asked. "Your home?"

"I won't be there," Diana explained. "But Given will fix you up, I'm sure."

"Given?"

"My roommate," Diana said. "Given. She's a healer. She's good. You'll love her."

When Walt got back to the hotel at about ten, he found Irv, as usual, reading a Sue Grafton mystery behind the desk. The only person in the world who read Sue Grafton books slower than Sue Grafton wrote them. Irv looked up from his book and said, "You look alive for a change."

"I have a date," Walter announced. "Tomorrow afternoon. Diana's house."

"Diana Pearson? No way."

"No way is right. But I'm going to her home. I have a date with Diana's roommate. Girl named Given. Will you swap shifts with me tomorrow?"

"I didn't know she had a roommate. Does she still live in that cabin up off San Marcos Pass, up by Painted Cave?"

"That's the place."

"That's where she lived with that piano player; he had the studio in the back. She must be renting it out."

The more nervous he got, the more he reminded himself that this was supposed to be an appointment, not a date. Still, Walt found her cabin fifteen minutes early and then felt like a fool having to bake in his car waiting for two o'clock. His back throbbed. It was an appointment, a *medical* appointment, and there was nothing wrong with showing up a little early. He got out of his car at five of two and hobbled up the path to Diana's front door, wishing he were tending the front desk at the Schooner Inn instead.

Diana's cabin rested on the sunny side of a slope at the top of the

pass. It was a hundred yards off the main road, and there were no visible signs of human existence other than the cabin itself and the gravel driveway that ended there. The air was hot, with only the gentlest of breezes stirring the fragrance of chaparral and dust. The only sound was the far-off echoing cry of a hawk.

A sign on the front door said, GIVEN – BACK ENTRANCE.

Walt followed the path around to the back of the cabin, where he found a porch gaily festooned with fuchsias and tinkling with gentle wind chimes. The back door was painted pale lavender. He knocked.

The woman who opened the door wore a white muslin gown with an amethyst brooch. She smiled happily and airily said, "Walt?"

Walt grinned and frowned at the same time. "I didn't expect to see you," he said.

The woman in white said, "I expected *you.* Come in. You are Walter Brady, aren't you?"

"I certainly am," Walt admitted, as he crossed the threshhold into a room full of floating color. "And you are Diana Pearson, are you not?"

She closed the door behind him and said, "I certainly am not."

He turned slowly and faced her for another look, a careful look.

"You look like Diana," he insisted. "But then, I've never seen Diana in daylight. But you look a lot—"

"So I've been told, but believe me, I'm not."

The long blond hair exploded from her head and fell all over her shoulders. Her heavy breasts rested low on her chest, with unbound nipples that pointed through the muslin. Most of all, when this woman smiled, her eyes were merry.

"No," Walt agreed. "You're not Diana at all."

"I'm Given." Her voice was higher than Diana's, too.

"I'm pleased to meet you," Walt said, holding out his hand.

Given approached him slowly and put her hands on his shoulders, as if to show him her face, which was painted by moving spots of color. It was a face like Diana's—round, lined, handsome—but the expression was not Diana's. Given smiled with clear joy. She wore lavender eye shadow.

She said, "You're not what I expected, either."

"What did Diana say about me?" Walt wanted to know.

"She said you were a bad back."

"That's all?" His back began to hurt again, reminded of itself.

Given put a hand on his chest. "But that's the least of what I see in you. Please, Walter, sit down." She sank to the floor.

Walt looked about the small room. There was no furniture. He stood on a plush golden rug, with the woman in white at his feet; she was leaning back against a large purple pillow. There were other pillows scattered about the floor. The room was slowly swimming in beams cast by prisms dangling in the western window. The bright white walls of the room were bare except for the moving spots of color.

"Sit down, Walter, and tell me about your back."

Walt felt the throb of pain as he chose a pillow and sat. Given pulled off his shoes and socks. "It's been a problem for months now," he began. She started pulling on his toes, one by one, with slow warm tugs. "I used to live in San Jose." She knelt before him and gripped him by the heels and leaned back. "I was managing a flea-bitten hotel in Santa Cruz and not managing a flea-bitten marriage in San Jose." She pulled him slowly towards her until he was flat on his back on the floor, his head off the pillow. She leaned forward, raising his knees. His back jolted him with electric pain and then he felt the pain lessen. "The commute traffic was terrible, the smog was terrible, the job was terrible, the relationship was shit, and I figured who needs this terrible shit?" She spread his knees and rocked him back and forth, side to side, so that his lower back was pressed against the carpet. "Then one day an earthquake came along and knocked the hotel down and finished off everybody in it. I got out just in time. Most of them were ready to die anyway, but...." The memory hit him as he spoke, and he cried out. "That night when I got home I found it pretty easy to tell my wife goodbye."

"Sometimes it takes a natural disaster to put our puny problems in perspective. Is that when your back went out? While you were saying goodbye?"

"It's been fucked ever since."

"So you came to Santa Barbara." She held his feet in her lap and rubbed the sides of them with her strong thumbs.

"That's right." There were tears in his eyes.

"When?"

"October eighteenth, last year."

"Do you know why?"

"I told you: life up there sucked."

"Why Santa Barbara?"

"No idea," he said. "It was a day's drive, and the car overheated, and I checked into the Schooner Inn, which was the cheapest hotel I could stand, and the next day I asked for a job. They needed a desk clerk, and I had experience. It's a nice town. I like to surf."

"You don't surf now, do you?"

"Can't. Damn back."

"You didn't come to Santa Barbara to surf, you know," Given said. "You came to meet me. I came here the same day. I came," she said softly, "to heal your back." She set his legs on the floor and said, "Take off all your clothes." She laughed lightly and said, "Don't be embarrassed. I'm a healer. Your healer. I'm going to make some tea."

She stood up, fingering the brooch on her chest, smiled down on him, and backed out of the room.

"So how did it go? How's the old back?" Irv asked him when he returned to the Schooner. "You fixed?"

Walt's ponytail was untied, and his hair was blown loose around his face by the sundowner wind. He felt like a stranger, a tourist in his own body. He felt light and his back did not hurt. He felt tall for the first time in months. He did a careful jumping-jack on the tile in front of the front desk, grinning at the surprise on Irv's face. "I feel great!"

Irv said, "No way," and looked back down at the mystery novel he had open on the counter. "She must be good; how much does she charge?"

"A hundred dollars an hour," Walt said.

"No way," Irv repeated. He closed his book and said, "What a rip-off. How many hours did you buy?"

"I spent two hours there this afternoon. And I want to go back up there tomorrow. Will you trade shifts with me again? Will you trade shifts this whole week, Irv? I'm going to get a full week's worth, five days, two hours a day. That's what she recommends."

Irv chuckled. "Of *course* that's what she recommends." He poked at the calculator and ran a tape. "One thousand dollars."

"She's worth it," Walt said. "I feel terrific. I can stand up, I can move freely—"

"You better quit while you're ahead," Irv offered.

"No, I want the whole nine yards."

"For a thousand."

"For a thou. It's all the money I have, but it's worth it."

"You're out of your mind."

"C'mon, Irv."

Irv shrugged. "It's your money. She must be doing more for you than just massage."

"Just the massage, Irv. It's enough, believe me."

"So are you falling in love with this one, too?" Irv asked.

Walt sighed. "No, I'm still hung up on the sad-eyed barmaid of the lowlands. But this Given lady sure knows how to treat my back." He told Irv about the prisms in the west window, the muslin gown, the musky tea, the ginger incense, the harmony of wind chimes and whale songs, the whole hot afternoon of fierce pain turning to glowing pleasure in his lower back as Given's strong fingers coaxed him to relax and enjoy the universe wherever it touched his body.

Irv shook his head. "That sure don't sound like Diana. Where the hell did she come from?"

"I'm from Gemini," she had told him. "Diana and I met at the Shasta Abbey last August. She was there for a grieving marathon and I was leading a workshop in gynopsychic empowerment. We bonded. She was in bad shape; she had just attempted suicide over a man who had left her. I was looking for a new space, and she had an empty space to fill. It was time for me to come to Southern California. I didn't know why at the time, but now I know. I came to meet you, Walter, to take care of your back. Roll over, please."

"I'm not sure," Walt said. "I'm not sure I heard correctly. I think

she said she was from outer space, but maybe she was just telling me her sign."

Walt still felt good at midnight, after sitting on the stool behind the front desk for six hours. He felt wide awake, too. So after turning the registration book over to Graveyard Greg, he decided to take a walk across the street.

Joe's was nearly empty. A couple of men were watching television at the far end of the bar, and Diana was polishing glasses. She looked up and said, "So! How was the appointment?" The lazy depth of her alto voice was a familiar surprise. She had a half a smile on her face. Walt thought, if she'd smile all the way open, I could swear she was Given. He sat down and grinned.

Diana wadded her towel and threw it down the counter and shuffled over to where he was sitting and checked him out. "Looking good," she admitted, nodding with a cocked eyebrow. "Sitting straight, smiling for a change. I knew you two would hit it off."

"Diana," Walt said, "I love you dearly. You saved my life."

"That wasn't me, babe," Diana said. "Thank Given."

"I did, and I will again."

"You're going back?"

"I'm a regular," Walt told her. "I haven't felt this good in years; I want to keep it this way, whatever it takes."

"All *right,*" Diana told him. She gave him two thumbs up, and asked, "So. What'll you have?"

"No alcohol, no sugar, no caffeine, where does that leave me? Calistoga, please. Diana?"

"What?"

"Are you aware that you look a lot like your roommate? I mean a *lot* like your roommate?"

Diana shrugged. "We're very different," she said. "We may share the same space, but we have different times. She's daytime, I'm nighttime. We're real different."

"I would agree." Walt had his own ideas about their difference— about Given's lightness, the merry lilt of her voice, the slowdancing

grace of her movement about the sunny, color-spotted room, the generosity of her healing thumbs. And he had ideas about Diana too, about the morose, efficient, fumbling dispenser of liquor, change, and sympathy. What surprised him now as he was comparing these two big blond women, finding them altogether different except for the inconsequential matter of their looks and their address, was realizing that the woman he still longed for and needed to please was Diana, the nighttime girl. He wanted to keep her in front of his barstool, talking to him, smiling sadly.

For the first time in hours his back gave him a twinge. He said, "One martini can't hurt."

Diana agreed, "It's always helped you in the past. Coming right up."

When she brought his drink, he said, "Will you join me?" *Ouch.*

She squeezed his little finger and said, "Get real. Hey, I'm glad it's going good with Given. That's not bad. All right." She let go of his finger and strolled away, to answer the needs of other drinkers, while Walt felt his spine catch fire.

"Walter, what happened?"

Given opened her door for him and he stumbled in. He was hot, he was crooked, he was cranky.

"You're upset, Walter," Given observed. She nodded and said, "Put your body on my floor. Now. Do it, and then tell me what you hate the most."

Walt sank carefully to his knees.

"Wait," she said, closing the door. "Take off all your clothes before you get too comfortable."

As Walt peeled off his tee shirt and slipped out of his shorts, Given switched on an electric fan. She was wearing a loose low-cut sky-blue smock without sleeves. She looked cool, moving gently across the room toward him in the new breeze from the fan. Colored dots began to dance about her face. She smiled down at him and hummed. "Stretch out, love."

Walt twitched as he lay on his back and raised his knees. He closed his eyes and concentrated on the drops of sweat that were

rolling off his flab. According to the announcer on his car radio, this was the hottest June 27th in Santa Barbara history, and here it was only two o'clock.

"So," Given said, kneeling by his side. "What happened?" She put her hands on his chest, squeezing his pectorals gently. "You're shaking, Walter. What's going on?"

"You tell me," he panted. "I was fine when I left here yesterday."

"I remember. You were radiant."

"It lasted about eight hours. I felt great. And then, about midnight, wham. Bingo. The back came back."

"And how does that make you feel?"

"Make me feel?" Who was this crazy woman? "It makes me feel like my back hurts!"

"And how does *that* make you feel?"

Walt grimaced and raised up onto his elbow and looked into her unearthly blue eyes and said, "What kind of new-age bullshit are you dealing, lady? *My back hurts.*"

"And that makes you angry? What? Sad? What? Disappointed? Worried? Am I getting warmer?"

He lay back down on his back and sighed. "Well, for one thing, we're talking about a lot of money involved."

"Roll over."

With great effort, Walt rolled over, turning his head away from her. He felt her removing the elastic band from his ponytail, then felt her cool hands wander down his back until one of them settled on his left buttock and squeezed.

"Ouch."

"Relax." There was a hand on each buttock now, and they were both squeezing hard. The pain in his butt absorbed the pain from his lower back like a sponge.

"I don't want you to worry about the money," she told him. She squeezed and released, squeezed and released, then began rocking his body forward and back against the give of the plush carpet.

"It's a lot of money," he repeated softly. The carpet felt good against the front of his body, all the way from the tops of his feet to the side of his face. He felt his crotch grow warmer. "It's all I've got."

"I don't want you to pay me," Given told him, "until you're sure the back is fixed forever. Which it will be, Walter. Which it will be." The sound of worry was gone from her voice. "It will be. Roll over and raise your knees."

Walt did as he was told, and Given moved to sit behind his head. She reached under his head and kneaded the cords of his neck.

He looked up into her face and saw her smiling down at him, upside down. Her eye shadow was blue today, daylight blue. Above her head, rainbow confetti danced on the ceiling.

She gripped his pecs again and said, "It's not worry I feel here."

"No?"

"Not worry, not anger." She caressed his nipples with her thumbs and gave his pecs a gentle squeeze.

"We're supposed to be working on my back here," Walt reminded her. "What do you expect to accomplish playing with my flabby tits?"

She chuckled. "You *could* use a little exercise in this department."

"Fix my back first, and I promise I'll exercise."

"I am fixing your back, Walter. It all starts here, you know. The back is where it ends up—in your case."

"What all starts where?"

Given leaned down over his face and kissed his nipples—one, two—as her own nipples—one, two—brushed his face through the thin cloth of her smock. She rubbed her nose over his hairy chest and then sat back on her haunches and smiled down at him. With her hands resting once again on his chest she said, "Here's where your problem starts."

"Are you talking chakras?"

She laughed. "Chakras! What an earthbound concept. Next you're going to start talking about auras."

"Wait a minute," Walt said. "I'm just a hotel clerk. You're the new-age healer. I was just—"

"I'm just a mechanic, myself," Given said, laying a finger on his lips. "I see you have a problem, I figure out what it is, and I fix it. You think it's a bad back. It's not. That's just what hurts. The prob-

lem's in here." She drew an X on his chest. "I'm going to remove it, that's all. Now it's time for you to quit arguing." She kissed his lips upside down.

"What *is* the problem?" Walt asked. "Will you tell me that much?"

"Of course." With her hands on his shoulders, she began to rock his body again, back and forth on the carpet, using his hips for a fulcrum. "We're dealing with grief, a bad case of grief. Do you miss your wife?"

"Absolutely not."

"Tell me exactly what you were thinking last night when the pain returned."

"I was noticing again how much you look like your roommate."

"Diana? You were with *Diana* at midnight last night?" For the first time, Walt heard annoyance in Given's voice. At the same time, he felt the electric current heat up in his back.

"Well, I went over to Joe's when I got off. To celebrate. To show her—"

"I told you no alcohol."

"I ordered Calistoga," Walt insisted. Her eyes were stern, and her grip on his shoulders grew tighter, the thumbs pressing in on his need to confess, and he said, "Well, I had a couple of martinis, but that was *after* my back started to hurt. After. My back was already hurting, and gin seems to—"

"Hush. It's okay. I know what we're dealing with here. It's Diana, isn't it?"

The jolt to his back made him buck his hips, and that gave him a spasm, and then he was writhing under her gaze. She repeated, "Diana. Diana. Diana Pearson." With each mention of the sad bartender's name, Walt hurt more.

"Poor Walter," Given said. "You're in love with a downer. It's okay, baby. You have my permission to cry. Cry, Walter. Cry about Diana."

Walt bawled. His nose filled up with snot. His eyes poured tears, his chest heaved with rasping gulps of air, and his hips twitched. Given produced tissues from the pocket of her smock, then sat holding his hand while he blew, sobbed, squirmed, and finally settled down.

"It's okay, baby," she told him. "I'm going to fix it."

"Will you do something for me, Given?" His back tightened up again.

"Of course."

The screws tightened on either side of his spine as he said, "Will you tell Diana it wouldn't be such a bad idea for her to go out with me? *Ouch!*"

Given leaned forward and blew a raspberry on his belly.

"What was that for?"

"I'm not going to help you court Diana, Walter. That's not what you need." She pulled her smock up over her head and laid it beside her on the carpet.

"What do I need?" Walt asked.

"What you need, my love, is joy for a change. Now. Take a deep breath. Another." She moved his penis to one side and held his scrotum in her healing hand. "You're going to be fine, Walter. You're going to be just fine. We're going to shoot the moon."

"No way," Irv said that afternoon, when Walter returned to the front desk of the Schooner Inn. "So now you're getting it for *free?* No fucking way."

"Yes way," Walt insisted. "It's different now. We have a relationship."

"You mean you're dicking her," Irv said.

Walt blushed and looked down at his crossed thumbs, but his back held firm. "I wouldn't say that," he said.

"Oh of course not," Irv said. "Nobody ever admits that kind of shit. But that's what's going on: you're dicking this lady. I thought you were hung up on Diana. That didn't take long." Irv picked up his Grafton novel and said, "It's all yours. Have a nice evening."

"You know what this means, don't you? It means I can't charge you. I just gave up a thousand dollars."

"I'll still pay you," Walt had offered. Color splashed like happy rain-drops on their glistening bodies.

"Don't insult me," Given said, laughing. "Didn't the earth move for you, Walter?"

"It didn't even leave a forwarding address," Walt admitted.

"Welcome to Spaceland," Given said. "Say good night, Gracie."

Walter said, "Gracie who?"

Given said, "Say goodbye, Diana."

"Diana who? Seriously," Walt said, "you have to let me pay you. I brought you a check for a thousand dollars. It's not for the sex, Given. It's for the back. My wonderful back."

Given chuckled, "They're the same thing, stupid. Don't worry, I've been paid. We're mated now, earthling. I'm in charge here. As long as you leave me in charge, you'll never have trouble with your back again."

"What about Diana?" he asked.

"Diana who? I'll take care of her."

They lay on their backs, sweltering happily, watching the dance of colors on the ceiling. "You have one hell of a body," Walt offered, sliding his palm on Given's slippery, sweet-smelling belly.

"Thank God I have a heavenly spirit," she said. "You know, I wasn't always this large. It's embarrassing."

"It's beautiful," Walt said, "My every dream come true. Roll over."

"Don't," she said.

"Please. I want another look."

Given rolled over, and he read the tattoo on her luxurious butt: "CASEY" encased in a lavender heart.

"Who's Casey?" Walt asked.

"I have no idea."

"You can tell me," Walt said.

"He belonged to another life," Given said. "I wasn't myself at the time. Forget about Casey, Walt. I have. And let's both forget about Diana."

"Diana who?"

"Wake up, asshole, I'm talking to you."

Walter looked up from his folded hands and looked into Diana's face. It was the first time he'd ever seen Diana outside Joe's Cafe. It was also the first time he'd ever seen Diana angry. Not sad, *mad*. Pissed. She wrung her dishrag between white fists. She glared across the front desk, leaned onto her elbows, and thundered into his face, "You screwed her, didn't you."

"She told you that?" Walt asked. "Given *told* you? What did she say?"

"Shit," Diana said. "Given didn't have to say anything, dipshit. You think I can't tell? By the smell, for God's sake?"

Walt felt tense, felt his back begin to guard itself. Then he felt his back relax as he remembered that very smell, and he said, "Diana, babe, don't put it down—you set it up. God, Diana, I love you forever. You've introduced me to paradise!"

"Give me one big fat break," Diana spat back. "Surely you can find a better whore for a thousand dollars!"

"Wait a minute."

"What?"

"What what?"

"You wait a minute."

"There's no thousand dollars," Walt told her. "Given and I are— seeing each other, I guess you'd call it, and—"

"You're not paying her?" Diana asked.

"No. So—"

"She's not even *charging?*" She slapped the counter with her damp towel. "Jesus God! She's supposed to be helping with the rent."

Walt grasped the towel and then held her wrist. "Listen," he told her. "I love that woman. I can't explain it, but I do."

Diana squinted and frowned. "This is going to be difficult," she said.

Walt said, "Look, I know you two share the same space. But face the facts: this really isn't any of your business."

Her jaw dropped and she shook her head slowly. "Facts," she said. "You don't know jack shit about facts." She turned and left the Schooner Inn, her ponytail swishing.

Walter still felt the presence of Given's skin on his, smelled her wild hair, gloried in the arsonist warmth of her loins. He watched Diana leave through the swinging doors of the Schooner Inn, and his back held firm. He had Given on the mountain.

Irv said, "Walt, the mountain's on fire."

Walt looked up from the front desk. Irv, standing on the staircase, was pale and quaking. "Come up on the roof and have a look, man. This is the big one."

Irv turned and ran back up the stairs, and Walter followed after him, three steps at a time.

The roof of the Schooner Inn was windy and hot. Walt and Irv stood braced against the fierce sundowner wind, gazing northwest into the twilit mountains. The mountains wore a tiara of flame. Even in the minutes Irv and Walt stood there silently side by side, the hot world changed for the far worse. Sirens filled the evening, and the air began to smell of smoke, the wind began to carry flecks of ash.

"That's the pass, man," Irv told him. "That's Painted Cave."

"Given's house," Walt said. "I've got to get up there."

Irv put a hand on his arm. "No way. You can't possibly, man. Nobody's getting on the pass tonight. This is the big one." The fire was growing down the mountain before their eyes. It now put enough hot light into the sky to illuminate the black swirling cloud that was blowing their way.

"Given's in deep shit," Walt said. "I have to do something."

"Let's go call Highway Patrol," Irv said. "Come on, man, we have to get off the fucking roof." He ducked down the hatch and Walt followed after, down the ladder.

At the front desk, Irv called 911 and was put on hold. Walt paced the lobby. Hold can sometimes last forever.

"So what's she like, this Given?" Irv asked him.

Walt stopped walking and thought. "She's different from any woman on earth. But you know what? She's like a cheerful Diana, if you can imagine such a thing."

"Diana Pearson?" Irv said. "Cheerful?"

"Try to imagine it," Walt said.

"That's easy. I can remember it well. Diana was happy."

"Diana Pearson?" Walt said. "Joyful?"

"Hell yes," Irv said. "When she and Casey were together, she was a totally different person."

"Casey?" Walt echoed. *"Casey?* Irv, I'll be across the street."

"Hold on," Irv said. "Here's CHP. Hello?"

Walt didn't wait.

❧

Everyone at Joe's was clustered under the television. Walt stood with the crowd long enough to see the news desk of KEYT-TV in a panic, shots taken from moving helicopters of a mountaintop on fire, and an animated map of Santa Barbara County with red gobbling up green. He shoved his way to the bar and asked the bartender, "Where's Diana?"

"She just left," he was told. "She lives up there at Painted Cave. She had to go check it out."

Walt ran out the back door of Joe's, into the parking lot, where hot wind hit him in the face. He saw her at the far end of the lot, getting into her truck. He ran toward her, but she was already firing up the engine and turning on the headlights.

He stood in her path. To get out of the lot, she was going to have to drive right through him.

She slowed down and stopped a foot from his face. She yelled, "Move it, Walter!"

He said, "Take me with you."

"Forget it."

"Dumb time to argue, Diana," Walt shouted. "Now just cool down. I'm going with you."

He walked around the shotgun side, and she waited until he was seated with the door closed before she tore out of the parking lot and headed down Anacapa to the freeway. "You're such an asshole sometimes," she muttered.

Walt didn't answer. He fiddled with the radio dials until he understood that they didn't work.

Diana said, "I hope you don't expect to find Given alive up there. She's not."

"I know," Walt said.

"She's not," Diana insisted.

"I know," Walt repeated. "You're Given."

"I most certainly am not," Diana shouted, swerving off the 101 onto the San Marcos Pass. "You couldn't be more full of shit."

The pass was blocked. Cars were backed up almost to the freeway. Diana pulled her truck to a halt at the end of a long line and turned off her engine, and almost immediately there were more cars

parked behind her, and then more cars parking behind them. Cars far in front were being turned back. Walt and Diana watched the headlights of the cars ahead of them maneuver their U-turns and pass them going downhill. They waited their turn. They kept their windows closed so they could breathe, and the inside of the cab was like a sauna without dials.

"You think you know what's going on, don't you?" Diana said.

"I think Santa Barbara is burning down," Walter answered. "If that's what you mean."

"That's not what I'm talking about."

"Then tell me," Walt said. "Tell me what I think I know all about."

"You think I'm crazy, don't you," Diana challenged. "Me and Given, you think we're both crazy. Well?"

"Not crazy," Walt admitted.

"Schizo, right? Bates Motel-time?"

"No," Walt said. "Not Bates Motel. Maybe *Three Faces of Eve.* But really, Diana, Given, whoever—"

"The name is Diana, and you're not even close," Diana snorted. "I want you to know that no part of me, no part of me whatsoever, *ever* wanted to have sex with you, Walt Brady. Ever."

"Whatever," Walter said. "Maybe Given feels differently, though."

"Given and I are entirely different people," Diana insisted. "Remember that."

"You just happen to share the same body," Walt pointed out.

"That's right."

"Whatever."

They sat quietly sweating and panting for a few minutes, as the air outside the cab of the truck grew darker with night and thicker with smoke. The line of headlights ahead of them was growing shorter, and their turn was coming soon.

Diana said, "I want you to know what happened. I don't know what Given told you, but I want you to know my side of it. It's nothing against you, Walt. But I would never fall in love with you. I would never fall in love with anybody. Love sucks.

"Given and I met last August at this abbey up in Shasta County.

I was a mess. I had tried to off myself, and so I was up at this retreat, doing meditation and trying to figure out if there was any reason I should hang onto my body when I was definitely finished with my spirit.

"So I meet this old lady, this neat old Modoc Indian lady, and she tells me if I'm done with my body she'd like to take it over. Turns out she's a walk-in, is what she calls it. She doesn't have a body of her own, she just uses other people's. She claims she's from out there, I mean *out there,* and knowing her, I wouldn't be surprised. How about you? Would you be surprised?"

"Not one bit," Walt answered. "So what did you do?"

"We agreed to try it out for a few months," Diana said. "She gets the body twelve hours a day, five in the morning till five in the afternoon. Then I take over. I bartend in the evenings, and I come home and go to sleep. She wakes up and takes walks in the woods and apparently romances her clients. Sounds like she's got the better end of the deal, but I don't know. I'd rather tend bar."

Walt chuckled, "Thanks a lot. So what are *you* doing all day, while she's in your body?"

"I'm nonexisting," Diana said. "Believe me, it's not so bad. I'd rather be nonexisting right now, to tell the truth, but this is my shift. Just my luck."

The car in front of them pulled a U-turn and Diana started her engine. An officer appeared out of the smoke and knocked on Diana's window. She rolled down her window and said, "I have to get up there. My house is up there, on Painted Cave Road."

"Not any more it isn't," the Highway Patrolman said. "You're going to have to turn around right now. We're keeping the pass clear for emergency vehicles. Let's go, move it out."

Diana rolled up her window and started her engine. She turned to Walt and said, "Will you do me a favor?"

"Sure. What."

"Get out of the truck. Right now. Just get out and grab a ride down the hill with somebody else."

"Forget it, Diana. Just turn the truck around and go down the hill like the nice cop told you to."

"You get out right now, Walt. I mean it." She gunned the truck and waited.

"No."

The patrolman tapped on Diana's window with his flashlight. "Come on, lady. Move it."

"Walt, get out. Do what I say."

"No."

"Jesus." Diana stepped on it and drove forward. She smashed into the sawhorse barricade, which took out one of her headlights, and she continued uphill, into the smoke.

"Diana, what the Christ are you doing?"

"You want out? You'd better say so now, Walter, and I'll stop once so you can get out. Otherwise I'm not stopping."

"What are you doing?"

Diana rolled her window down and drove on. She had to go slowly now on the curving road. The visibility was at about five feet. Smoke curled into the cab of the truck. Walter and Diana both coughed. The smoke felt greasy. It was hot in Walt's nostrils, and when he gulped for air through his mouth, it felt like flames going down his throat. He swatted at cinders floating before his eyes. He gasped for more air, his chest clenched, and the last thing he felt before his mind went black was the vise of pain at the base of his spine.

When he came to, the truck was pointed downhill, creeping in a long line of traffic toward the ocean. The windows of the cab were wide open. The air was hot and smoky, but it was clean enough to breathe.

Her right hand was on his thigh.

He looked across at her. Her blond hair was wild and unbound, greasy with smoke, darkened with dirt and sweat. She returned his look and smiled. She looked tired, with grease accenting the lines in her aging face, but her smile was happy. It was the merry-eyed, wide-mouthed smile of afternoon.

"Where are we going?" Walt asked.

"Wherever the traffic takes us," she answered.

"Do you have any plans for us?"

"After we get clear of this mess you can show me how to get to your hotel. I could use a shower," she answered. "And so could you. How's your back?"

Walt held her hand and brought her sticky fingers to his lips. "It's fine, I think. I'm going to miss Diana."

"Not for long, I hope," Given said. She put her hand back on his thigh and said, "I'll learn to make martinis, if you want me to."

"It wasn't the martinis," Walt said.

"Walt, she wanted to go. She wanted out. I'll miss her too, but she left me her truck, and she left me the clothes on my back, and she left me you. I'll settle for that. Will you?"

"I'm tired," Walt answered. "One thing: how did the fire start?"

Given shrugged. "Oxygen, fuel, and heat. That's all it takes."

"I'm not responsible in any way, am I?"

She laughed. "Yes, Walter. It's all one universe, I'm afraid, and everything we do affects everything that happens. Never forget that. Now rest."

The traffic was moving slowly to the sea, creeping in flight from a universe caught fire. Walt was lost in the middle of this flow of automotive lava, and someone else was driving. He put his head on her shoulder and closed his eyes.

From some specific sentient place far away, out there across the heavens, the blazing coastal mountains of Santa Barbara County were only the tiniest invisible fraction of a distant galaxy that appeared to be only one star in a graceful constellation, which in turn cooperated with eleven other constellations in determining the fates of those who paid attention and believed, and Walter Brady was in charge of it all as long as he accepted and did nothing about it. His back felt fine, and he went to sleep.

The Last Younger Man

CATHERINE RYAN HYDE

S HIRLEY BREAKS the surface of consciousness the way a sledgehammer might break through wet tar. Nothing neat or sudden about it. One cheek is pressed against cold, pebbly concrete, and as she lifts her head she touches painful indentations on her face. No memory, but that will likely prove a blessing.

To call it waking would be far too euphemistic, and Shirley dislikes euphemism, feeling duty-bound to strict reality, as though she owes it a debt for ignoring its existence in the past.

The man smiles at her, and extends a bottle in her direction. "Morning, Shirl. Little hair of the dog?"

She accepts the offering. A long slug of brandy finds a hollow place in her gut that, so far, can only tremble. It's a ghost of mornings past, waking up with a painful storm in her head and a man who seems to know her. Welcome back.

He sits in the alley beside her, still shaded from the early sun, in dirty jeans and a red flannel shirt, a bandanna tied around his head. A cross between a homeless man and a pirate. His back is pressed against the brick of the tavern. He seems at home, undisturbed to inhabit this place. He looked more respectable last night. But that's a memory. No need to encourage those.

She sits up, gingerly, and presses her back against the cold brick,

almost shoulder to shoulder with him. It's a trust thing, he is a drinking buddy, whether that will prove beneficial or not, regardless of how that friendship grew.

Some things drop into your life fully formed; live with it. A lesson she learned from her AA sponsor, whom she wishes not to think about just now.

She reaches for the bottle. "How do you suppose I got here?"

"Depends on what you mean by here, Shirl. Santa Barbara? This particular alley? This philosophical place in your life?"

Another slug of brandy burns its way down, to find and repair the damage it previously created. "All of the above."

Before he can answer, she hears it. The metallic sound of its wheels against the tracks. The whistle. It causes her to crumble along preset lines, like a hammer blow to glass that has already sustained cracks and fissures, and is held together only by luck and lack of disturbance.

He's talking, but it sounds distant. "It definitely had something to do with a train. You said you had to get off a train because you couldn't go by somebody's house. Some guy. Eric, I think. Something about being in his house watching the train, not the other way around. I didn't quite get that part."

"No," Shirley says. "Me either." Then she politely excuses herself to be sick in private.

She brings the man back to her hotel, by cab, not for any immoral or even humanitarian purposes, but because she drank all his brandy. She owes him.

It's not quite eight A.M. as they hit the hotel bar for bourbon and waters. The bartender is not the same one who asked Shirley to leave last night, to her relief.

The man raises his glass in a toast, but never says what they might be toasting. She downs her drink and orders another. It has nothing to do with feeling good, which she no longer expects. She has dropped below a centerline, where good cannot be reached, not by any imaginable stretch. The trick is to reach for stable and holding, and, having found it, to try not to let it go.

He looks around as though surveying Heaven or Eden. "Pretty classy, Shirl."

"The Miramar?"

"Well. I guess it's all relative. You don't remember my name, do you?"

"I was never good at names."

"Jim."

"Of course." She sees the bartender watching from the corner of his eye. She hopes he's mostly watching Jim, the dark, muscular miniature of a man who might almost be called a bum, though certainly an imaginative version. Then again, she might not look or smell much better herself. She finds excuses to leave.

They stroll out across the tracks to the boardwalk, and sit on plastic lounge chairs still wet with morning fog. Shirley closes her eyes to wait for it. She won't watch, only listen.

"I can't figure out if you love trains or hate them," Jim says when the whistle sounds in the distance.

"No. Me either."

"I like them myself. Haven't ridden one for years. But they look good going by. Something classy about a train."

"They look better from the outside."

The whistle sounds again, just behind them, a long series of warnings, and Shirley squeezes her eyes shut and tells herself to hold on. The way she might talk to a child.

Don't cry, Shirley. Hold on.

Then the sound fades, like everything else.

She does not wake up, rather regains consciousness. The outward surroundings seem an improvement, but, she reminds herself, that is only outward.

Jim sits in a chair by the window, legs crossed, looking out over the pool, his beard gone, his hair clean. He wears only a towel wrapped around his waist.

She measures and judges the clean-shaven face, dark and friendly, creased with use. The bandanna has been used to hide male pattern baldness. Like that matters. If anything, it's nice to hang around with someone her own age.

186 CATHERINE RYAN HYDE

He looks back and sees she is awake.

"Don't get the wrong idea, Shirl. I'm not planning to overstay my welcome. Dry clothes, I'm gone."

"Why don't you call room service, Jimbo. Get some food up here. Couple of shrimp cocktails, maybe. Steaks to follow."

He smiles as he waits on the line. "My ex-wife used to call me Jimbo."

"Don't get us confused."

"If I did I wouldn't be here."

"You probably didn't deserve her."

She hears the remark hit the carpet, clumsily. A bowling ball of a thing to say. Where on earth did it come from and how did it slip past the guards?

"True enough, Shirl. Yeah. Room service? Two steaks and two shrimp cocktails. And maybe even a bottle of champagne." He catches her eye and she nods. "Okay, well, in half an hour then." He hangs up the phone. "Twelve noon it starts."

She wants to apologize but it's gone, floated by in peace, and she hates to dredge it up again. She digs in her purse, finds her wallet. Flips through credit cards. Chooses the Visa, because it's less than five hundred dollars short of maxed.

Holds it out to him.

"What's that for?"

"Clothes." Every seemingly generous move on her part a clumsy apology, usually for a less identifiable transgression. "We have to get you looking like you belong here."

"Why, are we here for a while?"

"'Til the plastic runs out."

"Gee, thanks, Shirl."

"It's like Confederate dollars. Only as good as the institution behind it."

"You must have been pretty good to get all that credit."

"Emphasis on the past tense."

"I didn't mean it like that, Shirl."

"True enough, though."

After lunch she naps, and Jim comes back in a gray Italian suit,

with a gold stud in his left ear. He brings flowers. He has decided they should go dancing.

Jim dips her often as they dance, to the delight of the crowd that has circled the floor. Shirley knows they have drunk just enough to carry a crowd, to symbolize release, and that they will drink more, and their approval rating will be lost. She enjoys it while she can.

"So what was wrong with Eric?" he whispers in her ear.

"Nothing was wrong with him." Her body has lost the looseness that works, that collects envy. The dance has become stiff.

"So why'd you throw him over?"

She pushes away from him and finds her way back to their table, where champagne waits patiently on ice. The crowd finds other things to do.

In a moment he sits down beside her. "Sorry, Shirl."

"He was a lot younger than me."

"So? I'm younger than you, but we can still cut a rug."

"The hell you are. How old are you?"

"Forty."

"Forty?" In her own voice she hears rudeness, a claim by tone that he looks much older.

"It's like a car, Shirl. I'm not old in years, just mileage. How old are you?"

"None of your damn business," she says, and breaks for the door, wobbly but determined. Another younger man. Dammit. It's a curse, it knows where you are, it finds you.

By the time she flags down a cab, Jim is at her elbow, looking dashing, like a leading man from a romantic fifties movie. "Let's not spoil a good thing, Shirl."

She likes the feeling of his arm around her waist, and he climbs into the cab after her, and she lets him. After all, it's a party. Streetlights flash across his face as they ride, and she smiles at him, and hopes he can't see, because the smile feels hopeful and shy and other things she doesn't want it to be.

She asks the driver to stop at a liquor store, where she buys two more bottles of champagne. Jim says she's his kind of woman,

which she knew. After all these years, she knows whose kind of woman she is.

Back at the hotel they drag lounge chairs down onto the sand, and Jim pops the cork on one of the bottles, and it flies into the surf.

"To an endless party." He takes a drink and passes the bottle to her.

"Not endless. Just 'til the plastic runs out."

"And then?"

"Then I sober up and go home."

"Sober? What's that?"

It seems like a serious question to her, demanding a serious answer, though she knows he would disagree. She digs in her purse until she finds her keys, throws them in his lap, and he singles out the medallion, just as she meant him to, holds it up in the moonlight, and whistles softly.

"Twelve years, Shirl. Damn. Ending when?"

"A couple hours before we met."

"I had one of these once."

"You had a twelve-year medallion?"

"No, just a medallion. One year. And some chips for thirty days. About six of them, I think."

"So, how'd you get so far from the program?"

"I'm no farther from it than you are, Shirl. We are both royally drunk."

She says nothing, just stares at the moon, pleased with the accomplishment of keeping it in focus.

Then Jim says, "How do you know you've got another sober in you?"

"I did it once, I can do it again."

"Ah, but the first one's free, Shirl. You know that."

In the confusing hour after this unpleasant discussion, Shirley remembers falling off her lounge into wet sand. She remembers Jim lying close to her, though not how he got there, and kissing him for a long time, and wondering in a disconnected way why things didn't go further, and if they ever would.

Then it is light, and the tide is in, cold and salty all around

them, and all the clothes they wore the night before they still wear, and a handful of hotel employees watch them from the boardwalk, but it doesn't seem like her most important concern.

"What do you mean you can't authorize it. I know my own credit limit."

She is at the hotel desk, attempting to prepay a second week.

"Sorry, ma'am," the clerk says, though she hardly looks it. "That card's been reported stolen."

"That's ridiculous. It's a mistake. Look." She shows the woman her driver's license, so she can see that the name and the face match, and are clearly hers. She fishes out another card, and it also comes up stolen.

She can feel Jim fidgeting behind her.

When the last card has been tried, she walks away from the desk with him, thinking he looks less like a romantic lead and more like a man she met in an alley or a bar.

"I should have called my daughter. She's a worrier. And her husband's an attorney. I guess this wouldn't have happened it I'd let her know where I was. She must be frantic."

"Time to sober up and go home then." She doesn't like his voice. Suddenly they have near nothing, but he has this one thing to hold on to, the knowledge that she has made a difficult promise, and made it sound easy, and now the time has arrived.

She returns to a semblance of life, her back pressed against the familiar brick of the tavern, the air cold and wet with morning fog. Jim has covered her with the rumpled gray jacket of his new suit. His eyes look sad, in a way she never imagined they would.

"I dreamed you offered me a little hair of the dog."

"Would if I could, Shirl."

"How did you stay drunk before I came along?"

"Oh, I had ways. A little panhandling sometimes. Or I'd hang out near a liquor store and offer to buy for the underaged. For a bottle. If they were stupid I'd go out the back door with both. If they were smart they'd be waiting back there."

Shirley pulls her knees up to her chest and hides her face between them. She feels overpowered by the need to get out of this foggy glare, shower, and down two bourbon and waters. That a shower is beyond her means seems impossible to grasp.

"Jim, I can't live like this."

"Then I guess you'll be sobering up and going home."

After a difficult pause, Shirley digs through her purse for loose change. "Don't suppose you can get much for two-ninety."

"You suppose wrong, Shirl. The world is full of cheap wine."

"Should I be waiting by the back door?"

She expects him to look cut, but he doesn't bother. "Nah. You're my buddy, Shirl. I wouldn't run out on you."

While he's gone she decides she isn't really homeless. She owns her very own house, in San Luis Obispo; the trick is to get to it. I'll call my daughter, she thinks, but she's given the last of her change to Jim, who arrives back with a bottle of wine, which they split, and is gone too soon, and doesn't feel like enough.

Sometime near sunset, Shirley opens her eyes to see a familiar figure standing over her.

"Mom. My God."

"Valerie. How did you find me?"

"Your credit card trail was pretty clear. God, Mom, we've been sick with worry."

"Well, as you can see," she says, sweeping her arms wide to indicate her surroundings, "there was nothing to worry about." Valerie does not look amused, and when politely introduced to Jim she neither says, nor looks as if, she is happy to meet him.

Shirley sits up, confused by her surroundings, then remembers she's in a motel room with Valerie in Carpinteria, where she's been for almost three days, drying out. Preparing for home.

Valerie says, "I called Eric. He wanted to come down, but—"

"Oh, God, no, Valerie. Please."

"He's been worried sick about you, Mom. We all have." Shirley wants to run her hands through her mangled hair, but it seems

pathetic to even evidence concern for her looks, so far beyond immediate repair. "He wants to know why you left him like that." Another silence that Shirley refuses to fill. "We're trying to understand, Mom. Really we are."

"But you *don't* understand."

"Not completely."

"No. Me either."

Valerie's car idles smoothly at her back as Shirley carries the grocery bag into the alley. She's sure Jim has moved on, that she won't find him, and can't decide which she hopes will be true.

He's just as she left him, except in his old jeans and flannel shirt, and bandanna around his head. His eyes come up, startled, like a deer at a watering hole, but soften quickly.

"Shirl. You look positively respectable."

She sinks into a sitting position beside him. "Where's your new suit?"

"Right here," he says, holding up a bottle of good bourbon. She shies away from the fumes of his breath, not in revulsion, but fear of temptation. He isn't too drunk to notice. "Well, if I had someone to come pick me up and take care of me while I dried out, maybe I could look respectable, too."

"I'm glad to hear you say that. Let's go."

He seems to dissolve into himself. "Go where, Shirl?"

"Home."

"Where's home?"

"San Luis Obispo. What's the difference? *This* isn't it."

"I can't, Shirl."

"You had a year medallion once."

"No, I made that up. I had the thirty-day one, though."

Shirley stands, leaving the bag on the concrete. She reaches a hand down to him but he only studies his shoes. "Your ride's leaving, buddy."

"Shit, Shirl, if I could do that would I be doing this?"

"I brought you some food. I'll just leave it right here."

"You know I'll trade it."

"Guess there's not much I can do about that."

"Guess not."

"I put my address in the bag. Don't trade that away."

"No. I won't." He braves a glance at her, but briefly.

"So long, Jimbo."

"So long, Shirl."

She walks far enough to hear the steady, comforting hum of Valerie's waiting car, without once looking back.

"Hey, Shirley. Don't leave a light on for me."

She says she won't but it's a lie; she will. For a while. Not forever.

NOTES ON THE CONTRIBUTORS

NICHOLSON BAKER is the author of *The Mezzanine* (1988), *Room Temperature* (1990), *U and I* (1992), *Vox* (1992), *The Fermata* (1994), *The Size of Thoughts* (1996), and *The Everlasting Story of Nory* (1998). "K.590" first appeared in *The Little Magazine* and then was picked up by *Best American Short Stories 1982.* He has written for *The New Yorker* and *The Atlantic Monthly.* He is married with two children and lives in Berkeley, California.

T. CORAGHESSAN BOYLE is the author of eight novels, including *World's End* (1987) (for which he won the PEN/Faulkner award), *Tortilla Curtain* (1995), and *Riven Rock* (1998), and four collections of short stories, gathered in *Collected Stories* (1998). He lives in Montecito, adjacent to Santa Barbara.

JOHN M. DANIEL has worked as a bookseller, a free-lance writer, an editor, an entertainer, a teacher, and a publisher. A former Wallace Stegner Fellow in Creative Writing at Stanford, he is the author of *Play Melancholy Baby* (1986), a mystery novel, *The Woman by the Bridge* (1991), a collection of short stories, and *One for the Books: Confessions of a Small-Press Publisher* (1997). He lives in Santa Barbara with his wife, Susan, with whom, he has written, "he is happily enslaved to the publishing business."

CATHERINE RYAN HYDE is the author of one published novel, *Funerals for Horses* (1997), and a collection, *Earthquake Weather and Other Stories* (1998). Acclaimed for her short fiction, she has served as associate editor of the *Santa Barbara Review* and has been active in the Santa Barbara Writers' Conference for many years. She divides her time between Santa Barbara and Cambria on California's central coast.

SHEILA GOLBURGH JOHNSON has published short stories, non-fiction, and poetry in many literary journals, including *Crosscurrents,* in which "Yardwork" first appeared. Her book, *Shared Sightings: An Anthology of Bird Poetry,* appeared in 1995. She lives in Santa Barbara.

SALVATORE LaPUMA was born in a Sicilian section of Brooklyn, where he would set most of the stories in his first collection, *The Boys of Bensonhurst* (1987), for which he won the Flannery O'Connor Award for Short Fiction, and his novel, *A Time for Wedding Cake* (1990). He second collection, *Teaching Angels to Fly,* was published in 1992 and includes some stories set in Santa Barbara, where LaPuma moved in 1976.

SHELLY LOWENKOPF has lived in Santa Barbara since 1974. He has been editor-in-chief of two Santa Barbara book publishing ventures and has taught writing courses at UCSB and Adult Education. Although he defects on a weekly basis to teach at the graduate level Professional Writing Program at USC, he maintains a teaching presence in Santa Barbara through private seminars and yearly participation (since 1980) as a workshop leader and panel moderator for the Santa Barbara Writers' Conference.

DENNIS LYNDS is perhaps best known for his detective fiction written under various pseudonyms, particularly the Edgar Allen Poe Award-winning Dan Fortune series by "Michael Collins." Despite his prolific output of mystery novels, Lynds has continually published under his own name mainstream stories that have been gath-

ered in *Why Girls Ride Sidesaddle* (1980) and *Talking to the World and Other Stories* (1995).

GAYLE LYNDS, since graduating from the University of Iowa with a B.A. in journalism, has been a magazine editor, short story writer, and book author. She has also taught writing in the Santa Barbara area and numbers among her students Sheila Golburgh Johnson. Her first novel, the critically acclaimed best-selling thriller *Masquerade,* was published in 1996. Her second, *Mosaic,* appeared in 1998.

ROSS MACDONALD is, along with Chandler and Hammett, one of the big three of American Hardboiled Detective Novelists. His Lew Archer novels take place in the Santa Barbara facsimile, "Santa Teresa," and often play off real events, such as the catastrophic fires and oil spills that devastated Santa Barbara. His story in this volume was written in 1946 for *Ellery Queen's Mystery Magazine,* and were, with his other early stories, he wrote in 1976, "the price I paid to become a professional writer. Short and few as they are, the writing of them altered me. I accepted a limitation of form and style which opened up a world but changed me, or a part of me, from Kenneth Millar into Ross Macdonald."

MARVIN MUDRICK taught from 1947 right up until his death almost fifty years later at the University of California at Santa Barbara, where he was also Provost of the College of Creative Studies (1967–84). He was a regular contributor to *Hudson Review.* Many of his pieces were collected in *Books Are Not Life But Then What Is?* (1979) and *Nobody Here But Us Chickens* (1986). Although criticism was his regular beat, he did publish several short stories over the years, including "The Professor and the Poet," which was featured in the 1955 edition of *Best American Short Stories.*

JOHN SAYLES is a writer, director, actor, playwright, and film editor. His films include *Eight Men Out* (1988), *Passion Fish* (1993), and *Lone Star* (1996). Among his works of fiction are *Union Dues*

(1977), *Los Gusanos* (1991), and *The Anarchist's Convention & Other Stories* (1979). "Old Spanish Days" was written during a two-year period in the mid-seventies while Sayles was living in Santa Barbara and writing screenplays for the movie studios.

WALLACE STEGNER was the author of, among other novels, *Remembering Laughter* (1939), *Angle of Repose* (1971) (for which he was awarded the Pulitzer Prize), and *The Spectator Bird* (1977) (which won the National Book Award). His non-fiction includes *Beyond the Hundredth Meridian* (1954) and *The Sound of Mountain Water* (1969). His *Collected Stories* was published in 1990. He started the highly regarded writing program at Stanford, which bears his name.